D1246712

HOW TO
HOST A
VIKING
FUNERAL

HOW TO

The Case for Burning Your Regrets,

HOST A

Chasing Your Crazy Ideas, and

VIKING

Becoming the Person You're Meant to Be

FUNERAL

Kyle Scheele

HarperOne

An Imprint of HarperCollinsPublishers

HOW TO HOST A VIKING FUNERAL. Copyright © 2022 by Kyle Scheele.
All rights reserved. Printed in the United States of America. No part of
this book may be used or reproduced in any manner whatsoever without
written permission except in the case of brief quotations embodied in critical
articles and reviews. For information, address HarperCollins Publishers,
195 Broadway, New York, NY 10007.

HarperCollins books may be purchased for educational, business, or
sales promotional use. For information, please email the Special Markets
Department at SPsales@harpercollins.com.

FIRST EDITION

Designed by SBI Book Arts, LLC

Library of Congress Cataloging-in-Publication Data is available upon request.

ISBN 978-0-06-308727-9

22 23 24 25 26 LSC 10 9 8 7 6 5 4 3 2 1

This book is dedicated to my wife, Lindsay,
who believed in me when I didn't believe in myself

. . . and to the memory of Philip Marsh,
who was my friend.

CONTENTS

SECTION FOUR

EXPERIENCES

SECTION FIVE

IDENTITIES

SECTION SIX

RELATIONSHIPS

SECTION SEVEN

BELIEFS

SECTION EIGHT

THE PEOPLE WE USED TO BE

AUTHOR'S NOTE

When I set out to tell this story, I realized that, like any story, there are an infinite number of ways to tell it.

This particular tale involves a public art project that had contributions from more than twenty thousand people but that was put together almost entirely by one person (me). In light of that, the decision I had to make was this: Do I tell the story of the more than twenty thousand submissions, or do I tell the story of my own experience of putting the project together, of reading every one of those submissions and being impacted by them?

In the end, I realized that my own story is the only one I can tell. For one thing, the submissions were anonymous, and a great many of them lacked enough context to get a clear picture of what the story actually was. When someone wrote that they regret "Not telling him to stop,"* there are a number of things they could have meant, and while I have my own theories about which ones are more likely than others, in the end that probably says more about me than it does about the person who wrote those words.

But even if I knew for certain what a submission meant, I didn't know anything about the person who sent it. How old are they? What color is their skin? Where did they grow up, and with whom? Are they tall or short? Male, female, or nonbinary? Single, married, divorced, or widowed? All of those answers give insight into their stories, and I don't know a single one of them.

*Submission 5,747.

In light of that, I decided to tell the story as I experienced it. While I do share a good number of the submissions I received, this is ultimately not a book about a quantitative analysis of data. Instead it's a book about my own experience wading through those data and what I learned along the way about regret, heartache, and moving on.

James Joyce once wrote, "For myself, I always write about Dublin, because if I can get to the heart of Dublin I can get to the heart of all the cities of the world. In the particular is contained the universal."

My hope is that in the particulars of my story you will find something universal, something that connects to your own life, something to remind you that in the end we are not so different, you and I.

* * *

One more word of caution before we get started: you should know that this is gonna get weird.

This story involves multiple Viking funerals, thousands of square feet of cardboard, and enough hot glue to supply your mother-in-law's craft night for the rest of time—not to mention an in-depth analysis of which human names are appropriate for dogs, a metaphor about a trash compactor, and two separate stories about the same Billy Joel song.

But it also involves regret, self-doubt, insecurity, and, ultimately, redemption.

Or something like that.

So buckle up, friend. It's about to get bumpy.

worrying about
what others
think of me

insecurity

FAILURE

Not taking chances

ONE VIKING SHIP
LEADS TO ANOTHER

SELF DOUBT

Giving up
on myself

ng to scared
try new things

fear of making
the wrong decision

Fear of being judged

Letting **TEST failures** determine next steps.

Not knowing what to do.

Doubting Myself

fear of embarassment

the fear of failing and disappointing people

Worrying about things I have no control over.

1

HOW THIS WHOLE THING GOT STARTED

This book is about a crazy idea I had to build and burn a giant Viking ship, the journey I went on (both internally and externally) to make that happen, and what I learned about myself, and humanity, in the process.

But before I tell you about *that* Viking ship, I have to tell you about another one (as I mentioned in the Author's Note, there are multiple Viking ships in this story), because while this probably won't ever make any real sense to a sane person, at least this way you'll understand a little bit of how this whole thing got started.

In May 2016, I turned thirty years old. A few weeks prior to that, my mom asked if I was planning on doing anything special to celebrate the milestone. Since my parents live in the country, she suggested that I could have a bonfire on their property.

I thought about this for a few days, then called to let her know I would not be having a birthday party after all. Instead, I would have a funeral to mourn the death of my twenties.

My mother, naturally, thought this was absurd. "Is this your idea of a quirky party theme?" she asked. "What, are you going to have everyone dress in black, and you'll have a coffin for them to put their gifts inside?"

"No, Mom . . ." I laughed. "That would be creepy. I'm not having a *regular* funeral for my twenties. I'm having a *Viking* funeral."

She sighed. "Why are you so weird?"

I took that to mean that she was still on board with me having the event at her house.

The next person I had to convince was my wife, Lindsay. I waited until the kids were in bed, then sidled up next to her on the couch, where she was scrolling through Instagram.

"So I've been thinking about my birthday . . ." I said, handing her a glass of wine.

She put her phone down and gave me a suspicious look.

"What?!" I said, feigning innocence.

"I can already tell you're up to something," she said, accepting the wine but still looking wary.

"Well, I had this idea that instead of a birthday party, I could have a Viking funeral for my twenties," I began.

My wife rolled her eyes. This was not her first Kyle-presents-an-idea rodeo.

"Go on," she said, taking a sip.

"Well, I was thinking I could build a big Viking dragon ship, then I could put some letters and numbers inside that say 'my twenties,' then I could shoot a flaming arrow into it and set it on fire," I explained.

"And you're telling me this because . . ." she trailed off.

"Because it's going to cost us some money, and if I'm going to

get it done in time for my birthday, I'll have to drop everything else for the next few weeks, and that's a pretty big decision that I don't want to make without you being on board."

She laughed. "Oh, Kyle . . ."

"What?" I asked.

"It's cute that you think you're asking me for permission," she said.

"I *am* asking you for permission," I replied. "If you say no, I won't do it."

"That's really sweet that you think that's true," she said. "But I've known you long enough to recognize when you get this kind of idea."

"What kind of idea?" I asked.

"The kind of idea that you're going to do no matter what anyone says."

I was taken aback. "Babe!" I said. "I don't know what you're talking about. I mean yes, I'm excited about this idea. And yes, I really want to do this. But if you say no, I'll let it go."

"Again, it's adorable that you believe that. But what will really happen is that you will keep dropping increasingly less subtle hints about it until I give in. So I'll just save us the trouble and give in now."

I weighed my options: I could keep trying to convince her that I was serious about wanting her buy-in, or I could just accept the buy-in she'd already put on the table.

I went with door number two.

"You're the best, babe!" I said, kissing the top of her head as I got up from the couch.

I gathered my supplies, sat down in the kitchen, and began working on a maquette. "Maquette" is a French word that just

means "model." But at some point in the past, artsy-fartsy types got together and decided, "Why use an understandable English word when we could use a fancy-pants FRENCH word that makes us feel better than everyone else?" So now anytime an artist builds a model of something, they call it a maquette.

The purpose of a maquette is to help the artist figure out the proportions of a piece before they start building the full-size version of it. It's much cheaper to make a mistake on a scale model than it is on the final product.

This was going to be the biggest sculpture I'd ever built, so I figured I should build a maquette to help me figure out exactly how big to make it.

I knew that I was going to build it out of cardboard, because cardboard is cheap and strong and remarkably versatile, and also because there's something poetic about creating something beautiful from a material most people consider to be garbage.

I knew that I could get sheets of cardboard that were eight feet tall, so I decided I'd use every bit of that height. Then, I just had to figure out how long the ship should be.

"I think it's going to be eight feet tall by twelve feet long," I told Lindsay.

"Sounds good!" she said from the other room.

After building the maquette, though, I changed my mind.

"It looks weird being that short. I think I need to make it at least fourteen feet long for the proportions to look right."

"Okay, but can we keep it there? I don't want this getting out of hand."

Based on her tone of voice, it sounded like she was already beginning to regret her decision to green-light this whole thing.

"Fourteen feet it is," I said. "Not an inch longer. Scout's honor."

"You were never a scout, Kyle," she said, sounding suspicious.

"And thus I have no qualms about besmirching their honor!"

She laughed.

"I'm going to bed," she said, then added, "Fourteen feet, okay?"

"Fourteen feet!" I said, holding up my hand in that weird three-finger salute that Scouts and Hunger Games contestants use.

The final ship was sixteen feet long. My apologies to the Scouts.

* * *

Over the next few weeks, I built an enormous cardboard Viking ship in my garage.

I built it in pieces, knowing that I would have to transport it to my parents' house for the burning, but due to the size constraints of my garage, I couldn't actually fit all of the pieces inside at once without some creative Tetris-esque arranging. This meant that if I wanted to see how the ship actually looked all put together, I had to drag the pieces out into the driveway, where my neighbors could take mental snapshots to file away as evidence of me having lost my marbles.

I'd never built anything this size on my own before, so it was a make-it-up-as-you-go sort of operation. There were several times when I spent hours and hours building a piece of the ship, only to tear it all apart and start over because I realized I'd made a mistake.

The last few days of the project are a blur to me now. I was staying up well into the night, working on the ship with a few friends until they had to go home, then working by myself until my eyelids got so heavy I couldn't keep them open anymore. At that point I'd go to bed for a few hours, then I'd wake up, drink an entire pot of coffee, and get back to it. One night I got four hours of sleep. The next night I got three hours, then two hours the night after that.

The morning of the celebration, my wife called my phone.

"Where *are* you?" she asked.

"In the garage," I said.

"What time did you come to bed?" she asked.

"I'll let you know as soon as that happens," I said.

"Kyle, you *have* to come sleep."

Years of marriage have taught me to recognize when I'm going to lose an argument, so I unplugged the hot glue gun, walked inside, and laid down for an hour.

Later that morning, my friend Spencer and I loaded the pieces inside a van he'd borrowed from his work. It took us several trips, and we had to strap the giant numbers to the top of the van, but eventually we got the entire thing to my parents' house. I'll never forget following behind Spencer in my car, laughing at the absurdity of a giant cardboard zero strapped to the top of an unmarked white van as it went over hill and dale, snaking through back roads.

We assembled the pieces using my tried and true seat-of-the-pants approach. Since there was no electricity in the field, I had to plug my hot glue gun into an adapter in my brother's truck. Unfortunately, there just wasn't enough power to make it work for more than a few minutes at a time, so instead I used

a propane torch to melt the hot glue, then attempted to aim the drips where I needed them. This was less than ideal, but with some trial and error it was a workable technique.

Shortly after we got the ship assembled, people began to arrive for the celebration. A table was set up with snacks and drinks, and people milled about, taking pictures of the ship and commenting on what a strange and hilarious experience this whole thing was.

When the sun went down, we gathered together, I gave a short speech (I'm a professional speaker—I couldn't help myself), and we all shot Roman candles at the ship because I hadn't had time to figure out how to make a flaming arrow work.

Dozens of fiery projectiles struck the ship in unison, and my weeks of work began to burn. As the flames crept up the dragon's back, my daughter Lucy whispered in my ear.

"She was a beautiful ship, Dad."

I had to agree.

In a matter of minutes, the ship burned away to nothing. The flames rose high into the night sky, and the ash rained down like snow for minutes afterward, dusting the shoulders of everyone in attendance.

As the fire died down, people began saying their good-byes, telling me one last "Happy birthday," and heading home.

The next morning I boarded a plane, flew to Utah for a speaking engagement, and assumed that life would basically return to normal.

Boy, was I wrong.

2

A LONG HISTORY OF WEIRD PROJECTS

I have a long history of weird projects.

For instance, I once had this friend who wouldn't stop bugging me about running a marathon. He was a marathon runner, and like a lot of people with debilitating addictions, he wasn't content just to ruin his *own* life, he also wanted to drag everyone else down with him. So every time I'd see him, we'd have the same conversation:

> **Him:** You've got to run a marathon, dude. It's so much fun.
>
> **Me:** That's a lie. People die running marathons. Dying is not fun.
>
> **Him:** Okay, maybe "fun" is the wrong word, but it's such a cool feeling to be able to say that you've run a marathon.
>
> **Me:** Well, I could *say* that I've run a marathon now.
>
> **Him:** Yeah, but that would be dishonest.

Me: True, but I could still say it. And also, if honesty is the best policy, that means dishonesty is still the second-best policy, and I'm okay with silver.

Him: What is wrong with you?

At the end of our conversation, he would always point out that while I could *say* that I'd run a marathon, no one would really believe me. And I realized he was right. I'm not a runner, I don't talk about running, and I have no proof that I've ever run a marathon.

But I also realized that it would theoretically be possible to convince people you'd run a marathon without actually running one at all. Just as a thought experiment, I tried to come up with a list of all the kinds of proof a person would need to be convinced that another person had run a marathon.

Here's what I came up with:

1. **Physical proof:** When you run a marathon, they give you a race number, a T-shirt, maybe even a medal. Most people keep this stuff as mementos, hanging their medals in conspicuous places in their home to make you feel bad about yourself when you visit. So if you're going to convince someone that you've run a marathon, you'd have to figure out how to get all that stuff.

2. **Photographic proof:** There's no point in running a marathon if you don't get a picture of yourself looking miserable with your race number pinned to your sweaty T-shirt. So to convince people that you've run a marathon, you're going to need to fake a picture like that.

3. **Social proof:** If I tell you I ran the XYZ Marathon, you're going to be pretty suspicious if you Google that name and nothing comes up.

As I thought about these three things—physical proof, photographic proof, and social proof—I realized that none of them required any running at all.

I also realized that there are probably a lot of other people out there who, like me, want their marathon-running friends to just leave us alone to live our sedentary lives and who, like me, would be willing to bend the truth a bit if it would get the marathon mafia off our backs.

So I decided to host the world's first fake marathon.

I got some friends together and we made a plan.

The idea was simple. First, people would give us money. That's important.

Second, we would send them all of the stuff they'd get from a normal race. We'd send them a custom race number with their name printed on it. We'd send them a commemorative race T-shirt. If they paid us enough, we'd even send them a medal.

That took care of the physical proof.

For photographic proof, we'd ask each "participant" to pin on their race number, dress in their finest running gear, and have a friend take a picture of them pretending to run. Then we'd ask them to post this photo to their social media accounts and use the official race hashtag.

Seeing hundreds of pictures like this would help with social proof, too, but to really cement that side of things we'd put together an official race website with information, a race map,

and sponsors. We'd even list everyone's official finishing times. (Since I'd never run a marathon before, I didn't know how long it usually takes someone to finish one, so I scoured the internet for a spreadsheet of New York City Marathon finishing times. Then I stripped all of the names off it and replaced them with the names of our participants. In a blatant cash grab, the more money you gave us, the better your race time would be.)

I called the race Run Free, because it was free of running. I was hoping we could get a hundred or so people to sign up, because that seemed like a believable number.

In the end, more than a thousand people participated in the race. We raised just over twenty-three thousand dollars on Kickstarter, the race got sponsored by Groupon, and we were featured in the print edition of *Runner's World* magazine.

As soon as the *Runner's World* piece came out, I called my friend back:.

> **Me:** Hey, man, quick question. How many marathons have you run?
>
> **Him:** Well, between marathons and half marathons, probably like fifteen. Why?
>
> **Me:** Man, that's a lot. So how many times have you been in *Runner's World*?
>
> **Him:** Oh, I've never been in *Runner's World*.
>
> **Me:** I have! *click*

* * *

Run Free was a lot of fun to work on, but it was just one in a long series of weird side projects I've had over the years.

There was the time I made an app called BeardMyBaby, whose sole purpose was to put beards onto pictures of babies.

There was the time I took the backseat off a tandem bicycle and replaced it with the back half of a horse so that when you sat on the front seat, it looked like a centaur was riding the bike.

There was the time a local magazine held a contest for "Best Person to Invite to a Party" and my friend Jesse made the top five but not the top three, so I raised money to buy him a six-foot trophy that said, "Springfield's fourth or fifth best person to invite to a party."

I could go on, but I think you get the gist.

The reason I bring all this up is twofold:

First, because I want you to think, "Wow, Kyle is fascinating and creative and hilarious! I wish I could be like him!" (This is why any writer writes anything—because we want you to like us.)

But second, because it gives context to why I would spend time and money building a giant Viking ship only to immediately set it on fire.

I did it because, well . . . that's the kind of stuff I like to do.

And like all of the other projects I've done, I assumed it would be a thing that people laughed at, talked about for a bit, and subsequently forgot.

In other words, I assumed life would more or less go back to normal after the ship burned.

But that's not what happened.

When I first announced that I'd be having a Viking funeral for my twenties, I had a lot of people ask if I was going to record

the burning of the ship for people who couldn't be there. Then I had people ask if I was going to record the *creation* of the ship. A few people even said, "This idea is so weird, I'd watch one of those internet minidocumentaries about it."

So I called up some friends who run a video production company, and they agreed to help me put something together. During the construction of the ship, they came over and got footage of me cutting and gluing cardboard, and then they sat me down for an interview about the whole thing.

I probably talked for thirty minutes or so, and they used their editing magic to pull out the two or three good things I said in there and string them together into something coherent.

At one point they asked me if I was going to be sad to burn the ship after working so hard on it, and I said no. I said that you have to let go of the old to make room for the new. You have to let go of the past if you want to have room for better things in the future.

That quote made it into the final video, and the idea really seemed to resonate with people. The video began to spread around the internet, and I started to get emails and messages from people who'd seen it.

These messages all followed a pretty similar format. They'd say something like:

> Hey, Kyle,
>
> I saw your Viking birthday thing.
>
> It was weird.
>
> But somehow it inspired me to let go of some of my own stuff.
>
> So thanks.

P.S.: I just wish I could let go of my stuff with a cool Viking funeral like you did.

When I got one email like this, I thought, *Aw, that's nice.*

When I got two emails like this, I thought, *That's funny. They both said pretty much the same thing.*

But when the emails just kept coming, and they all said the same thing, I started to think maybe this wasn't going to be like my other projects. Maybe this wasn't going to be just another thing that faded into the background.

I had no idea how right I was.

3

THE SECOND SHIP

It wasn't all that unusual for me to get notes from people saying they liked a project of mine. What *was* unusual was that the notes *just kept coming*, even after I'd done multiple other projects.

Like, even after a whole *year's* worth of other projects.

In the year after I built the first Viking ship, I:

- launched a T-shirt company

- tried to get voted in as my town's "Best Cold Sandwich" (I'm almost 100 percent sure I won, but the magazine holding the competition invalidated my votes because, in their words, "You're not a sandwich")*

- built a giant sculpture of an astronaut head with lights and motors inside

- built an enormous cardboard fish submarine

*More on this in Chapter 23.

- made a video about kindness that got picked up by Upworthy and racked up hundreds of thousands of views

- got 37,000 people to sing "Don't Stop Believing," with me

- gave more than 125 speeches in 29 states

It was a busy year! But each of those projects came and went just like every project that had come before. People would like, comment, share, and talk about them for a while, then they'd move on to other things.

The Viking ship, however, just wouldn't fade away.

A full year after I burned the ship, I was still getting messages and comments about it. I would meet people and they'd say, "Oh, I know who you are! You're the Viking ship guy!"

That had never happened with any of my other projects.

So when yet another email came in that said, "You inspired me to let go of some of my own stuff . . . I just wish I had a cool Viking funeral like you did," I thought, *Well, maybe I can help with that.*

* * *

Once I realized the Viking ship wasn't going to go away quietly, I began talking with friends and family about the possibility of doing a follow-up project. Pretty soon, talking turned into looking at warehouse space, pricing out supplies, and—you guessed it—building a maquette.

Finally, in September 2017, I announced to the public that I would be doing one more Viking funeral.

This one wouldn't be for me, though, and it wouldn't be

about letting go of my twenties. Instead, this would be a chance for anyone who wanted to let go of something from *their* past.

The idea was simple: I asked people to take a note card and write down something they wanted to let go of. It could be a regret, a mistake, a limiting belief, a habit. It could be something that happened to them or something they'd done themselves. It could even be something that DIDN'T happen that they wish HAD happened. Anything really, as long as it was something they wanted to put behind them.

In other words, I asked, "What's something that makes you say, 'That's the person I used to be, but it's not me anymore'?" We all have these things, and most of us know we need to let them go. But that can be easier said than done, and sometimes what we need most is another person to come along and give us permission to say, "It's okay if you want to stop carrying that."

I asked people to mail their note card to me, and I promised I would build another Viking ship, fill it with the submissions, and set it on fire as a symbolic act of letting go.

It would be a Viking funeral for the people we used to be.

I put out a video explaining the whole idea, and immediately people began to respond. I got a hundred submissions, then five hundred, then a thousand. Sometimes I'd get an envelope with one card in it from an individual who saw the video and wanted to participate. At other times I'd get an envelope with a whole stack of cards from a dormitory floor or a soccer team or an Alcoholics Anonymous group who'd gotten together to fill out their cards and talk about the things they wanted to let go of. Sometimes I'd even get a package with hundreds and hundreds of cards from an entire school who'd done the project together.

Some of these cards were *heartbreaking*. Here's a small sampling of some of the first ones that came in:

Get rid
of my thoughts
about being abused

The Person that almost
killed themself
last Summer

The Constant feeling
that I'm not good
enough & the anger
that comes with it.

I wanna let go the
guilt for not seeing
that my long term
friend was suicidal.

I read every single card that came in. To be honest, sometimes it was hard to keep reading. There were cards that spoke of broken relationships, broken hearts, and broken dreams. There were cards from children who regretted the way they'd treated

their parents, parents who regretted the way they'd treated their children, cards from people who'd been abused, people who'd been made fun of, people who'd been ignored.

Sometimes I'd have to stop reading, put the cards down, and walk around the neighborhood to clear my head and remind myself that life isn't all despair and regret.

As the cards continued to come in, I began to build the ship. But unlike the first ship, this one wouldn't be done in a few weeks. In fact, this one wouldn't even be done in a few *months.* This one was going to take quite a bit longer, for one simple reason: this ship was going to be *much* bigger than the last one.

Part of the reason for this was that I don't like doing the same things over and over again. If I'm going to do something I've done before, it needs to be bigger or better in some way, or else I'll get bored and lose interest pretty quickly. But there was another reason, too.

In the video that my friends made about the first Viking funeral, there's a moment where a boy named Ian is standing in front of the ship, looking up at the dragon's head towering above him, and his jaw just drops.

When I saw that in the video, I thought, *Man, that looks cool! I wish* everyone *got to look at the ship from that perspective.* But the only way to do that would be to make the ship much, much bigger.

So that's what I decided to do.

In fact, I decided to make the second ship big enough that the first ship would've fit comfortably inside it. I did some rough estimates, and I figured it would take me about a year to build something that big.

So I rented a warehouse with sixteen-foot ceilings. I ordered a giant pile of lumber and a stack of cardboard so big that it broke the table I put it on. Then I got to work.

I started by building a wooden frame. Since this ship was so much bigger than the last one, I wasn't confident that I could build it out of cardboard alone. I decided it would be safer to build an internal support structure out of wood, then cover that with cardboard.

Building the frame by myself was a terrible idea. It turns out, there's a reason construction crews employ more than one person. Having even one extra set of hands would have made the process so much easier, but despite the fact that people had offered to help, I mostly worked alone.

This was for two reasons:

First, because I don't like to inconvenience people. I don't know where this comes from, but I have a long history of not accepting people's help (even when it's freely offered) because of some weird internal thing I have about not wanting to be a bother.

Second, because if I accepted someone's offer of help, I knew they would immediately become aware that I had no idea what I was doing.

I mean, I guess that's a slight exaggeration . . . I had SOME idea of what I was doing. I just didn't have a particularly robust grasp of how the vision in my head was going to translate into practical steps.

I'd built a maquette to figure out the dimensions of the ship, and then I'd gone back and built a second maquette just to work out the internal framing. But there was still a lot of standing around hemming and hawing, looking down at the

pile of lumber, then up at the sketch I'd drawn, then over at the maquette, then back at the pile of lumber. I preferred to do this without an audience, because that way I'd be the only person who knew how much of an idiot I was.

Eventually, though, I realized that framing the ship alone was a bad idea. At any moment, these sixteen-foot piles of lumber and screws could have come crashing down on me, at which point the Viking funeral would have been canceled and replaced with a standard-edition funeral. For me.

After several close calls and more swearing than I'd like to admit, I was forced to acknowledge that I needed some help. I called my friend Reuben, and he helped me get the frame together in a manner that was at least slightly safer and much more efficient than what I'd been doing.

Once the frame was done, I began the process of covering the ship in cardboard.

I borrowed a rusty, rickety bit of homemade scaffolding, checked to be sure my life insurance and tetanus shots were up to date, then clambered to the top and began stapling cardboard to the ship's frame.

Before I knew it, I had the first layer on. At this point it looked more like a toddler's drawing of a ship than an actual ship itself, but at least I had momentum. I knew from experience that things usually look pretty lame at this stage of a project, so I didn't worry. Things were moving along nicely now, and I knew that the ship would look better and better as I added more details.

The hard, boring part was behind me. From here on out, things were about to get really fun.

Or at least that's what I thought at the time.

4

EVERYTHING
GOES WRONG

In retrospect, I should've known that trouble was brewing in paradise.

To be honest, the whole warehouse situation had been tenuous from the get-go. While my landlord was a nice guy, there were a lot of red flags that I should have noticed earlier.

For starters, the roof leaked. Like, a lot. I remember the first time I came into the shop during a thunderstorm and there were waterfalls coming down from the ceiling. When your chosen medium is cardboard (not a particularly water-resistant material), this is concerning. I managed to move the ship around until I found a spot that avoided all of the different leaks, but I probably should've taken this as an omen.

Second, I wasn't the only one using the warehouse. I was the only paying tenant, but my landlord had several other buildings around town that he was renovating, and his construction crews would use my warehouse as a general staging ground. If

they tore out a bunch of wiring from a building, they'd leave it in a pile in my warehouse until they had time to sell it for scrap. If they needed to stain enough trim for an entire apartment complex, they'd do it on the floor of my shop.

This led to several misunderstandings. For instance, when the work crews saw a big stack of pristine cardboard sheeting, they didn't think, *I bet that's for a collaborative art project built around exploring the theme of regret.*

Instead they thought, *If we lay this on the floor, we can stain this wood on top of it and the floor won't get messy!*

Probably the biggest sign I missed, though, was the fact that my landlord was in the business of buying crappy old buildings and renovating them into cool loft apartments. I should have connected the dots that the warehouse I was using was, in fact, a crappy old building and would therefore likely be converted to loft apartments at some point in the future. But the thought never crossed my mind.

Then one day I walked in and there was another work crew in the warehouse, taking measurements.

Out of curiosity, I asked the guy in charge (I could tell because his hard hat was a different color than the other guys') what was going on.

"Oh, we're just putting together a bid," he said. "We'll be out of your hair in a minute."

"A bid for what?" I asked.

"They're gonna turn this whole warehouse into loft apartments."

"Oh, cool. Like, in a few years?"

The guy laughed. "No, like in a few weeks."

"Right, right, right," I said. "Cool, cool, cool."

I pulled out my phone to call my landlord, but I saw that I already had an email from his assistant.

The subject heading was "Thirty-Day Lease Termination Notice."

The email was pretty straightforward, but my favorite part was the line that said, "It has been a pleasure doing business with you and you have been a great tenant."

Or in other words, "You're a really great guy, Kyle, and you're gonna find another warehouse out there who appreciates you for who you are."

* * *

This was bad news. Like, really, really bad news.

Here's why: When I first got the idea to build another ship, I knew I would have to find a space to rent. But when I called around town, I quickly realized that I couldn't afford a big enough space.

Then one day a buddy of mine said, "My landlord owns this big empty warehouse behind us. You should ask him if he'd let you build the ship in there."

So I did. He listened as I explained the project, then said, "That sounds pretty cool. How does two hundred fifty bucks a month sound?"

I knew I would never find another space at that cost. Because of that, I ignored all the red flags about leaky roofs and stolen supplies and the fact that my lease was month to month.

So when everything came crashing down, I knew I was in quite the pickle.

The ship was nowhere near finished, and even if I worked around the clock I wasn't going to be able to get it completed in thirty days' time. This meant that I'd have to move it. But where was I going to move it to? I'd already called every warehouse in town, and I couldn't afford any of them.

All of a sudden it hit me that, if I couldn't figure something out, this project was going to become a massive, public failure.

I was going to have to tell the thousands of people who'd sent in their cards, "Hey! Remember that deal we made where you would open up and bare your deepest secrets because you trusted that I would do you the justice of taking your regrets and burning them in a beautiful Viking ship? Well, it turns out I can't hold up my end of the deal."

That idea haunted me.

What haunted me even more was the fact that so many of the cards people sent in felt like they were written specifically for my situation. People wanted to let go of things like:

A bad character trait that I wish I didn't have is that I'm afraid of not being good enough and failing at anything.

FAILURE

worrying about
What people will
think of Me

How was I supposed to help these people when I was facing all of these things myself?

I remember lying in bed at night, staring up at the ceiling, and trying to imagine any possible way this situation could resolve that didn't involve me looking like a giant failure. I couldn't think of a single one. I tried convincing myself that it would be just as meaningful if I built another small Viking ship and pretended that that had been the plan all along, but I could never really believe that.

Then one day my phone rang. It was my friend Donald.

"How goes the warehouse search?" he asked.

"Not great," I said. "I've exhausted all of my options and all I've got to show for it is a partially constructed Viking ship and a looming eviction."

"Well, I've got some good news then."

Donald is a partner in a construction company, and the company rented a big warehouse to store materials. When Donald told his business partner about my situation and explained the idea behind the project, the partner said, "Well, obviously we can't let this thing fail on our watch."

Donald and his partner agreed to clear out a space big enough for the ship, *and* they agreed to keep my rent at two hundred fifty dollars a month. I was saved.

As he told me all of this on the phone, I started to get choked

up. I held it together long enough to say thank you several times, then Donald told me he'd be in touch with the details later that day. When he hung up, I burst into tears.

A few days later I took the ship apart, loaded it into a van, and took it over to the new warehouse. Over the next few days, I began putting the whole thing back together again. It was easier this time, because I'd already done it once. This significantly cut down on the amount of hemming and hawing.

I felt like I'd dodged a bullet. The ship had a new home, submissions continued to come in, and with them came letters from people saying how much the project meant to them, how it had helped them work through some stuff that had held them back for a long time, how it had sparked important conversations with the people they loved.

Moreover, I'd learned some valuable lessons myself: that month-to-month leases are a bad idea, that things are rarely as bad as they seem, and that we should never underestimate the value of a friend who believes in us even when we don't believe in ourselves.

The warehouse situation had been a bump in the road, but I'd made it through with Donald's help, and things were back on track now. I was feeling good.

That good feeling lasted for all of four days.

5

TWO STEPS FORWARD, ONE AND THREE- QUARTERS STEPS BACK

F our days after I moved into the warehouse, my phone rang again. It was Donald.

"Hey, man, I've been meaning to call you," I said. "I can't thank you enough for setting me up with this space. You saved the day."

There was a pause on the other end of the line.

"About that," he began, "I've got some bad news."

Donald told me that they'd just gotten a call from their landlord saying that he wasn't going to be renewing their lease. He'd found another business that wanted to rent the space and was willing to pay more, and the owners had already signed the papers. It was a done deal.

"I'm so sorry, man," Donald said. "I had no idea this was going to happen. This was a total blindside."

I told him there was nothing to be sorry for, that there was

no way he could have known. We both said we'd keep an eye out for warehouse space, then we hung up.

If anything, I felt like I was the one who should be apologizing to Donald. It had become clear to me now that this Viking ship was cursed, that wherever it went, eviction notices were sure to follow. I'd brought that bad luck to Donald's warehouse, and now he and his business partner were paying the price. Even though I knew how ridiculous this sounded, I couldn't shake the feeling that I was somehow guilty for bringing Donald into all of this.

At this point, I accepted that the project was over. I was going to have to tell everyone I'd failed. I mean, I'd already called in every favor I could. I'd thrown a Hail Mary pass into the end zone, only to have it ruled incomplete on review. The clock had run out now and the game was over. It was time to announce my defeat.

Except the clock *hadn't* run out. See, unlike the first eviction, Donald's landlord hadn't just given us thirty days' notice. He'd given us a few months to move out.

And at first, that sounds better, right? A longer deadline meant less pressure and more opportunity to find a new space.

But when the first month goes by and you *haven't* found a new space, it feels like you're only prolonging the inevitable. I started to think maybe a thirty-day eviction would have been better, because at least then I'd be put out of my misery.

I was stuck in limbo. I couldn't keep working on the ship, because I knew I was going to have to tear it down again to move it. I couldn't move it, though, because I had no place to go. So each month I was writing a rent check for a project that I didn't think was ever going to be saved.

And all the while, cards were continuing to pour in. People

were continuing to tell me how thankful they were that I was doing this project, not knowing that I wasn't sure I *was* doing this project anymore.

Things got bad. I stopped leaving the house most days because I was afraid if I went out in public I would run into someone I know and they'd ask, "How's the ship coming along?" and I didn't want to have to answer that question.

It was a difficult time. Sometimes I would go into the warehouse and sit in the dark on the piles of lumber and cardboard, hoping that maybe proximity to the materials would give me some new idea, some fresh insight that could save everything. But no new ideas came.

Then one day my phone rang. And once again, it was Donald.

I expected him to say that our time had run out, that the landlord had finally asked him to leave, that I needed to pack everything up and vacate the premises.

But that's not what he said. Instead, he started talking about his RV.

"Hey, man, you know that RV that I have?" he asked.

"Yes?" I said, not sure where he was going with this.

"Well, we've been storing it at this place outside of town, but it's kind of far away. We'd love to keep it closer, but it's really hard to snag an RV storage unit nearby. Anyway, I got a call today that a spot opened up, and my name is at the top of the list."

"That's great, man," I said. "I'm really happy for you."

"Well, that's the thing," he said. "Because I got to thinking . . . *An RV storage unit is really tall and really long and really narrow, sorta like a Viking ship.*"

"Are you saying what I think you're saying?" I asked.

"I'm saying that I think I'll keep my RV where it's at for now, and you can use the storage unit to build the ship."

"I . . . I don't know what to say, man," I stammered. "I mean . . . thank you? Thank you *so much*, dude. You saved the day again."

"Well yeah, but I kinda ruined the day last time, so I think it cancels out."

I laughed. "Trust me, you're still way in the positive as far as I'm concerned."

* * *

A few days later, I took the ship apart once again, and once again I loaded it into a van and drove it across town to the storage unit.

As Donald had promised, the new space was tall, narrow, and long. It had garage doors at both ends so that an RV could pull all the way through, and it had a single set of electrical outlets in the center of the room.

What it *didn't* have was a lot of space to maneuver. The new space had just enough room to fit the ship, but not much more than that. This made me really nervous about using a big wooden frame. What if it tipped over? What if it crashed through the thin sheet metal wall and damaged the hundred-thousand-dollar RV on the other side?

I couldn't risk that.

This meant I was going to have to rethink the entire project. I was going to have to find a way to build this enormous ship with nothing but cardboard and hot glue. And frankly, I didn't even know if that was possible.

When I'd first started working on the project, I'd estimated it would take a year to complete. Now a year had come and gone, and all I had to show for it was an empty storage unit, a pile of cardboard, and a stack of lumber I couldn't use anymore. I was right back where I'd started, except this time I didn't have a plan.

The warehouse situation had been solved (for good this time), but in a sense I'd just traded one problem for another, and I didn't know if I'd be able to solve this one.

But I knew I couldn't quit. For one thing, Donald had gotten me this space. He'd done it because he believed in what I was doing. Was I really going to say, "Thanks, but no thanks"?

Moreover, I now had thousands and thousands of submissions from people all over the country. I wasn't going to tell them, "Sorry, guys, but this storage unit isn't 100 percent optimal, so I'm actually not going to build the ship after all. . . . Hope you understand!"

The cards that people sent continued to be heartbreaking, but in a way they were also enlightening. As I read through the submissions, I started noticing themes that came up again and again.

So many of the cards said things like this:

> I Regret not doing anything that types Risk I Regret not being able to do want i wanted because i was scared.

> I regret not taking a lot of risk

I regret ever deciding to give up.

And those are just the *general* ones. There were also many, many submissions that referenced a specific thing someone wished they hadn't quit. People who wished they hadn't given up on a sport or a hobby or a relationship or a dream.

In a way it was like the project reached out and saved itself. Not only did I feel like I couldn't quit because so many people had trusted me with their submissions, but I also felt like the submissions themselves showed me what would happen if I *did* quit: I'd spend the rest of my life wondering, *What if I'd seen that through? What if I hadn't given up? What could have happened if I'd just kept going?*

So that's what I did.

I stacked all of the now-useless lumber in one corner of the shop and got to work on a new plan. A friend had given me boxes and boxes of cardboard tubes that his employer was going to throw out, and I decided to try building a frame out of them.

I didn't know if this tube idea was going to work (it did), or if it was going to work for a little while and then fall apart later (it would). What I knew was that I wasn't going to find out by sitting around and thinking about it. I also knew that what I needed more than anything at this point was forward progress. The project had stalled, and I needed to get it going again.

So I plugged in my glue gun, opened a box of cardboard tubes, and got to work. Before I knew it, I'd framed in the center section of the ship and begun covering it with cardboard.

I was back on the horse now. The constant eviction problem

had been solved, I'd figured out a way to build without a wooden frame, and things were moving forward again.

Slowly, cautiously, I was starting to let myself feel hopeful. At this point I knew not to expect a smooth ride, but I also knew that I'd been able to face every obstacle that had come my way so far, and that gave me confidence that I could face whatever came next.

I knew the journey would probably be two steps forward, one and three-quarters steps back, but I also knew that still constitutes a quarter step of forward progress, and that if you keep stringing together enough of those quarter steps, you can eventually get anywhere.

hat if's
and regrets

Zegrets

I regret my past relationship
I regret hurting my close friends
I regret letting myself go
I regret doing drugs
I regret smoking
I regret cutting
I regret not trying.

A UNIFIED THEORY OF REGRET

Getting Rid of...
REGRETS

I regret not pushing myself hard enough and not making the best decisions for myself and others

I regret not playing Football

I regret sticking with a toxic group of friends for too long. I used to be rude & mean to others and I want to leave that behind me.

I Regret NOT Taking Risks Sooner!

Regrets

I regret the time i climbed on an old roof and made my mom climbi up to get me.

I regret not trying my best at everthing

All of my Regrets

6

NO REGURTS

When I was a kid, my favorite song was "We Didn't Start the Fire" by Billy Joel.

If you're not familiar with it, the song is basically a middle-aged white man rapping about all of the things that made the headlines during the first forty years of his life. I understand that makes it sound super lame, but the song is actually pretty incredible. There are history teachers who use it as part of their curriculum simply by having students pick a verse and research all of the lyrics.

While I've always been interested in history, that's not why I liked the song.

The reason I liked it was because at the end of the second verse, Billy Joel says, "Bardot, Budapest, Alabama, Khrushchev, Princess Grace, Peyton Place, *trouble in the Suez!*"

He really belts out those last four words, too. They sound like "trouble in the SU-EZZZZZZ!"

This line, of course, is a reference to the incident in October 1956 when President Gamal Abdel Nasser of Egypt decided to nationalize the Suez Canal, which almost led to an all-out

war. I'm sure this is common knowledge for most people, but I wanted to point it out for any readers who are idiots.

But here's the thing: I didn't KNOW he was saying "trouble in the Suez!"

I thought he was saying "*trouble in the sewers!*"

Which, of course, I interpreted as a reference to the Teenage Mutant Ninja Turtles, a group of crime-fighting anthropomorphic turtles who are named after Renaissance artists and who live in the sewers below New York City with their sensei, a giant rat named Master Splinter.

I was a HUGE fan of the Ninja Turtles, and I thought it was amazing that they were referenced in this song for grown-ups that was played on the radio. So every time the song would come on, I'd wait until the second verse and then I would shout, at the top of my lungs, "TROUBLE IN THE SEWERS!!!!!!"

I'm not sure what this says about my parents, but they never once told me I was wrong. I had to learn the hard way, years later, when I read the lyrics on the liner notes from the cassette tape.

The point of this story is that kids are dumb, or at least that I was dumb when I was a kid.

But really, the point is that so many of the things that we believe when we're young turn out to be completely untrue later in life. And most of it isn't our fault, either. We're working with limited information. When I was seven, you couldn't just look up the lyrics for "We Didn't Start the Fire." You had to try to figure them out yourself.

And if we can't even get the lyrics of a song right, what are the chances we're going to get the rest of life right on our first try?

The reason I bring all of this up is because of a pattern I started noticing with the submissions I was getting in the mail.

Most of the people who contributed to the project wrote really heartfelt stuff, stuff that would make you cry if you read too much of it in one sitting. But some people decided they didn't agree with the entire premise of having regrets in the first place. And instead of just thinking that quietly to themselves, they decided they should write their opinions down and mail them to me as submissions.

I found this out when I started seeing cards like these show up:

I don't reget anything because everything happens for a reason

nothing. my mistakes made me the person I am today.

But by far my favorite variant of these cards was this one:

I regret nothing.
NO REGERTS!!

I laughed so hard when I saw this card. I wanted to find this person and say, "Are you *sure*? You have *no* regerts whatsoever? Not even like a single, solitary regert?"

And in case you think this was an isolated incident, I can assure you it wasn't. Here's another one:

ꓵO REGERTs

And the best one of all:

I thought about these submissions a lot, and I tried to understand where they were coming from. But no matter how hard I thought about it, I couldn't follow their reasoning.

People's objections seemed to fall into three categories:

1. "Everything that happened led to this moment."

2. "Everything happens for a reason."

3. "There's no point in dwelling on the past."

But none of those reasons make any sense to me.

For starters, there's the idea that "everything that happened led to this moment, so if you changed something, who knows where you'd be?" This idea comes up a lot in time-travel movies. A guy will go back in time and accidentally knock a pencil off a table or something, and when he comes back to the present day, all the Taco Bells are gone.

Obviously none of us want that. So for some people, the

thinking goes, *I don't want to change anything in the past, because that could have unintended consequences in the present.*

But the thing is . . . we don't actually have the power to change the past, so the point is moot. I was building a giant cardboard Viking ship, not a functioning time machine. It's not like when someone wrote, "I regret the time I farted at a funeral."* I was going to jump in a DeLorean and show up to the wake with some Beano.

Instead, we look to the past for the same reason that athletes review game tape: we do it so that when we run into similar situations in the future, we will be better prepared to face them.

Another variant of this is the idea that "everything that happened made me the person I am today."

Well sure, but what if you could be a *better* person than you are today? What if you could keep all the things you love about yourself but eliminate some of the things you don't? Why wouldn't you want that?

The second reason didn't make any sense to me, either: "Everything happens for a reason."

People say this all the time, but it doesn't really hold up to even a surface-level examination. I mean yes, everything happens for a reason. That's how cause and effect works. But that doesn't mean everything happens for a *good* reason.

Sometimes the reason something happened was that you were careless. Or angry. Or cruel. Sometimes the reason it happened was because you didn't stop to consider the consequences your actions would have for yourself and others. Sometimes the reason something happened was a *bad* reason.

*Online submission 2,075.

If that's the case, wouldn't you regret that? Wouldn't you want to change that if you could?

But the third thing people said made the least sense of all: "There's no point in dwelling on the past."

I couldn't disagree more.

Do some people spend too much time dwelling on the past? Yes.

Is it possible to get stuck in regret and never move forward in life? Absolutely.

Is there a danger in living your life *always* second-guessing your every move? Of course there is.

But that doesn't mean that there are no valid reasons to dwell on the past.

In fact, I believe that dwelling on the past is the only way to ensure that you have a better future.

Or to quote George Santayana, "Those who cannot remember the past are condemned to repeat it."

In other words, if you never take time to stop and evaluate how your journey has gone up to this point, you never have the opportunity to learn from your mistakes. You never have the opportunity to grow or get better or change in positive ways. And that's a pretty sad life.

* * *

The truth is, there are only two kinds of people who have no regrets.

The first are perfect people. They have no regrets because they have nothing *to* regret. They've lived their lives flawlessly, making the perfect decision at each and every juncture.

These people are pretty rare. Every time we get one, we start a religion around them, and eventually we kill them because we're jealous of how perfect they are. So the odds are pretty good that you don't fit into this category.

That leaves the second type: delusional people.

These are people who believe they have nothing to regret despite a preponderance of evidence to the contrary. They have nothing to apologize for despite the trail of destruction they've left in their wake. They have nothing to reconsider because "there's no point in dwelling on the past."

The problem is that if we don't dwell on the past to some degree, we won't ever learn from our mistakes. Worse yet, we won't even be able to acknowledge that we've made mistakes in the first place. We'll always be blaming others for our problems, because that's the only explanation that fits our worldview. Obviously the problem can't be with us, because we have "no regurts."

"No regrets" should be a goal going forward, not a belief looking back. "No regrets" is like any other form of perfection: it's something we should all strive for, knowing full well that we'll never reach it.

* * *

All this talk of "no regrets" reminds me of a trash compactor my wife and I used to own.

I was so thrilled when we got it because it meant I'd have to take the trash out less often.

But what ended up happening was this: instead of taking the trash out, we'd use the compactor to smash it down. When it

filled up again, we'd smash it down it again. And again. And again. It wasn't like we thought we could do this *forever*. We just always thought we could do it at least one more time.

Eventually the bottom of the trash bag would blow out and we'd be stuck cleaning up a massive mess of exploded trash. This thing that was supposed to save us time ended up creating a much bigger problem.

I think regrets are like that, too. We pretend we don't have them, but in reality we've just pushed them down, thinking, *I'm too busy to take care of this now. I'll deal with it later.* But then we do that again and again, and before we know it we've blown out the bottoms of our emotional trash bags.

These days my wife and I have gone back to a regular old trash can, and I just take the trash out when it's full. Not surprisingly, I have yet to end up with trash all over the floor from a ruptured bag.

It's more work on a day-to-day basis, but much less work over the long haul.

7

THE PERSON YOU WERE FIVE MINUTES AGO

To be fair, though, I completely understand the appeal of "no regrets!"

For one thing, it sounds cool. Backflipping off a bridge into a river while yelling "no regrets!" just *oozes* confidence. And it's easy, too! Two words, no additional thought required! It's certainly much less work than confronting your own inadequacies and failures, and doing the hard work of self-improvement.

But "no regrets" only makes sense if you're perfect. And since perfection is off the table for most of us, the best thing we can hope for is progress. Or in other words, since we can't claim to have never made *any* mistakes, the best thing to aim for is making *fewer* mistakes than we made yesterday, and/or cleaning up the messes from those earlier mistakes.

My experience as a cardboard artist has been an almost-too-perfect metaphor for this principle.

Some artists have a hard time pinpointing when they started

drawing or painting, but in my case I can trace the origin of my artistic journey back to a single night.

I was flipping through entertainment options on the TV when I came across a documentary called *Beauty Is Embarrassing.*

Three things grabbed my attention about it. First, I'm a sucker for a catchy title. *Beauty Is Embarrassing*? Tell me more!

Second, the cover image hooked me. It was a shoulders-up photograph of a man wearing a giant, cardboard Lyndon Johnson mask in front of a painting of jumbled three-dimensional letters. Already I'm intrigued.

Finally, the description of the movie set the hook. *Beauty Is Embarrassing* is the story of Wayne White, a prolific creator who has worked on projects such as *Pee-Wee's Playhouse* and *Beakman's World*, directed music videos for the Smashing Pumpkins and The Offspring, created amazing art installations, and sold paintings that are both hilarious and beautiful. Plus, he has a big beard and swears like a sailor. I'm in.

I hit Play on the movie, and what followed was ninety-three minutes of medical-grade artistic inspiration injected directly into my cerebral cortex. When the movie was over, I was left feeling inspired, motivated, and just generally energized. If I had to sum it up in words, it just felt like *"I need to make something!"*

My wife was already in bed when I watched the movie, so the next night I made her watch it with me. The night after that I watched it again. This pattern continued on and off for a few weeks until the point where I had watched the movie over a dozen times and my wife asked me to stop talking about Wayne White.

Every time I watched the film, I was left with the same feeling I'd had the first time: *"I need to make something!"* But I never knew what I should make. Finally, during one of these repeat viewings, I grabbed a cardboard box from the recycling and decided to turn it into a mask, like Wayne did in the movie.

I didn't really know what I was doing, so I used masking tape to put all the pieces together. This meant that when I was done, there were little pieces of whitish-yellowish tape all over the mask, which was pretty distracting. To fix that, I decided to cover the rest of the mask in tape as well. (This is a technique I now refer to as tape-r-mâché. I very much do not recommend it.)

The mask still looked pretty awful, so the next day I painted it. When it dried, I had a mask that was bumpy, too small for my face, and for some reason looked extremely creepy. A big win for creativity and artistic expression!

But I was hooked. A few days later I made a bigger mask, then a bigger mask after that. The masks were progressing in size, but not necessarily in quality.

Then fate intervened.

A blizzard in the Northwest canceled a speaking engagement while I was already en route to the event, so I regrouped and flew to the next stop on my tour a day ahead of schedule. As the plane was getting ready to take off, I was scrolling through Instagram when I saw that Wayne White was doing an art installation an hour away from where I was going to be speaking.

On the plane, I devised a plan: I would drive to the art gallery, find a way in, and meet Wayne. Then we would become best friends and he would teach me all of his art secrets.

By the time I landed, got a rental car, and drove over to the gallery, it was after five o'clock. I walked up to the entrance only to find that the door was shut and the lights were off. Never one to be deterred by simple things like this, I pulled on the door handle just in case, and to my surprise and delight I found that it was unlocked.

Obviously the sensible thing to do in this situation would be to leave, since art galleries are full of expensive things and it was clear that I was not supposed to be there. But I've never been one to do the sensible thing, so instead I walked in and began flipping the lights on. My thought was that if I couldn't meet Wayne, I could at least get a look at the stuff he was working on.

I wandered all over that gallery, turning lights on and opening doors. I wandered down into the basement, then back to the ground level, but I didn't find anything like what I'd seen on Wayne's Instagram. Finally, I discovered another set of stairs going up, so I took them to the second floor, only to find the door locked.

Just as I was beginning to question the idea of trespassing in this art gallery, I heard a voice in the stairwell above me.

Because I had watched *Beauty Is Embarrassing* so many times, I immediately recognized the voice as belonging to Mimi Pond, an incredibly talented artist and writer who also happens to be Wayne's wife.

I practically sprinted up the stairs to find Mimi on a phone call in the stairwell. Not wanting to bother her, I nodded and smiled as I walked straight ahead and found an enormous room filled with half-built cardboard sculptures some twenty

feet high. Across the room, wearing his trademark navy blue mechanic's jumpsuit, was Wayne White.

Standing next to him was the curator of the gallery, a tall woman in a pencil skirt and glasses with her hair in a bun, the exact archetype of people I have historically not done well with. She briskly walked over to me with a confused look on her face, likely owing to the fact that she had just finished turning off all the lights on the ground floor twenty minutes earlier.

I don't remember exactly what I said when she approached, but I managed not to get kicked out of the gallery. I explained that I was a big fan of Wayne's work, that I'd seen his Instagram posts, and that I was in town unexpectedly with a day to kill. When I finished talking, she said, "Well, do you want to meet Wayne?"

I said that I'd love to, and she walked me across the room to where he was standing. She introduced me, and I told Wayne that I had nothing to do the following day, and I'd be happy to help out if he needed any assistance.

He asked, "Do ya like makin' stuff?"

I grinned and said, "I *love* makin' stuff!"

He said, "You're hired!" and told me to show up the next morning.

The following day I was the first person to arrive and the last person to leave. I figured if I could just outlast the other volunteers, I would get to talk to Wayne one-on-one, and that's exactly what happened.

Wayne was incredibly generous with his time and attention, and he gave me some tips that drastically improved the quality of my own cardboard work. He told me that tape and papier-

mâché took too much time and smoothed over all the fine details that make cardboard art great, and that I'd get much better results using hot glue. At the end of it all, he indulged me by signing a note card for me. He wrote, "Kyle, you are an expert cardboarder. Thank you, Wayne." His words were objectively untrue, but they gave me something to live up to.

When I flew back home a few days later, I got to work applying the advice that Wayne had given me.

Making masks led to making small sculptures, which led to making large sculptures, which led to making the first Viking ship, which led to making the second. At each step of the way, I had to learn new techniques and new approaches. But just as importantly, I had to *unlearn* the mistakes I'd made along the way. There are certain things you can get away with on a small scale that will simply not work when you're building something that's sixteen feet tall.

This is the part of the artistic process that no one sees. It's a constant journey of realizing you've been doing things the wrong way this whole time, then buckling down and learning how to do them right. At least that's how it's been for me, and for every artist I've ever talked to. And because art imitates life, the same thing is true in almost every other arena. No one starts out getting everything right. Instead they make mistakes, learn from those mistakes, and get better.

* * *

There's a quote from the late British philosopher Alan Watts that says, "You are under no obligation to be the same person you were five minutes ago."

I came across that quote when I was building the first Viking ship, and it struck me as being both profoundly true and profoundly perplexing.

Profoundly true, because we *aren't* under any obligation to be the same person we've always been. I certainly don't recall signing any binding agreement never to change or grow or evolve, and I'm not aware of any laws against personal growth.

But the quote is also profoundly perplexing, because if it's true (and it is), then why don't any of us live our lives like that? Why do so many of us seem bound by the mistakes and choices we've made in the past?

Perhaps the explanation can be found at the cellular level.

Every seven years or so, the vast majority of your body gets replaced, cell by cell. It's an automatic process that happens day in, day out, whether you want it to or not, as your body retires its old, worn-out cells and replaces them with new ones.

This means that Alan Watts was right. Not only are you not under any obligation to be the same person you were five minutes ago, but also you *can't* be. You aren't that person anymore, because some of the cells that made up that person have gone the way of the buffalo, and they've been replaced with new cells, fresh from the factory.

But there are some exceptions. There are some cells that don't get replaced automatically. Interestingly, these include the lenses of your eyes and your cerebral cortex.

Or in other words, your body will replace most of itself automatically. But if you want to change the way that you *see* the world or the way that you *think*, you have to do that manually. And that can be really hard.

8

HERE THERE
BE DRAGONS

Years ago, I was working for a nonprofit when we had a large group of volunteers show up to help us sort through some donations. They were hard workers, and they stayed a lot longer than we had expected them to. My boss felt bad about the fact that they hadn't eaten anything for hours, so he handed me his credit card and told me to go get pizza for everyone.

I did the math, and we needed about fifty pizzas. That was more pizzas than I had probably cumulatively ordered in my entire life, but the guy at the pizza place didn't seem fazed at all. He took my order and told me what time the pizzas would be ready. When I arrived, he even helped me load the pizzas into my car, which is where the problems started.

For starters, pizza boxes are not really meant to be stacked that high. They don't interlock in any way, so there's really nothing to keep the stacks intact when driving around a corner. I had visions of accidentally taking a turn too fast, leaving fifty pizzas flung all over the inside of my car, a

permanent aroma of pepperoni reminding me of my failure for years to come.

But that wasn't even the biggest issue. The biggest issue was the heat.

One fresh-from-the-oven pizza is warm. You've probably experienced this when a delivery guy has handed you your order from his special insulated pizza pouch on a cold day, and the box warms your goose-bumped arms.

Two fresh-from-the-oven pizzas are hot.

Fifty fresh-from-the-oven pizzas are a *furnace*.

When we got the pizzas loaded into the car, every window in the vehicle immediately fogged up, and drops of condensation began rolling down the dashboard.

I slid into the driver's seat and buckled my seat belt. Even through the seat, the heat radiating from the pizzas behind me made it feel like I was sitting with my back to a bonfire. It was stifling, and the steam from fifty pizzas made the humidity almost unbearable. I felt like I was sitting in a sauna where someone had just poured marinara onto the hot rocks.

I rolled down the windows and tried to use my sleeve to clear the windshield so I could see, but to no avail. As soon as I wiped the glass clean, the pizzas would lay on a fresh layer of pepperoni fog, immediately obscuring the view again. I felt like Sisyphus, but with pizza steam. I turned on the defrost, but that just added more heat to the situation. In the end, I had to drive all the way back to the office with my head out the window like an excited Dalmatian.

That was the day the term "strength in numbers" took on new meaning for me. I had never before considered the fact that

something as simple as pizza could do something like that to a car.

A similar thing happened with the submissions people sent in for the Viking ship. Individually, they ranged from the humorous to the heartbreaking. But as the submissions continued to pour in, I began to notice the cumulative power they had.

I started to pick up on trends, categories, and commonalities among the submissions. I began to have experiences where reading one submission would remind me of another. I began taking mental note of the submissions that hit me the hardest, drawing lines in my head between the vast and varied things that people regret.

I didn't really know why I was doing this, but it felt important. I didn't know what I was going to do with this information yet, but I thought, *Surely this will be valuable somehow, right?*

Around this time I bought a Nintendo Switch.

I'm not much of a video game guy, but my friend Andy was a persistent evangelist for the Switch, and he wasn't going to leave me alone until I bought one. He told me that it would be the perfect system for me, since I'm on planes all the time and there are only so many emails a person can send from the air before they go insane.

Finally, I relented and bought a Nintendo Switch and a copy of *The Legend of Zelda: Breath of the Wild.*

I could write the rest of this book on how great this game is, but I'm afraid my publisher would ask for their advance back, and that would be a problem because that money is long gone. Suffice it to say, the game is phenomenal.

Zelda: Breath of the Wild is an open-world game. Unlike

most video games that constrain you to a singular story line, Zelda feels like real life. If you see a cool mountain in the distance, there's nothing to stop you from going over and exploring it. If you are given a mission and decide you don't want to do it, you can ignore it entirely and catch a fish instead. There is an overarching goal in the game, but you're free to pretend there isn't and just walk around the map doing as you please.

Inevitably you will die at some point in the game. You'll fall off a cliff or drown in a lake or get shot with an arrow by a Moblin. When you do, the game reloads and you get another chance. But there's an important detail here: You don't start the game from where you died. Instead, you start the game from your last save point. This could be near where you died if you're a disciplined game-saver, or it could be halfway across the Kingdom of Hyrule.

Either way, the game gives you something to help you find your way back. When you pull up the map, there will be a small red X showing exactly where you last met your demise.

You are free to use this information as you please. Sometimes you'll head straight to the red X to continue what you were doing before. At other times the red X will serve as a warning, a tiny sign that says, "Don't go here! It did not go well for you the last time."

I know this sounds silly, but *Zelda: Breath of the Wild* led to a revelation for me. I realized that the submissions people sent in were like the red Xs on the map, each one a small sign that said: "Here's where I got hurt." "Here's where my life went off the rails." "Here's where I picked up a burden I'm still trying to put down."

Even individually, this is helpful information. We've all had an experience where we avoided a painful situation because we listened to another person tell us how much *they* regretted doing the exact thing *we* were considering doing.

But cumulatively, the information becomes much more powerful. Like pizzas in the back of a Toyota Corolla, the effects scale exponentially.

By collecting thousands of regrets from people from all walks of life, I was able to notice patterns. I was able to layer all of the maps they sent me and notice areas where there were clusters of red Xs.

I realized that if I could find a way to amalgamate all of these individual submissions into one map, it would be a very valuable tool. It would show you all of the places where people get hurt, where people get stuck, where people get burdened.

If you look at really old maps, maps from before the days of GPS and satellite images, there will be places where it just says, "Here There Be Dragons." We tend to scoff at that kind of stuff nowadays, thinking that these people were primitive in their beliefs, that they were superstitious fools to believe that something like dragons could actually be real.

But I don't think of them that way. I think they put that on the map because they got hurt there. They ran aground, or their ship was torn to bits by the waves, or the local flora and fauna turned out to be dangerous. And they knew that a map doesn't have enough space for them to write "Be careful here, we had a bad experience involving poison ivy and our nether regions," so instead they wrote, "Here There Be Dragons."

The unfortunate thing about dragons is that they're always guarding treasure. In the stories it's mostly gold and jewels and

magic rings and stuff, but in real life it's usually less tangible things, things like experience and meaning and wisdom. If we want to get those things, we have to go through difficult times in dangerous places. We have to go through some major red X territory.

But there are other areas of the map we can avoid altogether. Areas where there are dangers without dragons, trials without treasure. Areas where there is no benefit for us at all, only an incredible amount of pain and heartache.

If I could help people avoid those areas, perhaps all the struggles of building a giant cardboard Viking ship, all the warehouse evictions and hot glue burns would be worth it in the end. Perhaps all of the regrets people sent in could be redeemed somehow, used to help others avoid a similar fate.

With this in mind, I began to keep a record of every submission that came in. I began to scan and archive thousands of cards, one by one. I began keeping detailed lists of themes, trends, and commonalities in the submissions. I felt like one of those detectives in movies, surrounded by bulletin boards with thumbtacks and yarn, connecting pictures and notes and newspaper clippings, knowing he's on to something but not quite sure what it is yet.

I was still going to burn the cards, of course, because that's what I'd promised to do. But not before I used each one to place a bright red X on an ever-expanding map of human experience, each one a tiny sign saying, "Here There Be Dragons."

9

MAKING HEADS
AND TAILS

The irony of this whole situation was that while I was having all of these realizations about the regrets people were sending in, I wasn't actually making very much progress on the ship itself.

There were several reasons for this. For one thing, I had an incredibly busy travel schedule that year. I was getting invitations to speak all over the country, and it wasn't like I could bring pieces of the ship with me to work on.

When I did manage to get some time off the road, it was during the summer when temperatures in the warehouse would regularly exceed a hundred degrees. I still tried to work on the ship, but the sweat from my hands would leave streaks on the cardboard, which meant that I would have to redo those sections entirely. It felt like an exercise in futility.

Finally, in late September, the temperature came down enough that I could start working on the ship more or less every day. This was just in the nick of time, because at the end of October I was scheduled to give the biggest speech of my life.

* * *

The National FFA Convention and Expo is, as far as I am aware, the largest student gathering in the United States. In 2018, the year that I spoke there, nearly seventy thousand people were in attendance. FFA, which stands for "Future Farmers of America," is a student leadership organization that has its roots in agricultural education, but their impact goes far beyond just cows and plows. The National FFA Organization has more than seven hundred thousand members across the United States who participate in everything from cattle judging to public speaking and marketing competitions.

The first time I got invited to speak at an FFA state convention, I mistakenly assumed it was going to be a pretty low-tech affair. After all, these were farm kids, right?

That assumption lasted about thirty seconds into the opening session, when dual pyrotechnics on either side of the stage shot fifty feet into the air, creating columns of fire so massive I could feel the heat backstage. That's when I realized, *These people like to party.*

I've been to FFA events where there were laser-light shows, rock concerts, and crowd surfing. I once spoke at an FFA event where the state officers landed in a helicopter outside the arena during the opening session and sprinted onstage as the whole thing was livestreamed onto a JumboTron for the audience to see.

So when the FFA asked me to be the opening keynote speaker for their national convention, I was floored. In the world of professional speaking, this event is seen as the Super Bowl. When I shared the news with a fellow speaker who had done the event in the past, he said, "That's amazing,

man! Congratulations! This is the biggest event you will
ever do."

I took this to mean that he expected me to bomb the speech
so hard that my career would be over, but he quickly clarified.
"It's not that you *couldn't* do bigger events, it's that there really
aren't any."

I knew that this was an opportunity to get the Viking ship
in front of a whole bunch of new people, but I also knew that I
couldn't just *tell* them about the ship. I needed to *show* them.

I'd learned this lesson from years of sitting next to strangers
on airplanes. I'd come to realize that when someone asks
what you do and you use the phrase "cardboard artist," they
generally assume that your work is terrible. This is because
most cardboard art is made by children, and most art made by
children is terrible.

I know this is what people assume, because every single time
I've ever told someone that I'm a cardboard artist and then
subsequently showed them pictures of one of my pieces, they
have always said, "Oh, wow! That is *not* what I thought of when
you said 'cardboard art.'"

The problem with showing the ship at the convention was
that, as I've just said, I hadn't had a chance to make very much
progress on it since moving to the new warehouse. At this point
all I'd managed to complete was the empty middle section, a
giant extruded U shape that leaned noticeably to the left. Not
exactly the sort of thing that inspires people.

I realized that if I was going to talk about this thing onstage,
I at least needed to have the basic shape of the ship completed.
This gave me five weeks to get the dragon's head and tail
structures designed, built, and upright. That would be a lofty

goal on its own, but I also had to give ten speeches in four states during that time, plus we had a family camping trip, my son's birthday, and the sale of our house.

There's nothing like a deadline to focus your energy, though. By working long hours in the warehouse, I was able to get the ship's bow and stern upright. They were just basic shapes at this point, with no details or curves or any of the stuff that makes cardboard art really great, but they did have one thing going for them: they were *huge*.

I dragged them out into the open for some pictures (my son had to hold up the tail to keep it from falling over in the wind), then pulled them back into the shop, shut the garage door, and headed to Indianapolis for the convention.

* * *

Because there were nearly seventy thousand people in attendance, the opening session had to be repeated three times for everyone to attend. There were two sessions the first afternoon and one the next morning, and in between Garth Brooks played a concert exclusively for FFA members. This led to important questions: Was I opening for Garth Brooks? Was Garth Brooks opening for me?*

In addition to the arena-size crowds watching the speech in person, there were tens of thousands more who watched the livestream online, plus more still who watched the speech later, in their schools. This meant that my voice would be piped into

*The answer of course is that I opened for Garth Brooks, but I did such an amazing job that the next time *he* opened for *me*. At least that's the story I plan on telling my kids.

rooms around the world, rooms I would never set foot in. This gave me an idea.

As I walked onstage for the biggest speech of my life, I said this:

"I've got to get something out of the way really quick. I don't know if you know this, but this session is being livestreamed on the internet, and there are thousands of people watching this in their homes, their classrooms, their businesses. And that means that my voice is being piped all over the world, which gives me an opportunity to say something that I've always wanted to say."

I could feel the audience get nervous, unsure if I was about to go on a political rant or ask for social media followers or try to sell life insurance. But I did none of those things. Instead I said:

"Alexa, maximum volume."

I paused for a second as the audience chuckled. Then with a mischievous grin I said:

"Alexa, play 'Who Let the Dogs Out?'"

That got a big laugh from the audience in the arena, but around the country people began scrambling to turn off their Amazon devices as they blared the most obnoxious song known to mankind, a song that begins with a grown man yelling "WHO LET THE DOGS OUT?" and then gets progressively worse from there.*

*For days after the event, I got messages from people telling me I had set off their Alexa devices. The best message of all was from a student who was in the arena, whose grandmother was watching the event at home.

After my speech the student saw that she had a missed call. Checking her voice mail, she heard a recording of her grandmother yelling, "I can't get the Alexa to turn off!" while in the background she could hear "WHO LET THE DOGS OUT?! WHO? WHO-WHO-WHO-WHO?!" blaring at maximum volume.

I know I should not laugh at this, but I can't help myself.

Having gotten the audience on my side with my dumb joke, I transitioned into the rest of my speech. I talked about the importance of kindness and empathy, about the power of one person to make a difference in the world. I told stories about days in my life that had been pretty dark, and about the people who cared enough to help me through those days.

As my time onstage drew to a close, I talked about the Viking ship, about how so many of us have things in our life that we'd like to let go of, things that hold us back, things that we don't want to carry anymore. I told the audience that if they had anything like that, I'd be happy to put it in the ship and set it on fire. Then I showed a picture of the ship, and the audience went "Ooooh . . ." as if to say, "That is *not* what I thought of when you said 'cardboard art.'"

And then before I knew it, the speech was over. The FFA president came onstage and shook my hand and said thank you, the crowd gave me a kind and generous round of applause, and then a volunteer escorted me backstage, where I waited to do the whole thing all over again.

I gave the speech once more that evening, then attended a Garth Brooks concert where nearly seventy thousand teenagers sang along to a song called "That Summer," which is about a teenage boy who has an illicit affair with a "lonely widow woman" who "needs to feel the thunder."

After the concert I stayed up well past midnight replying to messages and comments from students and adults who'd seen the talks that day. I answered as many as I could before I passed out, exhausted. The next morning I woke up, grabbed some coffee, and gave my talk one last time.

I'd set up a simple form that allowed people to submit

their regrets online, and I'd promised that I would print out the submissions and burn them with the ship. Thousands of submissions came in during those two days, pushing me well past my initial goal of collecting ten thousand regrets for the project.

After the last speech was over, I said my good-byes, packed up my things, and headed home. And just like that, the biggest event of my career was behind me. It had been better than I could have possibly imagined, had gone every bit as well as I had hoped and more, and yet in a way it still felt entirely inconsequential.

Big events have a way of doing that. You put all of this focus onto a single day, a wedding or a funeral or a graduation or whatever, but the next day you just wake up again, and you drink your coffee and brush your teeth, and the world has the audacity to just keep spinning and spinning like nothing happened at all, the sun rising and setting over and over again like it's always done, like the thing that was so important to you was not even a blip on its celestial radar.

It's as if the universe wants to remind you that the show must go on, that time and tide wait for no man, that at each and every moment the present is rapidly and irreversibly becoming the past.

In moments like these, all you can really do is shrug your shoulders, put your head down, and get back to work. So that's what I did.

10

FLATS INTO CURVES

A week after the National FFA Convention, I wrapped up my fall speaking tour and headed home. It was early November, and the temperature was finally perfect for cardboard shipbuilding. The air was crisp and dry, and most days brought a light breeze through the shop, dragging fallen leaves in from outside and swirling them among the oddly shaped scraps of cardboard littering the floor. Best of all, my calendar was clear for the foreseeable future, which meant that I could spend almost every day working on the ship.

Now that the bow and stern had been roughed out, it was time to begin adding dimension and form, turning the rudimentary silhouette into a bona fide dragon ship.

With the first Viking ship, the dragon's head and tail had been simple, flat-sided shapes with scales and spikes that helped to mask the simplicity of the underlying structure, tricking the eye into thinking the ship was more complex than it actually was.

That was fine for a ship that was thrown together in a few weeks for a birthday party, but with the second ship I wanted

to do better. I wanted the dragon to look like a real dragon, or at least like what a dragon would look like if dragons were real. I wanted complex curves that flowed smoothly in all directions. I didn't want to rely on visual tricks to distract the eye this time.

In other words, I wanted a dragon that looked real enough to scare a kid. The problem was, I had no idea how to pull that off.

Cardboard is a flat, planar medium. It's corrugated, so you can get it to bend along one axis pretty well, but it's simply not designed for making complex curves. To put it another way, you can make an arch but not a dome. At least you can't make a dome without a whole lot of finagling.

There are two ways around this problem. The first is to break the complex curves into smaller, flatter shapes. Think of a disco ball, its spherical surface made up of hundreds of tiny mirrors. Each individual mirror is flat, but together they look round.

The problem with this approach is that it's insanely technical. To do it right, I'd need to design the entire ship using digital modeling software, then have the computer slice the three-dimensional shape into a million tiny two-dimensional polygons. Then I'd have to copy those shapes onto cardboard, cut them out perfectly, and glue them all together in exactly the right order and orientation, getting all of the angles perfect in the brief seconds before the hot glue dried.

For about a million reasons, this was out of the question.

That left option two: making it up as I went along.

I've always been an option two sorta guy, the kind of person who builds the plane as it's barreling down the runway. To be completely honest, it's not an approach I would recommend if you can avoid it, but it's always worked out for me in the end.

I began experimenting, using long, arched pieces of cardboard to add dimension to the underlying flat shapes, then layering strips on top of those pieces to form the complex curves I was aiming for. It was a tedious process, and I often had to stop and undo an entire section because it wasn't coming together the way I'd hoped. But slowly I began to get the hang of it, turning flats into curves, breathing life into the simple shapes I'd started with.

All the while, regrets continued to come in. The FFA speech had led to an influx of submissions, both online and through the mail. I continued to read through them as they arrived, doing my best to keep up with the seemingly unending stream of heartaches, mistakes, and losses.

Along with the submissions, I would often receive heartfelt messages from people who'd heard about the project. They'd tell me about their regrets, about the things that held them back, about their doubts and insecurities, their hope for better days ahead. Sometimes these would turn into lengthy back-and-forth conversations when I would listen, ask questions, and give advice and encouragement. These dialogues didn't exactly fit the boundaries of the project, but they taught me a lot.

Each time I read one of these messages or submissions, I grew my understanding of regret by a tiny bit. Slowly, one little red X at a time, a map of human experience began to come together in my mind. The submissions, which had initially seemed random, began to reveal patterns, clusters, and themes.

Some ideas were repeated over and over again throughout the project. For instance, I can't tell you how many submissions I received that said some variation of "I want to stop caring so much about what other people think of me."

Other submissions were repeated word for word, such as:

"Anxiety"

"Depression"

"Fear"

"Hatred"

"Anger"

Sometimes the regrets themselves were unique, but they fit into an overarching category. One category that always made me laugh were the submissions that simply listed a person's name: "I regret Ryan." I considered making a list of the most common names that came up, but I thought that might be cruel.

I took note of the submissions that hit me the hardest, of the themes that kept repeating themselves. I didn't realize it at the time, but in retrospect I can see that I was searching for a unified theory of regret, some all-encompassing framework that would help me make sense of all of this, help me learn something that could help others.

The statistician George Box famously said, "All models are wrong, but some are useful." In other words, it would never be possible to develop a framework that could completely and flawlessly categorize every single submission. But I could develop a framework that would help people (myself included) figure out what to do with their regrets by placing them in a broader context within the universe of possibilities.

As I sorted through the data I'd collected, I realized that almost every submission fell into one of five categories. Some fell into more than one category, and a few fell into all five. But with the exception of people who ignored the prompt altogether (e.g., the "no regurts" crowd) or the submissions that were so cryptic I had no idea what they were trying to communicate, everything could be placed into at least one of these boxes:

Beliefs

Relationships

Identities

Experiences

Fears*

It's not always immediately obvious how a particular submission fits into a category, but once you dig a little deeper, things start to make sense.

For example, a lot of the single-word submissions I listed above are hard to categorize offhand: "Anxiety," "Depression," "Hatred," "Anger." At first glance, these don't appear to fit in the framework at all. They aren't beliefs, relationships, identities, experiences, or fears.

But when you talk to people about these things, you start to realize that what they meant when they wrote "Anxiety"

*I know what you're thinking. "Wow, Kyle. B.R.I.E.F.! Pretty convenient that it makes a nice acronym." But let me tell you, it took some work to get there. For instance, I originally called the "Experiences" category "Actions," because most of the things in this category were things people regretted doing, actions they regretted taking. But this meant that the only acronym that could work would be I.B.A.R.F., and that seemed less than ideal for marketing purposes. Plus the word "Actions" was too narrow, since it excluded things that had happened *to* someone, or things that *hadn't* happened that they wished had. "Experiences" was broad enough to cover these situations, and it gave me better acronym options.

is something more along the lines of "I want to stop letting anxiety control my life." When they wrote "Hatred" or "Anger," what they meant was "I regret being a hateful, angry person."

In that sense, "Anxiety" becomes both an identity ("I am an anxious person") and a belief ("My anxiety defines who I am and what value I have"). "Hatred" and "Anger" fall into place similarly.

It's not a perfect framework, because it requires a good deal of nuance and a little bit of guesswork. But it really is useful once you get the hang of it.

By putting a submission into a category, it gives context. This is helpful for a few reasons. For starters, you're able to see your regret on the shelf next to others that are just like it. You realize that you're not alone in dealing with a particular issue, and sometimes that's all a person needs to gather the strength to address it.

Moreover, when you place your regret into a category, it goes from being this completely unique thing to being "just another _____." You realize that you've faced similar obstacles before, and you're able to use the lessons you learned in those situations to help overcome the problem in front of you now.

This wasn't all immediately obvious to me when I discovered the five categories, though. It took some time for me to go from "These are the five types of regrets" to "Here's how a person should deal with each type." And, of course, even once you understand how to do something, actually doing it is an entirely different story.

With that said, I can honestly say that the B.R.I.E.F. framework fundamentally changed the way I think about

regret, and it's been an incredibly helpful tool for the people I've shared it with. So with that in mind, from here on out I'll be telling the story through the lens of the five categories. And for reasons that will become clear later, I'll be starting with the last one and ending with the first.

fear of letting
everyone down

I wish I could let
go my fear of heights

To let go of
my irrational
fears &
inhibitions

Fear of not
being enough

my fear of being
alone
getting intimidated by
others so easily
fear of never finding
my people + my person

My Fear of the
Future

fear of rejection

The fear of my Parents Coming back after 17 Yrs to ruin my life...	Being afraid of having no one to turn to when I'm SCARED + ALONE
Being scared of my friends not liking me as much as I like them	I am letting go of my fear of coming out to my friends + family. —a

:-) FEARING
the
UNKNOWN :-)

Being scared to speak in public + speak to strangers who I've never met before.	fear of moving o and forgiving
holding MySelf back From doing what I want because Im Scared of what others think	my anxiety, fear of m friends, and my consta loneliness. MY fears a Pains from the Pas-

11

MY THIRD FAVORITE ROOSEVELT

There's a very famous quote from Franklin Delano Roosevelt (my third favorite Roosevelt behind Teddy and Eleanor) where he said, "The only thing we have to fear is fear itself."

I know it's probably bad form to insult a dead president, especially a Roosevelt, but man, what a dumb thing to say.

There are actually *plenty* of other things to fear besides fear itself. In fact, here is a quick list of things, just off the top of my head, that are totally reasonable to fear:

- bears

- murderers

- quicksand

- spontaneous human combustion

- coyotes

- swarms of bees

- being alone in a forest, especially at night

- smaller groups of bees that would not be considered a swarm but are still dangerous

- getting the middle seat on an airplane

- individual bees

- death

I could keep going, but I think you get the point. There are probably thousands of things that are completely reasonable to fear, maybe even millions. Anything that can kill you, for starters. Or anything that can kill someone you love. Anything that could drastically reduce your quality or quantity of life . . . these are all completely logical things to fear.

John Mayer (my second favorite Mayer behind Oscar) has a great line in one of his songs that says, "Fear is a friend who's misunderstood." I think that's true.

We often think of fear as a bad thing, but it's not. Fear is what kept our ancestors alive long enough to invent cities and lightbulbs and the Swiffer WetJet™. Fear keeps us from doing dangerous things that have no benefit to us. In situations that are truly dangerous, fear heightens our sense of awareness, focuses our attention, and helps us survive.

The problem comes when fear starts to creep into areas of our lives where we're *not* in any real danger. In those situations (and only in those situations), fear itself *is* the only thing we have to be afraid of. But not across the board.

I guess what I'm saying is that not all fears are created equal. There are healthy fears and there are unhealthy fears, and there's a big difference between the two.

Healthy fears put a fence around your life, a hedge around your behaviors and relationships and habits. That fence keeps you from going places that will get you hurt or that will get others hurt. If you are highly allergic to bees, for instance, it makes perfect sense for you to be afraid when you see a beehive.

The problem comes when our fears begin to keep us from things that aren't harmful to us at all, or from things that could actually benefit us. That's when a fear becomes unhealthy. If your fear of bees develops to the point where you never leave the house, that's an unhealthy fear.

Unhealthy fears build fences, too; they're just much, much smaller. Instead of keeping you protected, the fence of an unhealthy fear boxes you in. It forces you to live a life that is smaller than the life you're capable of living. It's a fence that has become a cage.

I thought about all of this as I read the fears that people wanted to let go of. Here are some of them:

"Fear of getting too close to someone and getting hurt again."

"Fear that my marriage will fail like my parents'."

"The constant fear that everyone hates me."

"Fear of being taken from my dad."

"Fear that I won't be a good mom."

"Fear about my heart condition."

"Fear of moving on in my life."

"Fear of letting people down."

"Fear of speaking in public."

"Fear of being made fun of."

"Fear of not being enough."

"Fear of facing my father."

"Fear of not being loved."

"Fear of losing our farm."

"Fear of being different."

"Fear of abandonment."

"Fear of losing people."

"Fear of not knowing."

"Fear of my sexuality."

"Fear of not fitting in."

"Fear of being alone."

"Fear of judgment."

"Fear of letting go."

"Fear of rejection."

"Fear of spiders."

"Fear of clowns."

"Fear of failure."

"Fear of water."

"Fear of death."

The interesting thing about this list, and about all of the other fears that people sent in, is that many (if not all) of them are completely reasonable fears to have. Many of them come from a healthy place. And yet these are all things people wanted to let go of, things they felt were holding them back.

That's the problem with fears. While I'm sure there are some fears that are *always* unhealthy, most can manifest in both healthy and unhealthy ways. It's all a matter of degree.

This is why I'm very wary when I hear someone say they want to conquer all of their fears. My first question is always, "*All* of your fears? Could you be more specific?"

If they say, "I will start by conquering my fear of the dark," then I think, "Okay, that sounds like a good one to start with. Dark is just the absence of light, after all. It can't really hurt you. I mean, in the long term you're going to run into some vitamin D issues, but there are supplements for that. What's next?"

If they then say, "Next I will conquer my fear of bears!" that's when I start to think, "Whoa whoa whoa, hold up there, friend. You may actually want to hold on to that one." Then I try to subtly work into the conversation the Werner Herzog film *Grizzly Man*, which is based on the true story of a man named Timothy Treadwell, who conquered his fear of bears and was subsequently killed and eaten by one, along with his girlfriend.

But the truth is, it may be reasonable to conquer your fear of bears if you live in an area where there aren't any bears, and

if that fear is impacting your life on a day-to-day basis. It all depends on the context.

So how does a person tell which fears are healthy and which are unhealthy?

For starters, I think it helps to try and explain your fear to someone else. If you can't articulate why you're afraid of a particular thing, it's likely that you have an unhealthy fear of that thing.

On the other hand, if you *can* explain it, it can be really helpful in getting other people to understand where your fear is coming from. My wife, for instance, is much more nervous in cars than I am. When we first met, I thought she was being unreasonably fearful, but then I learned that one of her childhood friends had died in a terrible car accident, and another friend had become a paraplegic in a completely different accident. Suddenly it all made a lot more sense. And just knowing that helps me go from "You're being silly about this" to "I understand this is a tender spot for you, and if I'd had the same experiences, I'd probably have a very similar set of fears."

Another way to distinguish healthy fears from unhealthy fears is that healthy fears are proportional to the level of danger in a situation. A fear of heights that kicks in when you look over the railing at the Grand Canyon is healthy. A fear of heights that kicks in when you're standing on your tiptoes is not.

In other words, a healthy fear will rise and fall in response to a threat. It's perfectly logical to be afraid of spiders when there's one on your face, but if you're walking around in constant, never-ending fear of spiders, that's not a good thing.

Speaking of spiders, here's a story that illustrates all of this pretty well.

During the early days of the shipbuilding process, before I'd even gotten kicked out of the first warehouse, there was a night when I woke up from a dead sleep because I was choking on something. That something happened to be one of those cheap plastic spider rings that you get on Halloween, the ones that are orange or black and are never big enough to fit on anyone's finger.

I'd somehow gotten one of these rings lodged in my throat while sleeping, and by the time I woke up it was halfway down my windpipe. I could feel its tiny plastic legs scratching the inside of my trachea as I hacked and coughed, trying to get it out before it made it all the way into one of my lungs.

I don't think I've ever coughed that hard in my life. My wife woke up from the noise, and I motioned for her to slap my back as hard as she could, but despite her best efforts the ring remained stubbornly in place precisely behind my Adam's apple. I sprinted into the bathroom and tried taking a drink of water, but it did nothing.

I was just getting ready to reach my hand down into my own throat to try to grab the ring when I finally woke up enough to ask myself a simple question:

How did a plastic spider ring get into my throat?

Specifically, how did a plastic spider ring get into my throat while everyone in my house, myself included, was asleep?

More specifically still, how did a plastic spider ring get into my throat while I slept in a house that did not, as far as I knew, contain a single plastic spider ring?

And just like that, the entire illusion dissolved. The plastic legs of the spider, which I was sure I'd felt scratching against the walls of my trachea just moments before, were suddenly gone. My cough stopped, and I went back to bed.

I would be embarrassed to share this story, except I know that all of us have had similar experiences. We've all woken up from a dream and just accepted without question whatever ideas the dream put in our head.

"I have octopus legs now. This is my life. I just have to make the most of it."

It's only when we finally wake up, when we finally fully exit the dream state, that we're able to see how foolish our fears were all along.

Lucius Annaeus Seneca (my first favorite Seneca) said, "We are often frightened more than hurt; and we suffer more from imagination than reality."

In the end, a healthy fear is one that has strong, demonstrable ties to reality, ties that flex as reality flexes, allowing the fear to wax and wane in proportion to the real danger of a situation. Sometimes we don't need to let go of a fear at all, we simply need to do some work to reestablish the strength of those ties.

12

WHAT IF NOBODY CARES?

By the end of the year, things with the ship were going really well. I'd long since surpassed my initial goal of receiving ten thousand regrets for the project, I'd finally figured out how to get the complex curves I was aiming for, and the ship was looking better than it had ever looked. There was only one problem: I was running out of money.

When I'd first set out to build the ship, I had to figure out how I was going to pay for this thing. I considered doing a fundraiser, or getting sponsors to cover the costs. But very early on, I got the feeling that this would be more of a hassle than a help.

Back then, I'd posted a quick note on Facebook saying something to the effect of "I'm about to start working on the biggest project of my life, and I'm looking for a giant warehouse to build it in." A local businessman had commented on the post, asking if he could sponsor the project, despite the fact that I'd given no details whatsoever about what the project actually

was. I said that we should talk more, and we set up a meeting at his office.

I explained the vision for the project, how I wanted to help people let go of things that were holding them back by building and burning a giant cardboard Viking ship. I showed him a rough budget, which included the warehouse space, the cardboard and hot glue, utilities, a heater, trailer rental, and a whole bunch of other costs.

He looked it over and said, "Hmmm. This is very doable. At the same time, it would be a substantial investment. If we were going to fund this, we'd want to make sure the project aligns with our values."

I was a little confused, because at this point I'd already explained what the project was, and it didn't seem particularly controversial to me. I asked him to clarify, and he said, "Well, there are some things people shouldn't let go of." By this I understood him to mean things such as sexual orientation and gender, things he had not so subtly expressed his opinions on earlier in the conversation. "What are you going to do if someone writes those things?"

"Well," I said, "if someone writes those things, I'm going to put them into the ship and burn them. That's what I'm going to do with anything people send me. For one thing, it's not my intention to tell anyone what they should or shouldn't let go of. This is a public art project, and people can submit whatever they want. But from a practical standpoint, these are anonymous submissions, so even if I did disagree with something someone sent in, it's not like I could send it back to them."

"Hmmm," he said, stroking his chin, "that makes sense. Then

perhaps we'd just need to be careful about which submissions we shared publicly."

"'We'?" I asked.

"Well, that's another thing I wanted to mention. Since my company would be providing the backing for this, I'd want that to be reflected in how we talk about the project. I'd want the website to explain that this is an idea that we came up with together as a reflection of our shared values."

"Hmmm," I said. This was intriguing to me for the simple fact that we had very much *not* come up with this idea together. Not to nitpick or anything, but *I* had come up with the idea. A number of other people had helped me shape and refine the idea, but one thing all of those people shared in common was that none of them were in any way associated with this man or his company.

I realized that this financial backing was going to come with a lot of strings attached, and I could already see how those strings could tangle around my metaphorical ankles and trip me up. Plus by this point I'd found the first warehouse and it had been much more affordable than I'd expected, so I decided I would just cover the costs of the project myself. You know, artistic integrity and all that.

But when I'd made that decision, I thought the project would take about a year. Now we were more than a year and a half in, and while things were finally trucking along nicely, the finish line was still a ways off. Every time I wrote a rent check for the warehouse, it felt like my family was really the one paying the price. In addition, the time I'd spent focused on building the ship had been time I wasn't spending marketing myself as a

speaker, which meant that business had dropped off a bit. There are only so many plates a person can spin.

These were all risks I'd taken into account at the beginning of the project, and we were by no means in dire straits. But as I looked at the dwindling money in my bank account and the as-yet-to-be-determined amount of work still left to do on the ship, I decided it was time to ask for help.

I did a back-of-the-napkin projection of how long the ship might take from here, and I ran the numbers on what the remaining costs would be. Then I put together a fundraising page on a website called Kickstarter. I shot a video in the warehouse wherein I begged people to give me their hard-earned money so that I could make it go up in smoke.

Kickstarter projects typically run about thirty days, but I was launching my project in early December, which meant that the final stretch of fundraising would fall during Christmas and New Year's. This seemed like a terrible idea.

The more I thought about it, doing a fundraiser at any time during the holiday season seemed like a terrible idea. People would have to decide whether they should spend their money on gifts and food for their friends and family, or donate it to the Salvation Army so the volunteer will stop that ear-piercing bell-ringing for one precious second, or give it to me to build a Viking ship out of cardboard. Out of these options, my project seemed like the weakest candidate.

Moreover, I was in a poor position to be asking for money, and I knew it. I'd already started the ship, already built it halfway, and already made a lot of promises to a lot of people (more than thirteen thousand at this point) that I was going to burn their regrets no matter what. I knew it would be entirely

reasonable for someone to look at the Kickstarter and say, "Come on, man, we all know you're not going to quit. You're in too deep now. If I don't give you my money, you'll just keep paying for this yourself." And they probably would have been right.

I was afraid of a lot of things, to be honest: What if nobody gives me any money? What if the Kickstarter is a spectacular public failure? What if the prevailing sentiment turns out to be, "Listen, Kyle, I'm happy to write something on a note card and mail it to you, but I'm not giving my money to a grown man so he can play around with cardboard and hot glue. Pay for this yourself"?

Essentially my fear was "What if nobody cares?"

This is one of a dueling set of fears in my life that go back a long way. The first comes from a desire for attention, for significance. I want people to like me, to think I'm interesting, to care about the things that I'm doing. So I'm constantly afraid that they won't.

But when they do like me, I inevitably feel guilty about it, because deep down I feel like I don't actually deserve anyone's attention, like the things I do are silly and insignificant. With all of the death and disease and horror in the world, why should anyone give two seconds of their brief life to some moron who hosts fake marathons and builds stupid stuff out of cardboard? Am I not just wasting everyone's time?

My life is a constant back-and-forth between these two extremes: first, I'm afraid that people won't like me, and then I'm afraid that they will. You can imagine how much fun it is to live in my head.

The interesting thing is, I have absolutely no evidence that

anyone thinks any of these things. Every time I think, *This is going to be the day my fears are proven true*, I turn out to be wrong. For instance, I once got hired to give a talk to a bunch of accountants, and the guy who hired me said, "Tell them about the fake marathon and the centaur bike and all of that stuff. They're gonna love it."

I remember thinking, *Are you delusional? These are professionals. They deal with real things like numbers and Excel documents and revenue forecasts. There is absolutely no way they're going to think I am anything but a clown who didn't get enough attention as a child.*

But that's not what happened. I gave the speech he asked for, fully expecting it to bomb, but instead they loved it. They laughed at all my ridiculous stories, and I was the highest-rated speaker at the conference. That same experience repeated itself at a conference for administrative assistants, a conference for parks and recreation employees, and a conference for nurse case managers. They all loved me.

A similar thing happened when I went to a therapist for the first time. I went with the express intention of talking about these dueling fears, about how I was secretly suspicious that all of the things I did in my life were a complete waste of time and talent, but also how I couldn't bring myself to stop doing them.

When I walked into the therapist's office, his assistant seated me on a couch and said that he would be in shortly. A minute later, a small man with a very pronounced physical disability slowly rolled into the room in a wheelchair. His arms and legs were withered and twisted, and he was unable to hold his head upright. I would later learn that he had advanced multiple sclerosis.

He pulled up across from me and began to move out of his wheelchair and into a recliner. During the process he almost fell to the ground, and for a moment I thought I was going to have to catch him. But in the end he got situated, and he asked me what I would like to talk about.

Here was a man whose life had dealt him a very difficult hand of cards, a man who could not leave his own home without assistance, could not drive a car or ride a bike or do any number of other things that I took for granted every day. And I had come here to talk about my problems, to tell him that I felt like perhaps I was wasting my time on these silly projects. It seemed inevitable that he would say, "Yeah, you idiot. Isn't that obvious? Don't you have any idea how lucky you are? And you're spending your time as a young, able-bodied person this way, hosting fake marathons and building things out of cardboard? What a waste of your life."

But that's not what he said.

To be honest, it took me a while to get around to explaining my issues because I was so self-conscious about the dynamics of the situation, but he was a good therapist and eventually he drew it out of me. I began to tell him about the silly projects I'd done, about how part of me felt guilty that I spent my time on these meaningless things, but another part of me felt like maybe they were important in some way. He asked what sort of silly projects I was talking about, and I explained about the fake marathon and the BeardMyBaby app, about the Viking ship I'd built for my birthday, the centaur bicycle, all of it.

The whole time I was looking down at the ground, feeling very self-conscious about all of the things I was telling him, thinking that surely he would frown on all of it. But when I

looked up, the man was convulsing with laughter. He said that the idea of a fake marathon was one of the funniest things he'd ever heard. He said he wished he had known about it at the time, because it would have been hilarious for him to participate as a disabled man. Then he said, "Kyle, I don't think any of these things are meaningless at all. I think you're bringing joy to people in a very real way, and I can tell you from my experience both as a therapist and a human being . . . people need joy."

I was speechless. I had been sure that I knew what this man would say, that I knew what his point of view would be, that he would be very much against my tomfoolery. But instead I realized that I had put words in his mouth, that I'd prejudged him based solely on his appearance, that I hadn't left room for his own humanity. I'd made a lot of assumptions about him that were rooted in my own fears, and those assumptions were simply not true.

That's the thing about fears: So many of them are not even remotely based in reality. Instead, fear tells us a story about the world, and then it constructs an elaborate web of assumptions that keeps us from investigating whether that story is even true. So often, all we need to break the illusion is a friend who can see things for what they really are and speak that truth to us, gently helping us to untangle the web until we can finally step free of the fear.

My therapist helped me to see that my dueling fears were unhealthy, and that while it would never be possible to please everyone, the majority of the people in my life loved me and supported me not in spite of my silly ideas, but in many ways because of them.

Like most life lessons, though, this is something I've had to learn again and again as I've reluctantly put myself out there, fully expecting to be ridiculed, only to find that I was loved and supported and encouraged the whole time.

* * *

I decided I would aim for a ten-day Kickstarter project so I could avoid the holidays altogether. I knew it was risky to have such a short funding period, but I couldn't see a better alternative. On the third of December, I clicked the button to take the project live, fully anticipating that it would be a flop.

The project was funded in eight days. Once again, the ship was saved.

13

THE CAVE YOU
FEAR TO ENTER

The Kickstarter project didn't just give me the funding to complete the ship, though. It also showed me how many people were in my corner.

As soon as I announced the fundraiser, I began receiving pledges. But I also received messages, lots of them, from people saying, "Hey, dude, things are pretty tight right now, and with the holidays and everything I can't really afford to give anything to your project. But I wanted to let you know that I've been following along the whole time and I'm cheering you on. Don't give up!"

I got a message from a church that had heard about the project and taken up a special collection to contribute as a group. I got another from a teacher whose students had all chipped in. One generous donor gave more than a thousand dollars.

It was as if everyone knew that my fear had been "What if nobody cares?" and they'd all joined forces to prove beyond the shadow of a doubt that it wasn't true. But I never would've

learned any of this if I hadn't actually launched the Kickstarter, if I hadn't pushed through the fear and put myself out there.

Unfortunately, I've found that this is almost always how this stuff works. You actually have to face your fear to find out what's on the other side of it. I wish there was another way around it, but it appears that's the price of admission.

The good news is, what's on the other side is almost always better than you ever expected. And even when it's not pleasant, it's generally survivable. Reality just can't compete with the fears we manufacture in our imagination.

I was once helping my brother move some furniture, and in the process I pulled a muscle in my back. It felt like nothing at first, but by the end of the day I couldn't stand upright without help. I'd gone to visit my parents, and my mom had to drive me back home because I was in so much pain. When I got to my house, my mom and my wife each got under one of my arms and helped me hobble back to bed. As a man in my early thirties, this was a very humbling experience.

I woke up in the middle of the night and tried to walk to the bathroom, but I only made it about three steps before I collapsed to the ground. Every time I tried to pull myself back into bed, excruciating pain shot through my lower back, causing me to fall down again. My wife tried to help, but there was really nothing she could do. Eventually an ambulance was called, and four paramedics came and lifted me back into bed. Again, I cannot stress this enough: I was thirty-three when this happened.

The lead paramedic put her hand on my back and said, "I can feel your muscles spasming. What did you do?" I explained that I'd just been carrying some furniture and turned in a weird direction, that it hadn't even hurt in the moment.

She told me it was likely that I hadn't actually injured anything at all, but that I'd done something that made my body think it was *about* to be injured. Then, to protect me from this perceived threat, my body decided to lock down all the muscles in my lower back. She said that our bodies would rather immobilize us temporarily with muscle pain than immobilize us permanently with a spinal injury or something worse. The problem is that you can't tell your body, "Okay, okay, I get it. I won't carry any more furniture. I'm actually home in bed now. You can relax." Because of this, your back will stay locked up long after the danger is gone.

She told me to stay in bed and try to slowly stretch the muscles in my back a little at a time. So that's what I did. I started by bending my knees, bringing them up toward the ceiling an inch at a time. I tried rolling to one side, then the other. It took me an entire day to be able to sit up unassisted, and another day to be able to stand without help.

I spent most of those days lying in bed watching YouTube videos of these two older guys named Bob and Brad, who bill themselves as "the two most famous physical therapists on the internet." Their videos are hilarious and informative, and by following some of their recommendations, I eventually discovered that my hip mobility was terrible (probably from sitting at a desk all day), and once I addressed that issue, everything was fine. I was completely back to normal.

It's dumb that our bodies do this. Personally, I think that instead of developing another app to share photos and videos on the internet, maybe we should put some effort into figuring out a way to tell our bodies to chill out for a second, to tell our lower backs, "Be cool, man. It's all right."

The thing is, our minds work the same way. Your brain's main job is to keep you alive, and that's a good thing. But because that's priority one, your brain is constantly coming up with a list of all the things that could possibly kill you. That's fine when the things on that list are really dangerous, but it becomes a problem when you stop cross-referencing that list with reality, when you become convinced that anything and everything is a threat to your survival. When that happens, you become locked down by fear, and it can take some time to stretch that out again.

The mythologist Joseph Campbell studied stories from a wide variety of cultures and times, and he discovered a pattern that shows up again and again across continents and centuries, a pattern he called "The Hero's Journey." Once you learn it, you'll start seeing it everywhere, from *Star Wars* to *Harry Potter* to *The Lord of the Rings* to *Ratatouille*. In short, the pattern goes something like this:

A hero leaves the comfort of their day-to-day existence, venturing out into a new world that is dangerous and unknown. There, they face challenges, overcome them, and claim a prize. They return home changed, and the treasure they've won brings a benefit to their people.

That's the five-second version, but Campbell also identified very specific milestones along that journey, stages with cool names such as "The Call to Adventure," "The Road of Trials," and "The Ultimate Boon."

One of the stages is called "The Abyss." It's when the hero has to go through a dark place (sometimes metaphorical, but often literally dark) where they face their fears and overcome them. In doing so, they receive something they need to

complete their journey, some magical item or weapon or jewel that will ultimately help them accomplish their task.

In speaking of this stage, Campbell said, "The cave you fear to enter holds the treasure you seek."

Campbell surmised that the reason this story shows up again and again through all cultures and times is that it has something to teach us. Ultimately, The Hero's Journey is the journey we all must go on. Each of us must face our fears and enter the caves that hold the treasures we are seeking.

In real life, though, we usually don't know what those treasures are ahead of time. We don't get to flip ahead in the story and see what magical item lies in wait for us. We simply have to face our fears with faith, believing that there is something better for us on the other side.

In the end, the money was the least important thing I got out of the Kickstarter project. It certainly helped, but it mostly served as an incentive to get me to enter the cave in the first place. Once I was there, I found the real treasure.

First, I found that I was loved and supported by more people than I ever could have imagined. That was a powerful thing, and it was a real source of strength when things got hard again in the days ahead.

But there was another thing. When I launched the project, many of my friends shared the story on their social media profiles. My friend Isaac was one of those people, and the story he shared caught the attention of a guy named Robert McMahon.

Robert works for a company called Southern Missouri Containers. They make cardboard boxes. Like, *lots* of cardboard boxes.

Robert messaged me and said, "Hey, Kyle, I saw your project. If you ever need cardboard, let me know." Then he sent me a picture of what I can only describe as a cardboard artist's fantasyland: a giant room filled with shelves of every kind of cardboard you can imagine.*

I didn't know it at the time, but I wouldn't have been able to complete the ship without Robert and his cave of cardboard wonder. The sheets of cardboard I'd been buying were simply too small, and Robert's stuff was both bigger and better. He became a valuable resource to me throughout the project, not only supplying me with cardboard but also helping with technical advice and even using his special equipment to help me cut out the lettering for the center of the ship. I can confidently say that I may never have completed the ship without his help.

But I didn't know any of that when I launched the Kickstarter project. I didn't know about the messages of support and encouragement I'd receive, about the generous donations from people I'd never met, about the groups that would come together to help me get funded. I certainly didn't know that the Kickstarter project would lead to me finding my cardboard Yoda. All I knew was that I needed to raise this money, and to do that I was going to have to push past my fears.

After I injured myself that time, I asked a physical therapist friend if there was something I could do to keep my back from locking up again. I was hoping he would give me a pill or an

*I know for most people there are not that many kinds of cardboard that you can imagine. Probably just one. But let me tell you, the world of cardboard is a fascinating and diverse place. There's single-wall, double-wall, and triple-wall, all with various thicknesses and corrugation patterns, various colors and strengths. It's amazing.

injection or something, some one-time cure-all that would carry me through the rest of my life. But he didn't do that.

Instead he told me to stretch every day. He said that our bodies are very efficient machines, and if you stop using your full range of motion, eventually your body will decide that it's a waste of calories to keep that flexibility intact. If you sit hunched over every day, eventually your muscles will contract until it's nearly impossible for you to be anything *but* hunched over. But if you stretch every day, your body will maintain that range of motion, albeit begrudgingly.

Our comfort zones are the same way. It is their nature to contract. If we don't stretch them out a little each day, eventually they lose their flexibility entirely, and it becomes extremely difficult to get them back to their original size. Facing our fears is not a one-time thing; it's a daily practice. This is annoying, but the alternative is worse: living a life that is much smaller than what it could be.

14

IF AT FIRST YOU DON'T SUCCEED

From the beginning, the entire Viking ship project had been an exercise in expanding my comfort zone. At the point when I'd first had the idea, I had never rented studio space before, never done a public art project, never built anything nearly this big, never had a project take this long, and never spent this much money on one of my ideas. But at each step of the way, I found that things were mostly easier than I'd expected them to be, that my fears had been almost entirely unfounded.

That's not to say that there weren't difficulties along the way. There were tons of them. It's just that every time I encountered one, I found that I was sufficiently equipped to figure out a way around or through it.

That's the paradoxical thing about fears. On one hand, fears often result from an overactive imagination. To quote one of the submissions I received, our fears often come from us "thinking

of the worst possible scenario every time something happens"* and then becoming deathly afraid of that thing.

But strangely, fears can also result from an *underactive* imagination. Our scared little lizard brains only imagine things right up to the point of disaster but not a moment past it. They whisper things to us such as: "What if you fall flat on your face?" "What if you're not good enough?" "What if everyone laughs at you?"

But they never actually take the time to imagine the answers to any of those questions.

We never imagine the part where we dust ourselves off and keep going. We never imagine that we can very likely *learn* to be good enough. We never imagine the moment where everyone laughs at us and then we join in and laugh at ourselves, too.

So many of us have a "fear of not being good enough,"** but we never stop to ask, "So what? What if it turns out that I'm *not* good enough? What would that even mean? What would I do? How would I respond?"

We forget that none of us started out being good at anything, that we all started our lives as helpless creatures who couldn't walk, couldn't talk, couldn't take care of ourselves in any way. We forget that our parents considered it a monumental achievement when we first learned to roll over halfway, and that even this, the simplest of mechanical accomplishments, can take more than half a year for an infant to master.

*Submission 9,143.

**Submission 8,290.

Not all creatures are like this, you know. Horses, for instance, can walk an hour after they're born. But humans take forever to do almost anything. It's almost as if our entire existence is designed to teach us that nothing is going to come easily, that we're going to have to work to accomplish every little thing, that there's no such thing as a free lunch.

But the trade-off is that the limits are so much higher. The possibilities are so much greater.

A horse has experienced almost everything it will ever experience by the time it is two years old. Plenty of humans aren't even potty-trained at that point. But once humans finally get their act together and learn to walk and talk and stop soiling themselves, it's insane how much they can accomplish. Horses don't draw or paint or invent self-driving cars. They don't write poetry or go to the moon or make movies about other horses. Humans do all of that stuff. Sure, it takes us a while to figure it out, but that's not the point. The point is that we eventually *do* figure it out.

In other words, our inadequacy is not a permanent condition.

In light of that, our fears end up looking rather silly. It's silly that so many of us have a "fear of trying something new"* when trying something new is the only way we move past our current state. It's the only way we grow at all. The alternative is just to keep repeating our same limited experiences over and over again, each day exactly like the one before, like the movie *Groundhog Day*. But that gets old. We aren't meant to live like horses.

*Submission 8,449.

* * *

After the Kickstarter funded, I got back to the day-to-day work of building the ship. And almost immediately, I hit a snag.

It turned out that figuring out the curves on the dragon had lulled me into a false sense of security. I had tricked myself into thinking that I had finally mastered cardboard once and for all, that I had tamed it, broken it like a wild stallion, bent it to my will.

In retrospect, I can see that I had made the classic mistake of allowing myself to believe the age-old lie of "Once I get past this one thing, it's all smooth sailing."

That's never been true, though. Not for me, or for anyone else, either. The deceptive thing about the mountains we climb is that they keep us from seeing the other, bigger mountains behind them. There are always more things to learn, always new challenges to face if we're up to them.

I'd figured out the curves on the dragon's body, but those turned out to be the least complicated curves of all, because they were mostly decorative. Next I had to finish the rest of the ship, and I found that the difficulty level had increased substantially.

I needed to close in the front section of the bow, where the sides of the ship arced toward each other to meet at the dragon's belly. Here the cardboard needed to curve in several different directions at once, but it also needed to serve a structural purpose, helping to stabilize the weight of the dragon's head and neck. When the dragon had been a simple flat shape, it had been able to stand up fine, but as the curves and detailing added more bulk, the whole thing had become increasingly

prone to falling over. I needed to stabilize things before I damaged it irreparably.

Looking back, I should have known this section would be a problem, because it had been a problem with the first Viking ship, too. Back then I had wasted hours on this one area, building it and tearing it apart and building it again. When I'd finally found a method that worked, it was a moment of pure joy.

I'd mistakenly assumed that I could just use that method again here, that surely there would be no difference between supporting an eight-foot dragon and supporting a sixteen-foot dragon.

But as you've probably deduced, it didn't work at all. Like, not even a little bit. Not only did it look terrible, but it had zero structural stability to it as well. It needed to be both beautiful and practical, but instead it was neither.

Dejected, I pulled the section apart and tried building it again using thicker cardboard. I tried using multiple layers of cardboard. I tried changing the direction in which the corrugation was oriented. I tried various internal supports. None of it worked.

It was a classic case of "What got you here won't get you there." I was beginning to realize that the structural properties of cardboard are just completely different when you're working on a large scale. There are a whole slew of things you can get away with when you're building something the size of a minivan that simply won't work when you're building something the size of a giraffe.

As I continued to fail again and again, my impostor syndrome, which had been in temporary remission, began to rear its ugly head.

Impostor syndrome is a well-documented phenomenon that affects creative people of all types. It is the deep-seated feeling that you are a fraud, that you do not actually know what you are doing at all, and that sooner or later people are going to find out. For someone with impostor syndrome, their deepest fear is that they will be publicly exposed as a charlatan and a huckster.

I've struggled with impostor syndrome on and off for years. I'm an author and speaker who never finished college, an artist who never took an art class after my sophomore year of high school. I'm entirely unqualified to do almost all of the things I do, and impostor syndrome likes to remind me of this regularly.

Once you have impostor syndrome, though, it doesn't limit itself to your career choices. Instead, it spreads to every area of your life. You begin to think, *I'm not actually a good dad, because I lost my temper with the kids last week. I'm not actually a good citizen, because I didn't have time to research the candidates for county collector so I just voted for the person with the funnier-sounding name.* Your brain builds a case against you in every area of your life, compiling evidence to prove beyond the shadow of a doubt that everything you're doing is wrong, that everything you've *ever* done is wrong, that you are an awful person with no redeeming qualities, and that you should be ashamed of yourself for the way you're living your life.

At least that's my own personal experience. I feel the need to give that disclaimer, because as soon as I start talking about impostor syndrome my brain goes, *Oh, so now you're the expert on this, huh? Remind me again where you went to medical school?*

Honestly, I could be at a support group for people who suffer

from impostor syndrome, and my brain would still be like, *Excuse me, sir, you aren't supposed to be here.*

As this one section of the ship continued to confound me, it only reinforced the feeling that I was, in fact, a fraud, that I had no idea what I was doing, and that sooner or later everyone was going to realize that.

Strangely enough, this thought actually led to a breakthrough for me. To be specific, it was the "later" part of "sooner or later" that led to my eureka moment. I realized that, at least for now, no one had yet discovered that I was in over my head, that I didn't actually know what I was doing. And because of that, it gave me time to fix things before they figured it out.

I realized that my inadequacy did not have to be permanent. The fact that I didn't know how to fix the ship *today* didn't mean that I would *never* know how. It just meant that I had some work to do.

But I was okay with that, because humans are made for a challenge. We're built to climb new mountains, slay new monsters, and learn new cardboarding techniques.

After all, we're not horses.

15

THE OPPOSITE
OF FEAR

It took three months for me to figure out the front curves on the ship.

Actually, that's not true. It took three months for me to figure out *one* of the front curves on the ship. Then I still had to replicate that once more on the other side, and twice more still for the back of the ship. And even then, I still ended up tweaking those areas right up until the day the ship burned, trying to get them to look exactly the way they looked in my head.

But in the end I did figure them out, and I wasn't exposed as a fraud, and none of the things impostor syndrome had threatened me with came true.

You'd think this would mean that I was finally able to put it behind me, that I never again felt insecure about my abilities. But of course that's not what happened. I eventually found new things to feel insecure about.

To some people that probably sounds depressing. It sounds

like an admission of defeat. But I don't see it that way at all. I see it as an acknowledgment of reality.

While we would all love to be able to conquer our fears once and for all, it typically doesn't work that way. Instead, our fears become things we learn to manage, an annoying uncle we learn to live with. For one thing, we can't get rid of him because he's family. But for another thing, he turns out to be right every now and then, just often enough to be useful.

My friend Michelle once did a project called "100 Days without Fear," where she faced a different fear every day for a hundred days and made a video about each one. Some of them were small fears, such as "getting acupuncture" or "holding a tarantula." Others were bigger fears, such as "quitting my job" or "diving with sharks." Her project culminated in a TEDx talk that went viral and started a worldwide movement of people choosing to face their fears, and now she travels the world writing and speaking about the topic. She's probably thought more about fear than anyone else I know.

You'd think after all of that time and effort, Michelle would be fearless, that she would have discovered the secret to getting rid of fear once and for all. But she's not. And she doesn't want to be, either.

After all that time, Michelle has concluded that fear isn't a bad thing. Fear is our ally. It's there to keep us alive. To get rid of it, to pursue fearlessness is to throw out something that is protecting you.

Michelle would tell you that fearlessness is not a good thing. A fearless person is a reckless person.

At about this time, I experienced the danger of fearlessness firsthand.

I'd been invited to speak at a leadership conference for high school students, and the people organizing the event had heard about the Viking ship. They asked if I would be open to doing a smaller Viking funeral at their event, and I said yes. They had some volunteers put together a more reasonably sized ship, closer to the size of my first one. They had students fill out cards with their regrets, and then they burned the ship on the front lawn of their school.

All of this was fine, and I was honored that they would go to all of this trouble for me. But shortly before the ship was to be set on fire, one of the volunteers decided to spice things up by adding fireworks to the equation. He bought a few thousand bottle rockets, quickly removed them from their packaging, and dumped them loosely among the piled regrets. Then he poured gasoline all over them.

I didn't know what to do in this situation. It wasn't my event, and it wasn't my decision to make, but this seemed like a recipe for disaster. I walked over and said, "Hey, man . . . uh . . . are we sure this is a good idea?"

The guy looked at me like I was insane and said, "Yeah! This will be awesome!"

"Are we at all concerned about these bottle rockets hitting the students?" I asked.

"Naw, man. They'll be fine," he said.

"Should we maybe, I don't know . . . try to point them away from where the students will be standing? It seems like they're just pointed in *every* direction right now, which feels like maybe not the most responsible arrangement," I said.

He laughed and said, "It'll be fine, man! Trust me."

I very much did not trust him. But when I brought the issue

up to a few other volunteers, none of them seemed particularly concerned, so I dropped it.

Then the event began. Seven hundred students formed a circle around the ship. They asked me to say a few words, and I talked about the importance of letting go of the things that hold us back. I talked about how we have to leave the past behind if we want to move toward a better future. And then I told them that maybe they should all scoot back, like a lot, because the ship was full of bottle rockets aimed at random.

The students laughed, and some of them took a few small steps backward, but mostly people seemed unconcerned. That attitude lasted right up until about fifteen seconds after the ship was lit.

To light the ship, the man in charge of this portion of the evening (the guy who'd built the ship, filled it with thousands of bottle rockets, and poured gasoline all over it) walked up, flicked a lighter a few times, and held the flame out toward the boat.

The gasoline fumes ignited in a ball of fire that made all the students gasp, but no one was close enough to get hurt. Then the ship began to burn.

For the first few seconds, all was well. The regrets began to brown at the edges, twisting and shriveling as they burned away to nothing. Then the bottle rockets began to fire.

At first one or two shot up toward the sky, whistling through the air as they left a trail of sparks behind them. Next a few went sideways, and the students in those sections of the circle jumped out of the way. A few nervous laughs were heard.

Then all hell broke loose.

Within a few seconds of the first bottle rocket launching,

dozens began launching all at once. It went from "pew . . .
POP . . . pew . . . POP . . . pew-pew . . . POP POP" to "pewpew
POPPOPpewPOPpewpewpewPOPPOPPOPpewpewPOPPOP
pewpewpew." Soon the individual sounds blurred into
one long, cacophonous note. The rockets were launching
randomly in all directions, exploding in the air like tiny
bombshells. Some of them had not been fully removed from
their packaging, and others had broken or burned sticks,
which meant they didn't fly in predictable, straight lines,
but rather zigzagged and spiraled as they shot toward the
students. Sometimes one bottle rocket would fly out of the
ship, bringing along several unlit bottle rockets tangled in its
wrapping. Then when it exploded, it would ignite the fuses on
the other bottle rockets it had dragged along for the ride.

The students, predictably, panicked. They began screaming
and scattering, running in every direction at once.

Then the explosions started.

I would later find out that in addition to the bottle rockets,
the gentleman in charge had arranged for larger artillery shell
fireworks to be launched from the hill behind us. These are
commonly referred to by my hillbilly friends as "mortars"
because they function much the same way a mortar shell
would: each shell explodes twice—once to launch it from the
tube, and then again in the air to create the dazzling display.

The problem with mortars is that you get what you pay
for, and from what I gathered, this gentleman had not paid a
particularly large sum for these. As such, the consistency was
all over the place. Some of them shot high into the sky, while
others launched only eight or ten feet out of their tubes before
exploding just above our heads.

The other problem was that none of us had any idea that there were going to be mortars launching from behind us in the first place, so when the first explosions went off, we assumed that the bottle rockets had ignited something over the hill, something that was now going to explode and kill us all. People who had been running toward the hill to escape the bottle rockets now turned and ran back toward the ship.

It was absolute pandemonium. Students and volunteers were running everywhere, and people were screaming. I remember time slowing down. I remember a sense of panic. I remember thinking, *My career is over*, as I pictured a headline the following day: "Predictably, Viking Funeral Goes Terribly Wrong."

In the end, the gasoline was our saving grace. Because the man had added so much accelerant to the fire, the bottle rockets all went off in a very short time. It was a terrifying forty seconds or so during which I felt a visceral sense of terror that I have not felt before or since, but then it was over. We did a quick inventory of everyone's eyeballs and found that we somehow miraculously still had the same number we'd started with. Once everyone was assured that the fireworks portion of the evening had concluded, the students all moved toward the still-burning ship, basking in the soft glow of the flames until the whole thing had burned away to nothing. Then they filed back into the gymnasium, shell-shocked but alive.

I remember laying in bed in my hotel that night, staring at the ceiling as I replayed the evening's events in my head, recounting the ways in which I had narrowly avoided disaster. I remember vowing that I would never again put myself or my audience in a situation like that. I remember thinking how lucky we'd been that no one had been injured.

The opposite of fear is not fearlessness. Gasoline-bottle-rocket-man was fearless, and it put seven hundred people in very real danger.

The opposite of fear is courage.

Courage to face the fears we need to face. Courage to do the things we need to do even if we're scared of doing them. Courage to stand up for what's right even when it's hard.

But courage isn't something you get once and then keep forever. Courage is something you have to summon again and again. But the good news is this: the more times you summon your courage, the easier it gets. It's as if your brain says, *We seem to be using this a lot, so I'm just going to keep it within easy reach.*

Overcoming my impostor syndrome with the cardboard curves didn't mean I never faced impostor syndrome again, but it did mean that I was better equipped to deal with it now. It meant that the next time it came around, I didn't go to the trouble of inviting it in for dinner. Instead I faced it head-on, asking myself, *Is there any truth to this feeling? Is there anything this impostor syndrome is trying to teach me? Is there any value in it at all?*

When I ask these questions, sometimes I find that my fears are actually healthy. Sometimes my impostor syndrome forces me to realize that I *am* an impostor, that I *don't* actually know what I'm doing, and that I should fix that. But at other times I realize that the impostor syndrome is a liar, and I summon the courage to send it packing.

As much as we all fantasize about banishing our fears once and for all, that's actually a terrible idea. Fear is a useful tool that has kept us and our ancestors alive since the beginning of

time, a fence that protects us from things that could harm us. But it's up to us to determine the best place for that fence, to set the boundaries where they will serve us best. It's up to us to determine which dangers should be fenced off and which should be faced head-on.

ving my Brother
hrow me in
 a Trash can
first day my freshmq
 year.

the things that
WERE & WEREN'T
 said...

My 30's

My Friend stabbed
me in the
 back

I want to let go of the past
with my father and the mental
abuse. I want let go of the
anxiety and the problems
of my past and family.

 I want to start fresh.

Being bullied
and taking it out
on other people
which makes me
no better than
the bully.

I want to let go of every
that bullied me and made
feel like im nothing

Falling in love
with the wrong
person.

I want to let go of
my past when I thought
of suicide

BECAUE MY OWN CHILDREN
LITTLE, I DID NOT UNIT
GRANDMOTHERS IN THE NURE
HOMES WHERE THEY LIVED
THEIR LAST YEARS. I AM
GOING TO MAKE IT A POI
TO VISIT OTHERS IN NURSING
NOW THAT I AM RET

my mother being
horrible 95% of my life &
causing psychological
issues in my life.

My mom cutting my hair
and left patches all over
my head.

Real One:
Not saying goodbye

My sexual assult when I was 3 by a
kid
My disorder, My anser, the
stress toxic relationships
broken

16

NO TURNAROUNDS

I was once doing one of those get-to-know-you exercises you do at team-building seminars, and one of the questions was, "What's the greatest compliment you've ever received?"

I knew the answer instantly: the greatest compliment I ever received was an offhand comment from my friend Isaac years ago.

A few weeks before the compliment was given, I had been driving home when I noticed that a business had erected a four-foot-by-four-foot sign in the middle of their driveway. The sign, which had been professionally made, said,

NO TURNAROUNDS

VIOLATORS WILL BE PROSECUTED

Apparently these people were tired of other people turning their cars around in their driveway, and they'd gone to great expense to make this clear to the general public.

At first the sign didn't really bother me, but as I drove by

it day after day, it began to get under my skin. For one thing, this was a business, not a residence, so it's not like cars turning around in their driveway were endangering their kids or something.

For another thing, I had driven that stretch of road multiple times a day for years, and I'd never once seen someone turn around in this particular driveway. On that basis alone, the sign felt ridiculous. Moreover, what law were they planning on prosecuting people under: The Grumpy Old Man Act of 1984?

The whole thing just felt very unneighborly to me, and every time I drove by the sign it would bother me a little bit more. I began to fantasize about organizing a protest: We would start at the town square, where I would give an impassioned speech about our constitutionally protected right to turn around in other people's driveways. (I planned on looking this up in the Constitution first just to check, but I was pretty sure it was in there.) Then, after the speech, there would be a brief bathroom break before everyone piled into their cars. We would all drive until we reached the spot, and then each car would slowly and politely perform a three-point turnaround in the driveway. In my head, I imagined the line of cars stretching for miles, and I pictured us being the main story on the evening news.

As I thought more about this, I realized that although the idea sounded very funny in my head, only a jerk would go through with it in real life. I also realized that I was not actually sure if a person *could* be prosecuted for turning around in another person's driveway, but I'd rather not find out.

Then I had a better idea.

Instead of turning my *car* around, what if *I* just stood in the driveway turning around and around in circles? And what if,

while I was doing that, I was lip-syncing to "Total Eclipse of the Heart," a song whose lyrics feature the phrase "turn around" over and over again?

I mentioned the idea to a few friends and it got a mild chuckle, which is all the encouragement I typically require. I grabbed a camera and headed down to the driveway, ready to join heroes such as Nelson Mandela and Henry David Thoreau in the long history of people who were thrown in jail for standing up for what's right.

I stood in the right-of-way where the driveway connected to the road, turned on my camera, hit Play on the song, and began turning around and around, lip-syncing as the camera recorded the whole spectacle.

"Total Eclipse of the Heart" is more than five and a half minutes long, and I wanted to make sure I got enough footage to edit a proper video, so I lip-synced the entire song four times. When you factor in the time it took to restart the song each time, plus the break I took to eat a granola bar, I was spinning around in this driveway for the better part of half an hour.

Toward the end an employee came out and stood there watching me with a mix of curiosity and concern. When I finished, he inquired about what I was doing, and I told him I was working on a student film project. (I've found there's almost nothing you can't get away with if you tell people you're working on a student film project.)

The man seemed confused, but I think mostly he was concerned that I was on drugs. I assured him that I was not, though I'm not sure how convinced he was since I was still a little dizzy after spinning around for so long. Eventually I said good-bye, packed up my camera gear, and headed home.

The next day I went into my favorite coffee shop to edit
the video. I pulled out two different cameras, a memory card
reader, and a bunch of cords, then set them all on the table next
to my computer, and began plugging things in.

My friend Isaac, who owns the coffee shop, came over and
asked what I was working on. I told him about the sign, and
about the idea I'd had to spin around on the side of the road
singing a Bonnie Tyler song from 1983.

He said, "Oh, yeah, you were telling me about that the other
day. So you actually did it?"

"I actually did it," I said. "Now I just have to edit this video
that will probably amass all of a dozen views if I'm lucky."

He laughed, then gave me the greatest compliment of my life.

He said, "That's what I like about you, Kyle. A lot of people
come in here and talk about crazy ideas that they're going to do.
But for most of them, the ideas never make it out of this shop.
You actually do the ideas. I like that."

I didn't think it was that big a deal in the moment, but as
time has gone on I've had other people echo this sentiment, and
I've come to see that Isaac was right. Most people *don't* actually
follow through on their crazy ideas. And that makes me sad.

People always ask me why I do these things, especially since
they take a lot of time, usually don't make any money, and
often are only seen by a small group of people, if at all. And the
reason I always give is this: "I do these things because one day I
will be dead."

One day I will be dead and cold and in the grave, and it
has been my experience that dead people do not tend to do
very many silly projects. So this is my opportunity, while I'm

still above the ground, to act on the crazy ideas that pop into my head.

But more than that, I do these things because I don't want to look back and wish that I had. I don't want to be that middle-aged guy who's always talking about the great ideas he never tried.

The reason I'm bringing all of this up is because we are now in the part of the book where we address the next category of things people wanted to let go of: Experiences.

I originally called this category "Actions," because a lot of the regrets people submitted had to do with actions they'd taken, things they wished they hadn't done. People regretted being a bully or a cheater or doing something unethical or embarrassing.

But as I looked at the submissions more closely, I began noticing that there were just as many regrets about things that people had *not* done that they wished they *had*: asking out the girl, trying out for the team, moving across the country, signing up for the class.

In fact, there were probably *more* of these submissions than the other kind. But there was another difference, too. They stung more. The more I read through them, the more I realized an important truth: the pain of regret fades, but the pain of "what if?" sticks around.

It makes sense when you think about it. If you regret doing something, you can often go back and make it right. You can apologize for the thing you said in a heated moment. You can pay back the shopkeeper you cheated. You can fix the window you broke playing baseball.

But in many cases, you can't go back and fix a mistake of inaction. You can't just go back and do the thing you wished you had done, because the moment has passed. The opportunity is gone.

For instance, I once found a working polygraph machine for sale in a thrift store. It had been donated by a local Bible college, and the thrift store had it on sale for fifty dollars. I immediately began to imagine all of the hijinks I could get myself into with a piece of equipment like that. But this was at a time in my life when fifty dollars represented a substantial portion of my net worth, and ultimately I chose not to buy the machine so I could make rent.

I know it sounds silly, but I have thought about that polygraph so many times over the years. I've thought of all the fun I could've had with it, all the viral videos I could've made by submitting people I love to a random lie detector test.

But that machine is long gone now. Trust me, I've gone back and checked many times. And while I'm sure I could go buy another polygraph on eBay, it wouldn't have "PROPERTY OF [REDACTED] BIBLE COLLEGE" stamped on the side, and that was half the appeal in the first place.

So if we can't go back and undo mistakes of inaction, how do we move forward? Are we simply cursed to carry that regret with us for the rest of our lives?

I don't think so. I think that ultimately we have to make a choice: we can live with that regret forever, or we can use it as a valuable life lesson, an ever-present reminder to seize the moment, to chase the muse when she comes, to buy the fifty-dollar polygraph before someone else does.

In life, as in that business's driveway, there are no turnarounds. We must keep moving, ever forward. But by taking a moment to look in the rearview mirror every now and then, we can learn things that will help us spot opportunities ahead before they pass us by. By looking back, we can learn the best way forward. We can learn to live a life that doesn't have us asking ourselves, *What if I'd tried?*

17

CUTTING CIRCLES
OUT OF SQUARES

Now that I had figured out the curves on the front of the ship, I was finally at a place where I could start adding details. Details are the most fun part of cardboarding because they are what transforms a simple base structure into something multilayered and magical.

There were several different categories of details I needed to figure out. First were the wooden planks that made up the hull. Those were pretty simple to handle: I just laid down an actual plank of wood and traced it onto the cardboard over and over again. Next came the hardware for the planks: fake bolts and metal plates to hold the ship together in rough seas. These were pretty easy as well.

That left the dragon.

As I mentioned earlier, my goal with the dragon was to make something convincing enough to scare a child. I wanted this thing to look real.

I started by looking at pictures of dragons online. I knew

that in doing so I was opening myself up to some very strange targeted advertising, but such is the price of progress. I saved dozens of these dragon pictures to my phone for inspiration and printed several off to bring to the shop.

I learned a lot about reptilian anatomy during this time. For instance, I learned that snakes have special scales on their stomach (called ventral scales) that allow them to slide along the ground without friction. They have a different kind of scales on the sides of their body (called dorsal scales) and still another kind on their back (vertebral scales). They also have more than a dozen unique kinds of scales on their heads alone. It's all very fascinating.

I wasn't making a snake, though; I was making a dragon. So I had to decide where to copy reptilian anatomy directly and where to take artistic license.

I started with the head, because I knew that would be the first thing people looked at. I wanted the dragon's face to have the rough, broken-up texture of pebbled leather. The only way I could think of to achieve that look was to cut a million circles out of cardboard and glue them on in close proximity to each other. So that's what I did. In no time at all, the floor of the warehouse was littered with the tiny cardboard shapes that happen when you're cutting circles out of squares. It took me several weeks just to get the face done, which did not bode well for how long the rest of the dragon would take.

Since the sides of the dragon's body had the most real estate, I decided to tackle those scales next. I started by making some sample patterns on a small piece of scrap cardboard.

I made three different scale patterns, each more complex than the last. The first was a simple pattern of diamond-shaped

scales that would be relatively easy to implement. The second was the same as the first, except there were two layers of scales this time, one offset from the other. This added a cool bit of visual intrigue, but it would double the number of pieces I needed to cut out.

Then there was the third pattern.

The third pattern mimicked the second pattern exactly, with two layers of offset scales. But it added a third layer as well, made up of smaller accent pieces that sat on top.

The third pattern was undeniably the coolest-looking one of all, but it also required three times as much work as the first pattern. And since I was already well past the one-year mark on this project, I had to decide if the extra effort was warranted.

I decided I would poll my Instagram followers to see what they thought. I posted pictures of the sample patterns and asked people to vote on their favorites.

Most people favored the third option, but plenty of people said, "I really like the third one, but I also recognize that it would be a lot more work. Honestly, any one of them would look great."

I started thinking that maybe I should just do the first pattern to get it over with. Maybe I should just finish the ship as quickly as possible, since it was already so far over time and budget.

Then I got a message from my friend Robby. He said, "Does it really matter what we think? You'll do the one that's the most complicated and takes the most time and looks the most awesome. And that's why we love you."

As soon as he said that, I knew he was right. As much as I wanted to be done with this ship, I also recognized that I may

never again get the opportunity to do something on this scale, and I didn't want to take the easy road and then spend the rest of my life wishing I'd done a better job.

I began cutting out thousands of cardboard diamonds by hand, filling trash bags with them. I remember sitting at my dining room table with a pair of scissors and a pile of cardboard, watching a movie on my laptop while I snipped away for hours and hours.

When I'd get a big batch of scales done, I would take them to the warehouse, glue them on, and then step back and think, *Man, I thought these would have gone further than that.* But I also thought, *Dang, this looks cool.*

That's the thing about making anything worthwhile. It always takes way longer than you think it's going to take. The pace of progress always feels staggeringly slow. But that seems to be the way it is for everyone. Those are the table stakes.

It's almost as if the universe is trying to get you to quit, to tap out, to take the easier path. But it's a trap. That path is easier in the moment, but it comes with the heavy price tag of long-term regret.

The hard truth is that anything worth accomplishing is going to involve struggle. It's going to involve difficulty and hardship and tedium. And it's going to require drawing upon everything that came before. But those are all the things that make memories valuable down the road. "Started from the bottom, now we're here!" is an inarguably better story than "Started at the top and now I'm still here, having my assistant bring me a fresh lemonade." And yet that's what so many of us fantasize about: a life of ease, unencumbered by the very difficulties that give life its meaning.

The poet Mary Ruefle said, "If we knew the value of suffering, we would ask for it." As much as I hate to admit it, I think she's right.

I once had a friend whose parents had lived the rags-to-riches story. When they'd first gotten married, they were so poor that they often ate popcorn for dinner at the end of each month, because by that point they'd run out of food and money. They lived in a trailer, and during a tornado they once put their infant daughter in the dryer because it was the safest place they could think of.

By the time I met them, they lived in a beautiful house on two hundred acres and their money woes were a distant memory. And yet, when they would talk about their early struggles, they would always say, "Those were some of the best times of our lives." It wasn't that they missed being poor, but rather that those early difficulties were such a contrast to their current situation that they couldn't help but be deeply grateful. Their success actually meant something because they'd gone on a long and difficult journey to earn it.

It's hard to hold onto this truth in the moment, though. When your reward is off in some distant, foggy future, it's hard to imagine how all of this could be worth it. But that's precisely why we look back: because in looking to our past, we're reminded of the times we kept going, and how glad we are that we did. And at the same time we're reminded of the times we quit, and how we still feel the sting of that regret.

In the end, the reason I went with the most complicated scale pattern was because I remembered times in the past when I'd given halfhearted efforts and lived to regret them. And while I didn't exactly love the idea of cutting out three times as many

scales and taking three times as long to put them on, I also knew that it was a small price to pay for the privilege of being proud of all of this when I looked back on it later.

In the midst of all the detail work, I was talking with my friend Branden about how long the whole thing was taking, and he asked, "Is there any part of you that would consider not detailing the back side of the ship? The side that won't be showing in any of the pictures? Seems like it would save a lot of time."

I laughed and said, "I know this is crazy, but there's just no way I could do that. It's not even a possibility in my mind."

"Come on!" he said. "Nobody is even going to see that part! Nobody would know!"

"You're right," I said. "But *I* would know."

18

VERNON

Around this time I was hired to speak at an event in Lincoln, Nebraska. Lincoln is about a six-hour drive for me, and there aren't any direct flights from where I live to there (there are hardly direct flights *anywhere* when you live in Springfield, Missouri), so I decided I would just make the road trip.

To get from southwestern Missouri to southeastern Nebraska, you start by taking Highway 13 north out of Springfield. You go through a few small towns on your way toward Kansas City, but mostly you're in the middle of nowhere, driving through cow fields for hours. Occasionally you'll pass a mom-and-pop restaurant, an antiques store, or if you're lucky, a truck stop.

A truck stop, for those who have not had the privilege, is like a gas station on steroids. It's designed to meet the needs of long-haul truck drivers, so it has fuel pumps that are set up for semitrucks, along with other accommodations, such as showers, lounges, and more.

When you grow up in the Midwest, you spend a lot of time

in truck stops. Since truck stops are what gas stations become when they've reached their final form, if you're on a long road trip and you need gas, you're going to pick a truck stop over a gas station every time. Truck stops have souvenirs (for people who want to brag about visiting highways, I guess?), arcades, restaurants, and more.

Truck stops know their clientele, so they always have a giant section of the store that's devoted to semitruck parts and paraphernalia. There are paper mileage logs, CB radio antennas, and miniature baseball bats called "tire thumpers" that are supposedly used to check tire pressure but seem more likely to be used for "friendly interrogations" by organized crime syndicates.

I love truck stops.

So when I was driving the six hours from Springfield to Lincoln and I saw a truck stop ahead, I decided to get out and stretch my legs.

I got out of my truck, walked around for a bit, and used the facilities. Then, because I wasn't in any particular hurry, I decided to peruse the merchandise. I looked at the CDs of audiobooks (apparently truckers haven't heard of Audible yet), the dozens of different energy drinks, and the impressive variety of gummy worms, bears, snakes, and other forest creatures.

Then I came to the bargain shelf.

Every truck stop has a bargain shelf. Somewhere, tucked away in the dark recesses of the store, there's a shelf full of things that the manager just can't get rid of. For one reason or another, these items have just not appealed to the truck stop's

customer base, so they've been marked down and shoved out of sight, relegated to a place of dishonor on the bargain shelf.

I love the bargain shelf, because you can find some really weird stuff there.

But on this particular trip, on this particular bargain shelf, I didn't find anything weird. Instead I found something deeply sad: a single, blank VHS tape.

I want to clarify that this is not a memory from my childhood. This is not a memory from some distant past. This happened in 2019.

Video rental stores started phasing out VHS tapes in the early 2000s, and by the time I graduated from high school in 2004, nobody I knew was using VHS tapes.

Let's allow for the fact that this story takes place in a truck stop, a place that is typically not keeping in lockstep with the advancement of technological trends (as evidenced by the paper mileage logs and audiobook CDs). Even so, my most generous guess is that this tape must've been sitting on this shelf for at least a decade, if not fifteen years or more.

I don't know if every human being has an innate tendency to anthropomorphize inanimate objects, but I know that I do. So when I saw this dust-covered tape sitting in the back of a truck stop along Highway 13, I said out loud, "How long have *you* been here, old friend?"

I took a picture of the tape and posted it to my Instagram stories along with a caption:

> Guys, this gas station has one blank VHS tape for sale. How long has this poor fella been here, just waiting for someone to buy him?

He probably watched all of his friends leave years ago,
and he kept thinking, *I'm next!*

But then he wasn't.

Then I wrote, "I can't just leave him here, you guys."

A minute later I posted a picture of the tape laying on the
checkout counter with the caption, "Today's your lucky day,
friend. You're coming with me."

Then I posted a picture of the tape buckled into the
passenger seat of my truck and wrote, "Welcome to the family."

A while later I crossed over the state line, and I pulled over
to take a picture of the VHS tape in front of the "Welcome to
Nebraska" sign. I wrote, "My new friend hasn't been out of that
gas station, let alone that state, in years. Time to change that."

I posted some more pictures of the tape as I walked around
Lincoln and got ready for the event that evening. Then during
my speech, just as a joke, I took a picture of the tape onstage
with thousands of people in the background. I posted it to
Instagram with the caption, "When he woke up this morning,
I bet he had no idea he'd end the day keynoting in front of
thousands. #Dontstopbelieving."

When I got back to my hotel room, I had dozens and dozens
of messages from people saying, "Okay, I know this is weird,
but this VHS tape story is getting me really emotional."

I decided it would be fun to keep the whole thing going, so
a few days later, when I had another trip, I took a picture of the
tape at the airport and wrote, "Early flight this morning, but it's
all good because my buddy is with me."

Immediately I got several messages saying, "Does this tape
have a name? I feel like he needs a name."

So I named him Vernon.

Whenever I would travel somewhere for a speaking engagement, I took Vernon with me. I took pictures of him buckled into a plane seat, looking out the window at a hotel, or riding on a moving sidewalk. I stopped at tourist traps and took pictures of Vernon in front of the scenic overlooks.

To be honest, the whole thing was just a fun thing to do while I was on the road. Traveling for work can be lonely and boring, and this gave me a way to break up the monotony. I didn't really intend it to be anything more than that.

But then something happened that I didn't expect.

When I would speak at events, I wouldn't mention Vernon because he had nothing to do with the subject of my talk. But if there was a Q&A afterward, someone would inevitably ask a question about him anyway. When I was taking pictures with audience members, they would ask, "Is Vernon here? Can we get him in the picture?" If I didn't post something about him for a few days, I would get messages from people asking, "Is Vernon okay?"

Somehow this inanimate VHS tape had developed a small but passionate cult following.

That summer I got onstage at a large national conference in Anaheim, where there were more than ten thousand people in the audience. I was giving an all-new talk, and for the first time I decided to talk about Vernon onstage.

I started by telling the story of finding him in the truck stop. Since this was an audience of high school students, I gave a quick background on what VHS tapes were and when they went out of style.

I talked about how when Vernon first got placed on the shelf,

he probably had high hopes. Blank VHS tapes were used for all sorts of important things back then. He probably dreamed of recording someone's wedding ceremony, or a child's first steps, or the TV broadcast version of *The Shawshank Redemption*.

I said that when Vernon was first placed on the shelf with the other blank tapes, he was probably a little disappointed to be at the back of the line, but he thought surely it wouldn't be long before he was the front tape. He watched his friends fly off the shelves, heading out into the world to seek their fortunes, and he knew his day would come soon.

But then he began to notice that it was taking longer and longer for the tapes to sell. Instead of moving up a spot each week, it began to take multiple weeks, then months. By the time it was finally his turn at the front of the line, he'd been on the shelf for a few years. He was no longer the big man on campus. His shiny new cellophane, which had been protected by the tapes in front of him, now began to gather dust.

I really leaned into this part of the story, doing my best to tug at the audience's heartstrings. And it worked. As I looked out into the crowd, I noticed people who were wiping tears away.

I'm going to repeat that, just to let it sink in: People were crying. About the imagined emotional journey of an inanimate object.

When I got to the part about rescuing Vernon, about taking him out of that truck stop and traveling across the country with him, the audience reacted like I had lifted a car off a child. They were *so* into this story.

Then I said, "Actually, guys, Vernon is here tonight. Would you like to meet him?"

Before I even finished the question, the room went nuts. As

my friend Mal ran up to the stage to hand Vernon up to me, a chant of "VER-NON! VER-NON! VER-NON! VER-NON!" began to echo through the conference center. When I held Vernon up onstage, the room exploded in applause. We took a selfie with the crowd, then I finished my speech and headed backstage.

After that talk, people waited in line for two and a half hours to get a picture with Vernon. It was ridiculous.

I've thought about this a lot since that day, about why this silly story, this story of a VHS tape that was rescued from a truck stop and went on to travel the world, would connect so strongly with an audience.

And I think I've figured it out.

As silly as this sounds (and believe me, I know it sounds silly), I think the reason why Vernon's story connects with so many people is this: deep inside, all of us are Vernon.

In our darkest moments, all of us have felt like the world has passed us by. Like we missed our chance. Like our best days are behind us, and our only future is a slow slide into oblivion. So when we hear a story like Vernon's, a part of us thinks, "Maybe there's hope for me still."

I know that sounds ridiculous, but I believe with all of my heart that it's true. And I believe that because of all of the "if only I'd done _____ " regrets people sent me.

At the heart of all of these regrets is an idea that is perfectly summed up in a lyric from "Total Eclipse of the Heart." In the first verse of that song, Bonnie Tyler sings, "Every now and then I get a little bit nervous that the best of all the years have gone by."

Don't we all, Bonnie? In our darkest moments, don't we all

get nervous that perhaps we've blown it? That perhaps we've used up our last opportunity? That we'll never get another chance like that one?

It isn't true, though. Life is full of new chances. Each day brings new opportunities. And sometimes yesterday's failure leads us down a path we wouldn't have found otherwise.

It's easy to think that you missed your chance, that you played it too safe (or not safe enough) and as a result you're stuck on a road you don't want to be on. But that isn't true.

Ten years ago I was stuck in a job that had no future. I had no prospects of any kind. I had a wife and a kid, and every month was a struggle to make ends meet. I remember feeling totally and completely hopeless. I would go home every night, lay facedown on the couch, and mumble into the cushion, "I can't go back to work tomorrow. I can't go back to that place." My wife would gently rub my back and say, "Babe . . . you *have* to go back to that place. We need food and shelter."

Then one day I saw an ad for a motivational speaker training course, and something inside me said, "You would be good at that." There were hundreds of late nights, mountains of self-doubt, and thousands of rejections along the way, but a decade later I've spoken to more than 350,000 people in 49 states.

Several years before that I was sitting on a plane coming back from a trip with some friends. I'd just ended a relationship, and I was feeling pretty disillusioned with romance. A girl I hardly knew pulled out a picture of her family, and just to make her mad I pointed at the girl I assumed was her sister and said, "Who's that? She's a babe. I'm going to marry her." Two years later, I married her.

And that whole time, Vernon was sitting on a shelf in a truck

stop on Highway 13, thinking that it was only a matter of time before he was thrown in the trash.

The point is, none of us knows what's ahead for us. None of us has any idea what opportunities lay ahead, what open doors are just around the corner.

So you messed up in the past? So you squandered every opportunity, burned every bridge? No matter. Tomorrow is a new day. Dust yourself off and sit up straight on that truck stop shelf, because you have no idea who's about to walk in the door.

19

THE DANGER OF
SEEING ONE SIDE

While I was standing onstage at that conference listening to ten thousand people chant Vernon's name, back in Missouri the hot glue in the dragon's tail was weakening. While I was flying home the next day, individual cardboard bonds began to separate one by one. And by the time I walked into the shop a day later, the entire tail section of the ship had collapsed.

I remember coming back from that conference feeling so energized, so ready to get back to work on the ship. And I remember watching the garage door go up at the shop and feeling like something was different, but I couldn't place it. Then I noticed that the dragon's tail was missing from view, and I walked back to find it crumpled against the back wall.

I was disheartened, but not particularly surprised. It was July in Missouri, and the warehouse was a metal building with no air conditioning. Temperatures inside would regularly exceed a hundred degrees. For all its strengths, hot glue is essentially

just plastic with a low melting point. Unlike other glues, it doesn't "set" permanently. When it's hot, it flows. When it cools, it hardens and bonds things together. But if it gets hot again, it flows again, and those bonds can separate. And in this particular instance, they did.

Going directly from such a high point onstage to such a low point in the warehouse felt strangely poetic, because it mirrored something I'd been noticing with the submissions.

Most of the submissions were anonymous, so I had no impression of the lives of the people that sent them in. But occasionally I would get a peek behind the curtain. Sometimes a person would write a letter accompanying their submission, giving me more background on the thing they'd written. Sometimes a teacher would collect regrets from her entire class and send them along with a note about the students. And at other times I would collect cards from an event where I was speaking, so I got to meet the people face-to-face.

I've gotten to speak at all sorts of events over the years, from business conferences to college orientations to gymnasiums full of elementary school students. I've given keynote addresses in suits, school assemblies in jeans, and outdoor leadership workshops in shorts. But during this particular season, I was getting hired to do a lot of work with high school student leadership groups.

These groups are all different (some focus on students who want to be doctors, while others focus on students who want to be farmers or teachers or business leaders), but they share a lot of similarities. For one thing, they are generally not a place for slackers. If a student has taken the time to join their local

club, pay dues, complete projects, and then qualify to attend a state or national conference, they're usually a pretty driven individual. These are the kids who are often members of the student council while also being on three different varsity sports teams and volunteering with a nonprofit on weekends.

And yet, when I would read the cards that came in at these events full of superachievers, I couldn't tell any difference from the cards that came in anonymously. These kids, who from all outward appearances had everything going for them, often felt that they were on the verge of falling apart, just like the rest of us.

I remember early on, before I had even officially announced the project, I was speaking at a camp in New England. When I drove onto the grounds, I saw a beautiful manicured forest where students had hung their brightly colored, seventy-dollar ENO hammocks from every tree. When I met the students, I saw enough Patagonia apparel to supply an REI photo shoot.

The kids were amazing, though. They were a kind and generous audience that paid attention and laughed in all the right places. At the end of my speech I told them I needed a favor from them, and I explained about the project. I told them I was going to be holding a Viking funeral for the people we used to be, and that I was going to be announcing it publicly soon, but that I needed some submissions first to give people a better idea of what this whole thing was all about. Then I talked about letting go of the past, about how the things we hold on to can weigh us down. I had the staff pass out note cards and markers, and I asked each student to write something they wanted to let go of. Then they turned the cards facedown and passed them to the front of the room.

Afterward the staff asked if I would be willing to stick around to talk to students, and of course I said yes, that I would love to. A line formed, and I stood there for an hour or so taking pictures with people and listening to their stories.

Out of the corner of my eye I noticed that one of the students kept slipping to the back of the line. As people would line up, she would say, "Oh, you can go ahead of me! No, it's no big deal, I promise. I insist!" Her friends asked if she wanted them to wait for her, and she said, "Oh, no, you guys go on ahead! I just want to talk to Kyle for a quick second." She put on a big smile, like she was just waiting in line to tell me she liked my shoes or something, but as soon as her friends were gone the smile disappeared.

Eventually the line dwindled as I worked my way through all the different conversations. Finally, I finished with the person in front of her, and the girl stepped up to talk to me. I recognized her from earlier in the day, when I'd seen her surrounded by other girls, all laughing and talking and having fun. She was very clearly one of the more popular kids at this camp.

I said hello, and she said that her name was Julie.* I asked her how she was enjoying the camp so far. She said she was having a great time and that she'd really enjoyed my talk. I said thanks.

After years of doing this kind of work, I've found that there's a certain pattern to these interactions, a sort of dance that plays out the same way every time. There's a natural flow to the

*I have changed her name here for reasons that will become apparent.

conversation, and you just sort of have to let it happen. It was very obvious that this girl had something big she wanted to talk about, but I knew that if I asked her about it right away she may very well clam up. So we just kept talking about nothing in particular. She told me about her life back home, about the activities she was involved in, about her coming senior year. I asked what her plans were after high school, about whether she was going to move away for college or try to stay close to home, about what she was thinking of majoring in, about where her friends would be going.

After a few minutes there was a pause as we reached the end of a particular conversational rabbit trail. I smiled and let the silence hang there for a second, knowing that she was probably working up the courage to say whatever she had waited in line for an hour to say.

She fidgeted a little, then reached into her back pocket and pulled out a note card. "I wanted to give you this," she said. "I forgot to turn it in earlier when we were supposed to pass the cards in." I smiled and nodded, both of us knowing full well that this was a white lie, that she'd held on to the card intentionally for some reason, perhaps out of embarrassment or fear that someone next to her would see it.

Normally when someone would hand me a card directly, I would make a point of not looking at it. I would make sure the person saw me shuffle it into the stack of other cards facedown so that they would know that their secret was safe with me, their anonymity intact.

But this girl handed me her card face up, with the text pointed toward me, like she wanted me to read it.

"This is the thing I want to let go of," she said.

I looked down at the card, which said,

my sexual
assault
experience

I let out a quiet gasp and said, "Oh, Julie . . . I am so, so sorry."

I stood there staring down at the card in my hands, not knowing what to say. When I looked up again, she was crying.

"What do I do?" she asked, her voice breaking as she wiped her tears on her sleeve.

In moments like these, I come face-to-face with the glaring realization that I am entirely in over my head, that I am unqualified to be having these types of conversations, that I do not have the foggiest idea of what the right thing is to say. But then I realize that there are no right things to say, that there are no words I could speak that would magically make this girl's pain go away.

"Julie," I said, "look at me for a second. This is not your fault. You did not deserve this, and this does not define you. No matter what the details of the situation were, and they're none of my business, it doesn't change any of those things."

I told her that she was brave for being able to stand in line for an hour with that card in her pocket. We talked about practical next steps, and I recommended talking with a counselor or a teacher or another trusted adult. I told her that as much as I wished writing something down on a card would make it go

away, it was really more of a symbolic gesture and that there was real, difficult work to be done to move on. She laughed and said she knew that but also that writing it down had been genuinely helpful for her.

Eventually she asked if she could give me a hug, and I said of course, and then she walked off toward her cabin looking a little less burdened, like she'd set down a load she'd been carrying for too long.

I've thought a lot about Julie since then, and about the others like her who are facing difficult situations while to the outside world it looks like they have everything a person could ever want. I hope they are able to find healing, that they have people in their lives with whom they can be honest and transparent. We all need people like that.

When the tail section of the ship collapsed, I decided to leave it alone for the time being and forge ahead on finishing the dragon's head. A week later I had finished all three layers of scales on one side, and I'd applied the ventral scales to the dragon's belly.

I posted a picture of the ship from the only angle that hid all of the unfinished work. If you saw that picture, you would think the dragon was basically done. It looked amazing. But the truth is that the entire illusion was so precarious that if I'd moved the camera six inches in any direction, you would have seen how imperfect and flawed the whole thing really was, how far it was from being finished.

This is the danger in comparing ourselves with others. When we look at the people around us, we see only a small sliver of their lives, and it's usually only the parts they want us to see.

But when we look at our own lives, we see the messy piles of cardboard scraps, the giant sections of unfinished work, the collapsed dragon tail crumpled against the back wall.

When we look at the regrets from our past, they seem so powerful to us because we are convinced we are the only ones who carry these things. We don't see the regrets our friends and family members carry, too. We don't see the things our rivals and role models are burdened with. We don't see how someone like Julie could possibly struggle because her life looks so perfect from this angle. But it's all an illusion.

If there's one thing this project taught me, it's that everyone around you is carrying a burden you cannot see. And in light of this, we should do two things.

First, we should be quicker to give grace, and be more generous with how we give it. We should be more understanding, more loving, less reactive. We should understand that life is hard for everyone, and we should treat people accordingly.

But second, we should understand that our own burdens, as difficult and painful as they are, do not disqualify us from the good life. When we realize that the people who have accomplished all the things we dream of accomplishing have done so while carrying heavy burdens of their own, we realize that maybe there's hope for us, too. That maybe, despite the things that happened (or didn't happen) in our past, we can still hold out hope for a brighter future.

20

COMPANY POLICY

I think part of the reason I was able to handle the dragon's tail collapsing was that I was pretty used to things going wrong by this point. When you get kicked out of two different warehouses for reasons that have nothing to do with you, when you have to start building your ship three times, when the project that was supposed to take a year ends up taking more than two, you sort of just have to accept that this is how this whole thing is going to go.

That doesn't mean it was easy, though. There were a million moments when I wanted to give up, when it felt like this thing was too hard, when I didn't feel up to the challenge anymore. To be honest, the only thing that kept me from quitting was my pride; I didn't want to admit that I'd failed.

Still, there were days when I so desperately wanted a way out. I remember one night during the summer when I was huddled in the bathroom with my wife and kids during a tornado warning, and I was watching the radar, thinking, *Please let it hit the warehouse. If a tornado takes out the ship, no one will fault me for throwing in the towel.*

You know things are bad when a tornado is your best hope.

But I had no such luck. The ship would always fall apart just enough to be a huge inconvenience but never enough to give me a legitimate reason to back out.

At first these setbacks were pretty devastating. In the early months of the project I spent entire days pacing back and forth in the warehouse, thinking, *How am I possibly going to deal with this?* while never doing anything to actually try to deal with it.

Eventually I realized that I was wasting a lot of time this way, so I made a sign and hung it in the shop. It said:

COMPANY POLICY:

PITY PARTIES ARE NOT TO EXCEED FIVE MINUTES.

AFTER THAT, GET BACK TO WORK.

—MGMT

This is the kind of thing I would never say to another person, but it was exactly what I needed to hear myself.

I'm a chronic overthinker, which means that it's easy for me to go down some pretty crazy rabbit trails thinking about what could have, should have, or would have been if only I'd done X, Y, or Z. I can waste an incredible amount of time mourning the things that didn't happen or the things that went wrong. But at the end of the day, all that does is use up valuable time that I should be spending moving forward.

I hung the sign as a reminder that while it's okay to be

bummed when things don't go your way, you've got to put some hard limits on that if you're ever going to accomplish very much in life. You've got to be able to get ahold of yourself to pull out of the downward spiral.

I used to have a boss that was great at this. If he caught someone moping around or being lazy, he would hand them a broom and say, "If you've got time to lean, you've got time to clean." Essentially he was saying, "I'm not paying you to stand around. There's work to be done."

It's interesting that we expect this from our bosses but we don't expect it from ourselves. We apply the get-back-to-work mentality to our jobs because we have to. But we don't often apply that same thinking to our LIFE'S work, which is so much more important.

The truth is that every minute spent what-iffing is a minute you will never get back. Every pity party you throw is a waste of the most precious commodity you have: time.

It's not that you don't have the right to mourn. You absolutely do. We all do. Life is incredibly difficult, and every one of us will earn the right to feel hurt, to feel cheated, to feel bitter and angry and resentful. But having the right to do something doesn't make that thing a good idea.

At the same time, I'm not advocating moving on without mourning at all. I don't think that's emotionally healthy, either. The parent who says, "Stop crying or I'll *give you* something to cry about" is just as misguided as the parent who rushes their child to the emergency room every time they skin their knee. The results of both situations are children who never learn the proper way to deal with pain and difficulty.

That's why the five-minute pity party rule has been so helpful for me. It gives me enough time to acknowledge the suckiness of the situation, to really wallow in my own self-pity for a bit. And to tell the truth, that feels good. But then the timer goes off and I say, "Okay, Kyle, break's over. Time to get back to work."

Your pity party may need to be five minutes, or it may need to be fifty. It may need to be five days or five weeks or five months. That all depends on what you're dealing with. I certainly wouldn't expect you to mourn the end of a marriage or the death of a friend in the same amount of time that I mourned the collapse of a cardboard dragon tail.

Whatever your limit is, though, hold yourself to it. It's tempting to give yourself an extension, but it's a trap.

One thing that I think we miss out on in modern society is the usefulness of rituals around mourning. In many cultures, there is a prescribed amount of time during which a person is expected to outwardly express their grief. A family sits in mourning for seven days, or a widow wears black for forty nights. But then the period ends, and life is expected to more or less move on.

Without setting boundaries for ourselves, we become like a teenage driver the first time they encounter a roundabout: we simply don't have any idea how to exit, and we keep circling over and over again.

The things that happened in the past are real, and they have real implications for the present and the future. But they're also set in stone, unchangeable without a DeLorean and a flux capacitor. As much as it sucks to admit, all the hand-wringing in the world won't undo the past. All my pacing and

wallowing wouldn't magically fix the dragon's tail. I had to do that myself.

Letting go of the past is also an acknowledgment that large parts of it were outside of your control. With so many of the regrets people sent in, I thought, *Why are you holding on to that? That couldn't possibly be your fault.* Maybe you were a child, or maybe it was an accident, or maybe there were forces at play that were simply bigger than what you could handle. That's okay. More of life than we like to admit falls into that category.

In the end, the past is like Disneyland. It's a nice place to visit, and it can certainly be fun to spend time there. But you can't live there. For one thing, it's too expensive. But for another, it's not the real world. It's designed to look like it, but the closer you look, the more you see the edges of the facade.

Eventually you have to return to your normal life. Eventually you have to go back home because you're out of clean clothes and Disneyland doesn't have a Laundromat. When you get home it can feel like a letdown at first because there are no fireworks and no parades and you can't just buy a turkey leg any time of the day or night. But after a while you realize that in a very real way it's actually better here. Disneyland is fun, but it's also a static thing that you don't get to contribute to. You can't paint the walls or refinish the floors or build your own tree house on Tom Sawyer Island. It's a take-it-or-leave-it transaction. But at home, you have agency. You have choice. You have the power to make things better.

The same thing is true of the past. It's tempting to stay there, but real living is done in the present. The real impact can only be made going forward.

So go to Disneyland for a few days if you want. Heck, you can even pick up some souvenirs while you're there, something to remind you of your time in the park. But then you've got to come back home because your real life, with all of its ups and downs, with all of its struggles and triumphs, is waiting for you, and there's work to be done.

...dentifying as a victim

I don't want to be the annoying guy I want to know when to take a step back.

I want to stop wearing a mask and be my real self. also always having to be right.

I am _not_ stupid

SECTION FIVE
IDENTITIES

Short Idiotic geek who can't get more than one friend

Fear of becoming who you are

I want to let go of the coward I used to be as well as the introvert and worry-wart I used to be

Being myself, regardless of who people expect me to be. Exceed their expectations.

I'm greedy, rude, and negative

My biggest regret is not accepting my for who I am

People Pleaser

I regret not lovin myself sooner.

I would like to lose the identity of being the "shy one."

The constant feel that I'm not g enough & the ang that comes with it.

Pretending to be someone I'm not to impress others.

I am not my father or my brother.

I am not unloved.

Am I good enough? As a mother, wife, friend. Am I smart enough to do something that really matters? Am I making an impact for good? Or just getting in my own way?

21

A DOG NAMED KYLE

My neighbors have too many dogs. I generally like dogs, but my neighbors have too many. I know what you're wondering. *How many dogs do they have?*

Two. They have two dogs.

Under normal circumstances, two dogs is not necessarily too many dogs. Growing up out in the country, my family had as many as five dogs at one time. But in the case of my neighbors, two dogs is too many, because their owners are clearly not set up to handle two dogs. The dogs incessantly bark at all hours of the day, are constantly trying to dig their way under the fence, and don't seem to bring the owners any joy at all.

But the worst thing about the dogs is this: one of them is named Kyle.

I think we can all agree that Kyle is a bad name for a dog, for reasons that are difficult to articulate.

It's fine to use human names for dogs, but there are certain unspoken rules that one must take into account. For example, if the name is fairly unusual or outdated, if it's a name that you would be surprised to see on someone's driver's license, that's

a great dog name. Franklin, Rufus, Chester, Jezebel, Archie. These are all great names for dogs, because I don't know very many humans with these names.

There are other names that are still used with some regularity for humans, but for whatever reason they're also acceptable for a dog to have: names such as Max, Annie, Charlie, or Maggie. I can't explain to you why these names are okay, but they are.

But there are some human names that just feel weird for a dog to have, and Kyle is one of them.

It's possible that I am biased, though, because my name is Kyle.

If my neighbors had a dog named Kyle that was well behaved, it would just be a funny coincidence that I laughed about with my friends. But they don't have a dog like that. They have a dog named Kyle that is an absolute terror.

He doesn't come in when they call him, he digs up their flower beds, and he runs around the yard too fast, barking at strangers. Because of these things, he is constantly getting yelled at. I'll be sitting in my backyard reading a book, and my neighbors' door will open.

"KYLE!" they'll yell. "KYLE! KYLE! GET YOUR BUTT INSIDE!"

I know they're not talking to me, but sometimes I will go inside anyway.

I once came home from work and was walking around to the back of my truck to unload some things. I opened the tailgate, and from my neighbors' backyard I heard, "KYLE! GET OUT OF THERE AND COME INSIDE!" So I closed the tailgate and went inside.

I am fully aware that these are ridiculous things for me to do, but I also can't help but do them. Whenever someone yells my name in an angry way, I immediately internalize it and feel guilty, even when I know I haven't done anything wrong.

I don't think I'm alone in this, either.

One of the most common regrets I received was "I want to stop caring so much about what other people think of me." I read some variant of that idea hundreds and hundreds of times over the course of the project. That one regret may have even been the most common submission of all, but it was certainly the most common submission in the third category: identities.

I used the word "identities" to cover anything people wanted to let go of that wasn't something they'd *done* but rather something they felt they *were*. For instance, if someone wanted to let go of the fact that they had failed at a particular thing, that would be an experience. But if someone wanted to let go of the fact that they themselves felt like a failure no matter what the circumstances were, that would be an identity.

At first glance, "caring about what other people think" sounds like an experience because it's an action that a person takes, but I placed it in the identities category because I think it goes much deeper than that. I think what most people meant was "I want to stop *changing who I am* based on what other people think."

I think this for several reasons, one of which is that some people came right out and said it. One person wrote, "I want to let go of my insecurities, including what people think of me and how I let that impact the way I see myself."* Another person

*Submission 353.

said they wanted to leave behind "the people who don't accept me for who I am."* Perhaps most succinctly, one person wrote that they wanted to stop "letting others control the way I see myself."**

I find this fascinating, because we all do it. But what I find most fascinating is the way in which we choose whose opinions are important to us.

If you think about it, "caring what other people think" is not inherently a good or a bad thing. It depends entirely on *which* people's opinions you're taking into account. And for many of us, we're only listening to people who have negative opinions of us. We are selectively editing out the overwhelmingly positive opinions of our friends, our family, our significant others . . . anyone who says we are strong or beautiful or worthy of love. We discount those opinions and instead focus on the people who say that we are weak, that we are ugly, that no one will ever love us because we are entirely unworthy of that love.

If I were to have another neighbor who had a well-behaved dog named Kyle who they lavished praise upon, would I internalize that as quickly? I don't think I would. I don't think hearing "Kyle is such a good boy! Oh, yes he is!" would make me feel that I, too, am a good boy. So why am I so quick to take on the mantle of the bad dog? I don't have a good answer for that.

At the other end of the spectrum, we all know people who *only* listen to voices that validate their decisions, and that can be just as detrimental. When any bit of criticism, no matter

*Submission 315.

**Submission 354.

how constructive, is seen as "toxic" or "shaming," it's going to be difficult to change or grow at all because you will have surrounded yourself with yes-people.

As is typically the case in life, the answer doesn't lie in the extremes but somewhere in the middle. We should not exclusively listen to the voices that criticize and condemn us, but we should also not listen only to the voices that tell us we are amazing and flawless and fierce. Ideally, the content of the message shouldn't be the determining factor at all. Rather, we should consider who is delivering the message.

There are some people for whom you will never be good enough, and there are others for whom you can do no wrong, and neither of those groups deserve for their opinions to be given a moment of your time, because their opinions will not change regardless of what you do, and that's dangerous.

If we are to grow and change and become the best versions of ourselves, we need people in our lives who meet two criteria.

First, they must want the absolute best for us, and they must believe that we are worthy and capable of achieving it.

But second, they must be unequivocally willing to call us out when we are wrong, to tell us when our actions do not match the standards we are capable of.

We do not need people who will tell us "You are worthless" even when we have done well, and we do not need people who will tell us "You are amazing" even when we've done wrong. What we need are people who will look us in the eyes in difficult moments and say, "I love you, but you are better than this," and who will walk alongside us in good times and bad, not content to let us stay where we are, but always wanting more for us. Those are the people whose voices we should heed.

It is not wise to "stop caring what other people think" if by "other people" we mean "*all* other people." It is only wise to let go of the people whose opinions are set in stone, because trying to change them will be a fool's errand.

I spent far too many years of my life worrying about what other people thought of me and my weird projects. I wasted so much time and energy thinking about the imagined opinions of other people. Eventually I realized that I did not want to be on my deathbed looking back and thinking, *I could've accomplished so much more with that time, but instead I played too small because I was worried about what people thought.*

So I made a list of requirements that a person has to meet before I will take their criticisms to heart.

First, they have to be a real person. No more imaginary critics or people I invented in my head. This was honestly a hard decision to make, because some of these imaginary voices had been with me for *years*, but it was time for us to go our separate ways.

Second, before I will listen to a person, I must be sure that they want the absolute best for me. If it's clear that someone hates my guts or would love nothing more than to watch me fail, I won't waste my time. That person may still have entirely valid criticisms of me and my work, but I don't have to listen to them.

Finally, and perhaps most importantly, no armchair quarterbacks. You don't get a seat at the table until you've tried to make something yourself. I'm really only interested in feedback from people who've been, as Teddy Roosevelt* said,

*My first favorite Roosevelt.

"in the arena," because those are the voices who know what they're talking about.

The great thing that happens when you clean house like this, when you stop giving your critics free rent in your head, is that it clears up a lot of mental room for new ideas, new pursuits, and new adventures. Instead of asking, "What will everyone think of this?" you can ask, "What amazing new thing should I create today?"

22

ONLY AN ARTIST

When I was a senior in high school, I was walking into school one day and noticed that the Maintenance Department had chopped down a fir tree that was too close to the building. They had cut it into pieces for easy removal, and the top piece, a conical section about three feet long, was lying on the ground looking like a tiny Christmas tree.

The moment I saw it, I knew exactly what I was going to do. I ran to my locker, emptied the contents into my backpack, and put the tree inside, its end tucked into a cut-off soda bottle full of water. That night I went to the store and got garland, tinsel, and battery-powered Christmas lights. I brought a star and some ornaments from home, and for the next month I had a fully decorated, live Christmas tree in my locker. Between classes I would run down the hall, open the door to my locker, and just stand there letting people see the tree as they walked to their classes. The fragrant scent of balsam fir permeated my locker for the rest of that school year.

In college I was a counselor at a summer camp, and there was a competition where each team was given a bag full of

Popsicle sticks, glue, rubber bands, and pipe cleaners, and whoever could build the strongest bridge would win a prize. I convinced my team that instead of building a bridge, it would be funnier if we built a refrigerator. We spent three days building a tiny refrigerator out of arts and crafts supplies. It had a separate freezer compartment, removable shelves, and even an adorable little egg tray that someone made by whittling minuscule divots into a piece of Popsicle stick.

When the time came to test everyone's bridges, we brought ours in under a piece of black cloth. The recreation staff pointed at our team and said, "Okay, guys, bring up your bridge!" We pulled off the cloth and in unison (we had practiced this a bunch of times) said, "BRIDGE? I thought you said FRIDGE!!" Our entire team burst into laughter as the rest of the camp looked at us like we were insane.

As an adult, I was once sitting around a campfire when someone asked everyone in the circle, "If you won the lottery, what's the craziest thing you would buy?" People talked about mansions and exotic cars and trips around the world. Then it was my turn. I answered with no hesitation.

I said, "If I won the lottery, I would buy a zebra that perfectly matched the size and shape of one of my mom's horses, and I would have it painted to look exactly like the horse. Then I would swap them in the middle of the night. Eventually the paint would begin to wear off as the 'horse' rubbed against the bars of the corral, and my mother would think she was losing her mind as she watched a horse that she's had for years and years slowly reveal itself to be a zebra in disguise."

"Hmmm," said the person who had asked the question. "I would buy a Maserati."

It took me a long time to realize that not everyone's brain works this way, that most people don't default to seeing every situation from a different angle than it's intended to be seen from. But for whatever reason, I do.

When I first bought the tandem bicycle that would later become the centaur bike, I was talking with Isaac about it at the coffee shop and said, "Well, the first idea I had was to chop the back seat off and replace it with a sculpture of a horse's butt so it looks like a centaur is riding the bike. But that idea seems super obvious, so I figure someone has to have done it already."

Isaac laughed, then squinted and tilted his head a bit as he realized that I wasn't joking. "Kyle," he said, "I think that idea is only super obvious to *you*." And he was right. I could never find anyone else who had done a tandem-to-centaur bike conversion, or even talked about the idea, so I finally did it myself.

Despite all of these obvious signs, it took a very long time for me to realize that there are only two possible explanations for all of this: either there is something wrong with the way my brain works, or I am an artist (some would say that these are, in fact, the same thing).

There are many people that resist the title of "artist" for reasons that are pretentious, self-important, or artsy-fartsy. People will say things such as, "I'm not an artist, I'm an explorer of cosmic reality," or "Artist? What a limiting term. I'm simply a willing channel for the muse."

My hesitancy had nothing to do with these things. Instead, I resisted the term "artist" because I felt like I didn't qualify, like my work wasn't good enough or serious enough or lacked some other quality that real artists had.

I saw the term "artist" as this thing that was wholly *other*, this title that I would never be able to live up to, an identity I would never be qualified to have.

Other people would try to apply the term to me, but I would duck out from under it. When I would show someone one of my cardboard sculptures, they'd say, "Oh, so you're an artist?" and I would laugh and say, "No, no, I'm just a guy who likes to make stuff," as though those are somehow different things.

My friend Andy, who is both a professional illustrator and also my unofficial backup therapist, would always push back and say, "Kyle, there is no doubt in my mind that you are an artist."

I would say, "That's really nice of you to say, but I think you're wrong."

Finally, Andy asked me to list all of the reasons why I didn't think I'm an artist. I thought about it, and I could only come up with one: I can't draw realistic people.

When I told Andy this, he laughed for what felt like ten minutes. "Kyle," he said, "I can't draw realistic people either!"

Andy has done illustrations for outlets such as the *New York Times*, *The Washington Post*, *Nickelodeon*, Facebook, and more. He's a bona fide artist who makes his full-time living drawing pictures. And yet he's right: Andy can't draw realistic people. His style is cartoony and colorful and goofy and fun. Sometimes his characters have no noses, and other times their noses are really exaggerated. When Andy draws people, they usually have the wrong number of fingers and their skin is rarely any color that a real person's skin could even be without serious nutritional deficiencies. And yet somehow it all works. He's developed a unique style that people love.

If Andy, who is undeniably an artist (and a skilled one at that), can't draw realistic people, then why was that such a deal breaker for me?

Andy told me, "I think you're getting hung up on this term because you think it's bragging. But that's not even true. You know, there is such a thing as a *bad* artist."

Andy showed me that the term "artist" isn't about how talented you are, it's about how you see the world. And once I saw that, I realized that I was, and have always been, an artist.

Identities are such tricky things because they are both very personal and very public. An identity is a truth you feel about yourself, but it's also a truth that shapes the way you interact with the world. Because of this, it can be difficult to figure out how those two planes will intersect with each other.

Most of the identity-based submissions I received had to do with this conflict. A person felt one way inside but was scared about what would happen when they fully embraced that identity on the outside.

I'm not just talking about obvious things, such as gender or sexual orientation, although those did come up. I'm also talking about things such as being a mother who also wants a career, or being a father who wants to stay at home, or being a PhD who decides to abandon the field they've put so much time into because they feel like it no longer fits who they are.

For many of these submissions the person had already accepted the identity internally but was afraid of how the rest of the world would react if they were to own it with confidence.

For me, the decision to finally call myself an artist felt like such a huge thing, but the world took almost no notice at all. A few of my friends, the ones who knew how much I'd struggled

with the term, said, "Good for you, man!" the first time I posted something online where I referred to myself as an artist. But by and large, everyone else already thought I was an artist. Either that, or they just didn't care.

* * *

The writer Austin Kleon gives the advice "Forget the noun, do the verb." His point is that we often get hung up on whether we're a writer, when we should just be focused on actually writing. We get hung up on whether we deserve the term "creative," when we should be focused on the actual creating.

When we follow that advice, the identity will eventually take care of itself. Eventually your body of work will be big enough that you'll have to admit that you are, in fact, the thing you've been so scared to call yourself.

Or at least that's what happened to me. After years of struggling with this particular noun, I found myself standing twelve feet in the air on a ladder, looking into the mouth of a sixteen-foot dragon ship, holding up two different cardboard teeth prototypes, trying to decide which one fit the dragon's head better. And at that moment a thought popped into my head:

Only an artist would be asking this question.

23

BEST COLD SANDWICH

Every year in the town where I live, a local magazine hands out awards for "Best Barbershop," "Best Spa," "Best Bakery," etc. In addition to all of the business categories, they also honor individuals for things such as "Best Local Instagram Account," "Best TV News Personality," and "Best Person to Invite to a Party."*

One year I noticed that one of the categories was "Best Cold Sandwich." That reminded me of a story I once heard about an assignment that is given in introductory college philosophy courses.

The assignment is simple: define what a sandwich is.

It seems like an easy A, because obviously all of us know what a sandwich is. But the thing is, nobody can ever do it. Every answer you come up with will either be so broad that it includes lots of things that are not sandwiches, or it will be so narrow that it excludes things that we all agree *are* sandwiches.

For instance, a common answer that students come up with

*See chapter 2, page 14.

is "a sandwich is two pieces of bread with something edible between them."

But by that line of reasoning, a loaf of bread would be a sandwich (or several sandwiches, depending on how you look at it), and that's ridiculous. And at the same time, open-faced sandwiches would be disqualified, even though they have "sandwich" right there in the name.

It's a dangerous assignment, because if you start to think about it too long you go a little bit insane. You start to realize that words don't have any inherent meaning at all outside of the meaning we give them, and even that is fuzzy.

The point of the assignment is to demonstrate the fact that language is tricky, and that even when we have a very clear idea of something in our head (for instance, what does or does not qualify as a sandwich), it can be incredibly difficult to put those thoughts into words. The only real answer to the question "What is a sandwich?" is "A sandwich is whatever we have all collectively decided a sandwich is."

With that in mind, I decided that I would attempt to be voted in as my town's Best Cold Sandwich.

To be honest, I didn't think I'd have any problems getting elected. I was traveling and speaking to big audiences every week, and after my speeches I would ask the audience to pull out their phones, go to the magazine's website, and vote for me. I figured that none of the actual sandwich shops in town stood a chance.

After I did this a few times, someone from the magazine reached out to me. "We're seeing a lot of votes come in for you under the 'Best Cold Sandwich' category, but we're confused because you don't operate a restaurant. Are these people saying

that you personally make the best cold sandwich in town?" she asked.

"No, no, no," I laughed. "They're saying that I, personally, *AM* the best cold sandwich in town."

There was a pause on the other end of the line. "I'm not sure I understand . . ." the woman said.

I explained about the college philosophy assignment, about how it's impossible to define what a sandwich is, about how a loaf of bread is not a sandwich but an open-faced sandwich is.

"Right . . ." she said.

"So really, a sandwich is just whatever we all *decide* a sandwich is," I said. "So if I can win the election for Best Cold Sandwich, imagine what that would mean for young people!"

"What exactly would that mean for young people?" she asked.

"It's hard to put into words . . ." I admitted.

In the end, the magazine refused to honor my votes, saying that they felt obligated to give the award to an actual sandwich. I said that they were spitting in the face of democracy, and then I felt bad for being mean so I sent them a tray of sandwiches as a peace offering.

The whole experience was pretty ridiculous, but it also made me realize a very important truth about identities: no matter how many people say you are a thing, there will always be someone else who says you aren't.

In retrospect, I think a huge part of my struggle with the term "artist" had to do with the reality that I'd seen so many artists spend so much of their time disparaging other artists. Even world-renowned painters can't escape the constant

critiques of "That's not art, that's just paint splattered on a canvas" or "My two-year-old could've done that." If that's what people say about Jackson Pollock, then how could I even stand a chance?

I couldn't. Not as an artist, and not as a cold sandwich, either. Even if the magazine had allowed the votes to be counted, there would still be plenty of people who would've said, "That's stupid" or "He's not a sandwich!" I know this because even when an actual sandwich won the category, some people still thought they'd picked the wrong one.

Running for Best Cold Sandwich taught me that trying to get consensus is an exercise in futility. And yet so many of us do it. We decide that we'll only truly embrace our chosen identity once everyone else around us embraces it, too. But that's not how these things work.

At about the time I was running for Best Cold Sandwich, I did a survey of a bunch of my friends, asking questions such as:

- Is a quesadilla a type of grilled cheese sandwich?

- Is a mozzarella stick a type of grilled cheese sandwich?

- Is spaghetti a type of breadstick?

- Is cereal a soup?

- Is a hot dog a sandwich?

- Is a hot dog a taco?

- Are pizza pockets ravioli?

- Are Pop-Tarts ravioli?

- If you put enough open-faced sandwiches together, does it become nachos?*

If you're thinking of doing a similar survey among your own friends, let me give you some advice: don't.

People get very uncomfortable when you start pointing out that we really don't have workable definitions for many of the words we use every day.

Most people gave up trying to defend their definitions, and essentially defaulted to "A quesadilla is/isn't a grilled cheese sandwich because I say so." But others doubled down, creating increasingly strange sets of rules that would determine a thing's sandwichness (or lack thereof).

My friend Joe, for instance, said, "A hot dog is not a sandwich because it uses tube meat."

"First of all, 'tube meat' is a disgusting term," I said. "And second of all, bologna is tube meat, and people make bologna sandwiches."

Joe said, "That's different, because with bologna the tube meat is sliced into pieces."

"So if I sliced a hot dog into pieces and laid them flat on the bun, would it be a sandwich then?" I asked.

"Yes," Joe said.

Some people said that cereal isn't a soup because it's cold, but then I reminded them that gazpacho is a soup that is cold.

Needless to say, people did not like these questions.

*For those who are wondering, the correct answer to all of these questions is yes.

Moreover, there wasn't consensus on a single one of them. The closest I got was with "Is spaghetti a type of breadstick?" Ninety-five percent of people said that it wasn't, but that still means that in a room of twenty people, one of them thinks it is. And if you ask me, they're right.

The point of all of this is that if we can't even agree on what a sandwich is, what are the odds that we're going to agree on what a meaningful life is? What are the odds that you're going to get consensus on what job you should take, or whom you should marry, or what city you should live in?

Zero percent. Especially when you're trying to get consensus on a thing that is inherently undefinable.

So many of the submissions I received were from people who just felt that they weren't *enough*. They felt this inadequacy at a visceral level, and they wanted to let it go.

At first it seems that a good way to move past this feeling would be to quantify it, to decide exactly what the qualifications are for being "enough," and then to work on meeting those qualifications. But that's a trap. It doesn't work, because even if you do end up hitting the mark, your brain will just raise the bar again. It will say, *Oh, you met the standards? Then the standards must not have been high enough.*

The whole thing is a cruel trick you're playing on yourself, a target you set because you know you can just move it later.

The way to really get past feeling like you aren't enough is the same way to get past questions about quesadillas and mozzarella sticks and the soupness of cereal. You don't try to define it or defend it, you just say, "It is this way because I say it's this way."

A quesadilla is a grilled cheese sandwich because I say it is a

grilled cheese sandwich, and I am an artist because I say I am an artist, and you are enough because you say you are enough. Others are free to disagree, but I'm not going to spend any of my time trying to defend my definitions, because they're mine, and because every moment I spend trying to achieve consensus is a moment I won't get back.

You can spend all your time trying to defend your definition of what a meaningful life is, or you can just go out and live yours. But every moment you spend on the former is a moment you don't have for the latter.

24

READING THE LABEL FROM INSIDE THE JAR

One of the things that people don't realize about cardboard art, and about art in general, is just how boring and tedious the actual creation process is. In *Beauty Is Embarrassing*, there's a scene* where Wayne White is working on one of his famous word paintings. He's applying the red underpainting, a base layer of paint that no one ever sees in the final work. He's working very slowly and methodically, taking great care to keep the brush exactly where he wants it. As he works, he says, "This is the ditch-digging part of art. A lot of art is ditch-digging. Most people want things to be easy. It's never easy."

This is always really disappointing to people. Over the years I've had a number of close friends ask if they could come watch me work, and I always say, "Sure, but you're going to be really bored." They laugh, thinking I'm showing some kind of false

*It starts at about 11:43 in the movie.

modesty. Then they come, watch me work, and are bored out of their minds.

There are a few reasons for this. One is that there's a lot of boring work involved with sculpture before you get to any of the cool stuff. On something as big as a sixteen-foot-tall dragon ship, the majority of the time was spent building the understructure and then covering it with a cardboard skin, all of which eventually got hidden by the scales and spikes and other details. But even with the detailing, it just takes a long time to make something that big. There were times I would spend an entire afternoon gluing scales onto the dragon, and at the end it would feel like I'd hardly covered any ground at all.

But the biggest reason why cardboarding is boring is that a lot of time is spent just *looking at the thing you're working on.* While building the ship I would work on a section for a bit, then step back and see how it looked from different angles, then go back and make a tiny adjustment before stepping back again. I was constantly evaluating the ship from every perspective imaginable: I would kneel to see how it would look to a child, walk across the room to see how it looked at a distance, and even climb on a ladder to see how it might look in a drone video shot.

This is all really important, because it's very easy to make something that looks fine up close when you're working on it, but as soon as you step back you realize the texture is wrong or the scale doesn't seem right or the eyes are in the wrong place.

It's unfortunate that we never get the chance to do this with ourselves in real life. We never get the chance to see ourselves the way others see us. We never get to look at ourselves from

a variety of angles in a variety of settings, to step back and observe ourselves the way we might observe a sculpture in progress. We see ourselves only from the inside, or in mirrors or photographs or videos, most of which are taken when we know we're being observed. Meanwhile, everyone else gets to see us when our guard is down, when we're watching TV or reading in a hammock or mowing the lawn.

It's a shame, too, because it means that so many of the things that are obvious to others are things that take us forever to realize about ourselves. At least that's been my experience.

For example, when I was in middle school, I asked for a paintball gun for Christmas. My mom immediately shot the idea down,* saying she had no interest in giving me a weapon as a gift. She said it was dangerous and that I was not old enough to have that kind of responsibility.

I asked my parents if they would be willing to allow me to plead my case and they agreed, and in a move that ended up foreshadowing my public speaking career a decade later, I prepared an oral presentation.

I sat my parents down in the living room and explained the basics of how a paintball gun works. I explained that while there are certain dangers involved, they are substantially less than they would be with an actual firearm. I explained that a paintball gun cannot, for instance, fire through a wall into the next room. I also explained the safety measures I was willing to take to ensure that no one would get hurt.

It was a thorough presentation, and it won my parents over. They didn't come out and *say* that I was getting a paintball gun,

*Pun fully intended.

because that would have spoiled the surprise on Christmas, but they did let me know that I'd done a good job.

My mom said, "Very well done, Kyle. You've presented a compelling case."

"Thank you," I said, probably looking a little smug.

"I do want to say something, though," she continued. "I don't think you actually want this paintball gun at all. I think what you really want is to win this argument."

"What?!" I said. "Were you not paying attention to this whole presentation? I can go over it again, but I think I made it very clear that what I want is, in fact, a paintball gun."

"If you say so," she said with a smirk. "But I do happen to be your mom, and I know you pretty well, and I've noticed that there is nothing you like more than the thrill of the chase. You like to get yourself into difficult situations just to see if you can get out of them. You like to try hard things just to see if you can do them. But once you've done them, you have no interest in the thing anymore. My prediction is that if you get this paintball gun, in two weeks it will be on a shelf in your closet, where it will gather dust indefinitely."

I was absolutely appalled, and I told my mom that she was wrong, that she didn't know me at all, and that I would be using the paintball gun every chance I got.

Christmas came, and there was a paintball gun under the tree. I used it a single-digit number of times, then forgot all about it and moved on to something new. But even then, it still took me years to realize what my mom had known all along.

I can't tell you how many times this same scenario has played out in my life. After a great deal of introspection I will come to some huge realization about myself, and when I share it with

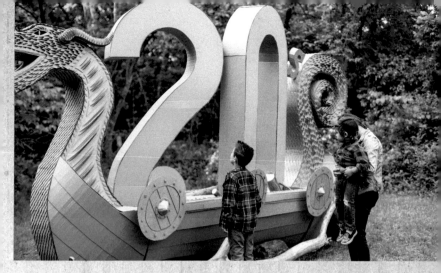

Above: The ship that started it all. When I saw this picture of Ian looking up at the first Viking ship, I thought "When I build the next one, I want *everyone* to see it from this perspective." *Right:* The two maquettes show just how much bigger the second ship was (cameo appearances from Vernon and my third favorite Roosevelt). *Below:* Inside the first warehouse. I was so excited to finally have the frame done. Little did I know that none of this would end up being in the final ship.

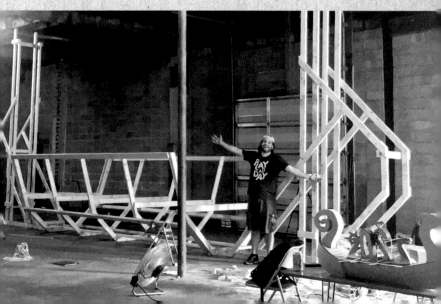

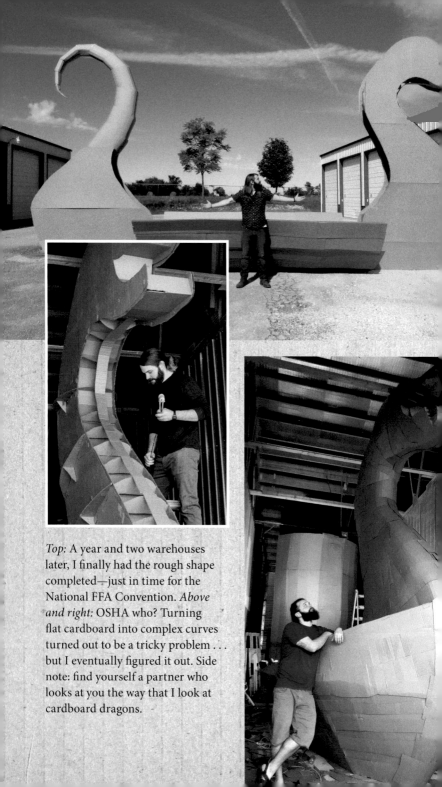

Top: A year and two warehouses later, I finally had the rough shape completed—just in time for the National FFA Convention. *Above and right:* OSHA who? Turning flat cardboard into complex curves turned out to be a tricky problem . . . but I eventually figured it out. Side note: find yourself a partner who looks at you the way that I look at cardboard dragons.

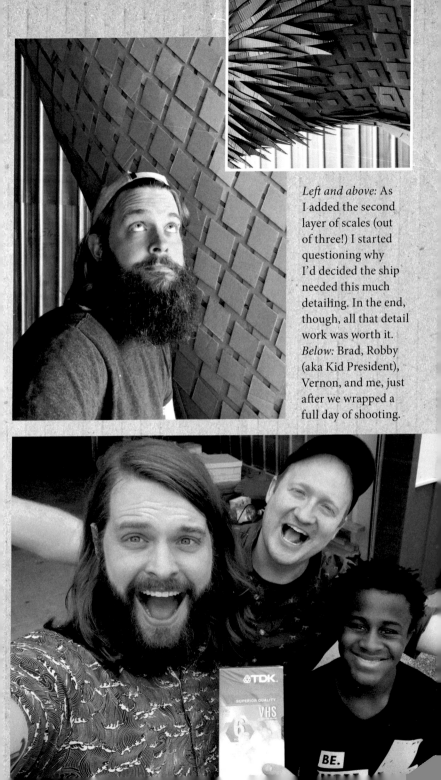

Left and above: As I added the second layer of scales (out of three!) I started questioning why I'd decided the ship needed this much detailing. In the end, though, all that detail work was worth it.
Below: Brad, Robby (aka Kid President), Vernon, and me, just after we wrapped a full day of shooting.

Above: Cardboard art requires extremely precise measurements. This particular piece was one Kyle in length. *Right*: This lettering piece, designed by Bob Ewing, was covered with handwritten submissions people had sent in. *Opposite, top*: Loading the dragon onto the trailer ranks among my all-time highest stress moments. Despite the fact that the ship hung off both sides of the trailer, we made it to the site with no problems.

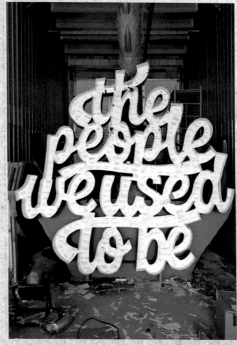

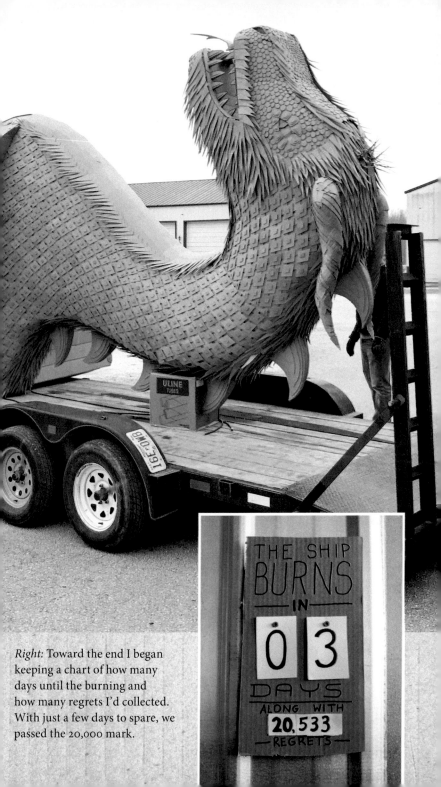

Right: Toward the end I began keeping a chart of how many days until the burning and how many regrets I'd collected. With just a few days to spare, we passed the 20,000 mark.

THE SHIP BURNS IN

0 3

DAYS

ALONG WITH

20,533

REGRETS

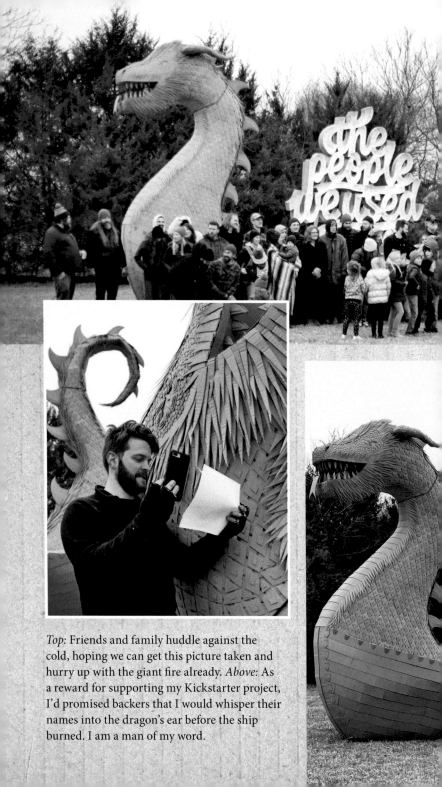

Top: Friends and family huddle against the cold, hoping we can get this picture taken and hurry up with the giant fire already. *Above:* As a reward for supporting my Kickstarter project, I'd promised backers that I would whisper their names into the dragon's ear before the ship burned. I am a man of my word.

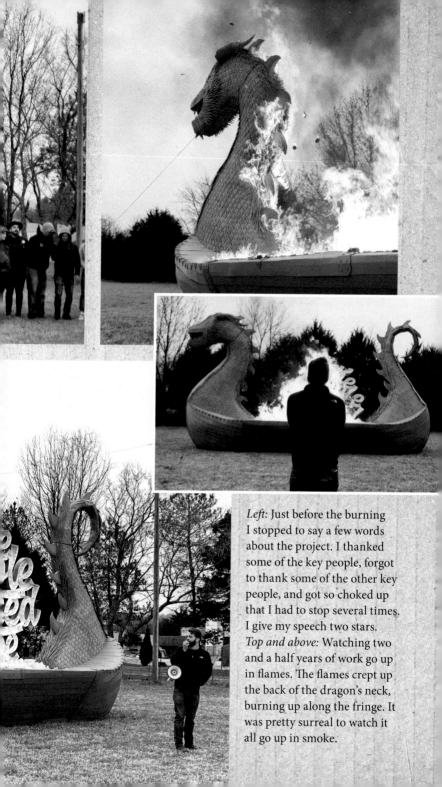

Left: Just before the burning I stopped to say a few words about the project. I thanked some of the key people, forgot to thank some of the other key people, and got so choked up that I had to stop several times. I give my speech two stars.

Top and above: Watching two and a half years of work go up in flames. The flames crept up the back of the dragon's neck, burning up along the fringe. It was pretty surreal to watch it all go up in smoke.

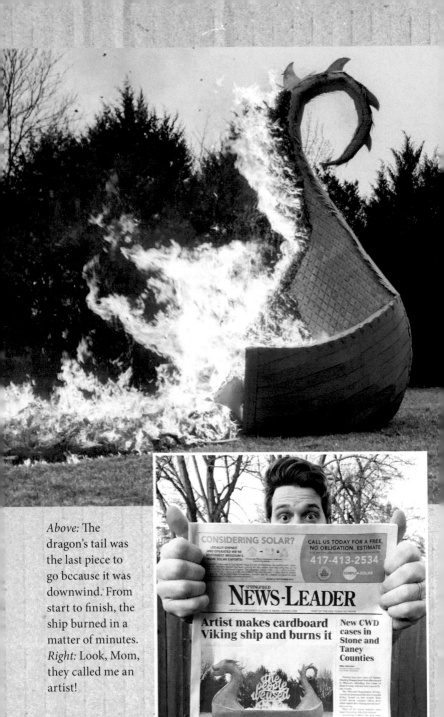

Above: The dragon's tail was the last piece to go because it was downwind. From start to finish, the ship burned in a matter of minutes. *Right:* Look, Mom, they called me an artist!

CONSIDERING SOLAR?
LOCALLY OWNED AND OPERATED. WE'RE SOUTHWEST MISSOURI'S HOME SOLAR EXPERTS!

CALL US TODAY FOR A FREE, NO OBLIGATION, ESTIMATE
417-413-2534
SIMPLY SOLAR

SPRINGFIELD
NEWS-LEADER
SATURDAY, DECEMBER 21, 2019 · NEWS-LEADER.COM · PART OF THE USA TODAY NETWORK

Artist makes cardboard Viking ship and burns it

New CWD cases in Stone and Taney Counties

'Why not do a Viking funeral for the people we used to be?'

someone close to me they'll say, "Yeah, duh. We've all known that about you for a long time."

It seems as though life is sort of like that party game where you have a name written on your forehead and you have to go around asking other people to give you clues so you can figure out who you're supposed to be. Anyone else can look at you and instantly see who you are, but you're stuck asking, "Am I tall? Have I been elected to public office? Do I have a beard?"

At the same time, there are things about us that other people never see because they take place entirely inside our own heads: our hopes and dreams, our fears and worries, our silly ideas and celebrity crushes.

So in the end, no one has all the information. There are things you know that your friends don't, and things they can see that you can't. In light of that, is it any wonder that identity is such a difficult thing to figure out? Is it any wonder that we struggle so much to really understand who we are?

I heard someone say once, "You can't read the label when you're inside the jar." I think that's true, and I think it should shape not only how we treat ourselves, but how we treat others as well.

For ourselves, we should realize that there are things about us we will never see without the help of others. We should ask for outside perspectives from people who love us, people who are not afraid to tell us the truth. We should look for the rough edges that need to be sanded off, the ways in which we hurt others without even knowing it. But we should also look for the gifts we have that we take for granted, gifts we can use to make the world a better place.

When we look at others, we should remind ourselves that the

person we're so quick to judge has an entire inner life we cannot see, a whole universe of yearnings and fears and aspirations and terrors. And that realization should give us pause, should cause us to think twice before we label someone we don't fully know. It should cause us to seek compassion over condemnation, to look for common ground rather than battleground.

Perhaps if we all did this, there would be more understanding all around. If you can show me all the things I can't see about myself, and I can do the same for you, then together we can get a much fuller picture of who we are and who we can become.

25

I'M NOT THAT PERSON ANYMORE

When I was in high school, there was a kid in my class we'll call Jason. Jason was the scariest person I had ever met. He had somehow managed to get a double dose of puberty before the rest of us had finished working our way through our first, so he had the muscles and facial hair of a forty-five-year-old bodybuilder. Every day, regardless of the weather, Jason wore a white tank top that highlighted just how much bigger his arms were than mine.

In the entire four years we spent together, I don't think I saw Jason smile once. He walked around with a perpetual scowl, and I got the feeling that if I made direct eye contact with him, he would end my life. Jason was constantly getting in trouble and spent most of his time in in-school suspension. If I saw him coming down the hallway, I made a point of getting out of the way or stepping behind someone else. One of my main goals every day was "do not be noticed by Jason."

This makes me sound like I was a very timid person in high

school, but I wasn't at all. When we voted on superlatives my senior year, I didn't win "Most Likely to Succeed" or "Best Hair." I won "Loudest." I was always getting in trouble for talking too much, and on two separate occasions was banned from making announcements over the PA system. But for some reason, Jason terrified me to the point of complete silence. In four years, I don't think I said two words to him.

Jason and I graduated and went our separate ways, and I mostly forgot about him. I went to college and then dropped out and then moved across the country and back again. I started a career and a family and went about the humdrum work of building a life. I had won the four-year game of "do not be noticed by Jason," and my prize was the peace of mind I got from not having to think about him anymore.

Ten years went by, and I received an invitation to my high school reunion. I wasn't sure if I would bother attending, since I'd mostly not kept in touch with my classmates. But my wife said that I should go, that she wanted to meet the people I went to high school with. So I RSVP'd, and then, in a twist of fate, one of my children got sick at the last minute and my wife had to stay home.

The reunion was held in the side room of a restaurant, a long, narrow space with seating in the front, a dance floor in the middle, and the buffet in the back near the restrooms.

By the time I made it through the buffet line, all of the regular-size plates were gone. I grabbed two of the smaller plates, piled them up with whatever I could grab, and began walking back toward the seating area. I was carrying a drink and two plates, so I was mostly looking down at them, trying not to drop anything as I headed down the path between the tables.

Just as I neared the end, I saw the feet of someone coming the other way. As we prepared to pass each other, I heard a voice say, "Hey, Scheele!"

I looked up, and there was Jason.

I was shocked to see him. For starters, I had always been under the impression that Jason had hated his time in high school, so I had not at all expected him to come to a class reunion. But if I'm being honest, I was mostly surprised that he wasn't in prison or dead. We hadn't voted on "Most likely to die in a shoot-out in the next ten years," but if we had, I think Jason would've won in a landslide.

"H-h-hey, Jason," I stammered.

"Listen, Scheele, I've got something I want to tell you," he said.

This is where it ends, I thought. *I'm going to die right here, having never even gotten the chance to eat these lukewarm chicken wings.*

"Um, okay, man," I said. "What is it?"

"I've been following you," he said.

"What?" I said, surprised and more than a little terrified.

"Online, I mean," he said.

"Oh," I said with a nervous laugh.

"I've been following the work you do, and I really respect it, man. I think the world needs more people spreading positivity, and I think it's really cool what you're doing. I just wanted to tell you that."

"Oh," I said again, taken aback. "I don't know what to say, man. Thanks? Yeah. Thanks. Thanks, Jason," I said.

He nodded, and we both moved along. I spent the evening catching up with people I hadn't seen in years, and then I went back home and life carried on mostly the same as it had before.

But there was one difference. That conversation with Jason, those brief few words we exchanged between folding tables, just wouldn't get out of my head. I thought about it constantly, and over time it caused me to question almost everything I knew.

Had I misread Jason in high school? Had I spent four years afraid of him for no reason? Had I been too quick to pass judgment on someone based solely on their outward appearance?

I started following Jason on social media, and what I saw was a guy who was in love with life. He posted pictures of himself with his wife, at music festivals and on float trips with friends. In every picture he wore an ear-to-ear smile.

Finally, I decided to reach out to him. I had to know: Had I misjudged him in high school, or had he really been that bad? If the latter, what had changed? How could a person go from so much anger to so much joy? I typed a long message explaining the questions I had, summoned up an extra bit of courage, and then hit Send.

A few minutes later, Jason responded.

He told me that my memory of him in high school was spot-on, that he *had* been an angry, mean, disillusioned kid. He said that he'd had an "F the world" attitude and that he'd fallen in with people who made him think it was cool to be a jerk. He admitted he'd been on a path that would have likely ended in prison, just as I'd thought. But then after high school, a chance encounter had led to him reevaluating the way he'd looked at the world. A friend had invited him to a music festival, where he met a bunch of genuinely kind people who made him realize that he didn't need to treat people the way he always had. After that, everything changed for him.

Jason said that high school was one of the biggest regrets in his life, and that he works hard now to be kind to others in the hopes that it can offset some of the pain he caused in the past.

When I think about letting go of an identity, I think about Jason. I think about the way that his life today doesn't resemble his past in the slightest. And when I think about that, it gives me hope.

Before Jason, I think I would have told you that it's possible for a person to change. But I also know that I would have had unspoken beliefs about the limits of that change, about just how much a person could actually transform. And if I'm honest, those limits would have been miles away from where Jason ended up.

Jason showed me that identities are like snakeskins: sometimes we have to shed them entirely in order to grow. We have to leave our old identity behind, allow it to shrivel away to nothing, to have room to grow into the person we're meant to be.

It's not an easy process, though. It's painful and difficult and it always takes longer than you want it to. But the alternative is worse. For a snake, they must shed their skin or else they will die. For us, the death is generally figurative, but it is still a death nonetheless: the death of our growth, the death of our hopes and dreams, the death of a better future. If we are to avoid these, we must part with the people we used to be. We must shed our identity like so many scales.

As I look back on all the submissions I received for the ship, all the identities that people wanted to see go up in smoke, it occurs to me just how powerful identity change can be. It occurs to me that five of the most powerful words in the English language are these: "I'm not that person anymore."

But their power is in direct proportion to their truth. You can't just say, "I'm not that person anymore" and expect things to be different. Like Jason, you have to actually leave the old you behind.

Saying "I'm not that person anymore" doesn't absolve you of the things you did when you were that person. It doesn't pay the debts or right the wrongs. But it does allow you to stop living as though those things define you. It does allow you a clean break, a moment in time after which you stop living inside the parameters of the person you used to be.

My hope for you is that you find a way to let go of whatever parts of your identity are holding you back. Perhaps they were things that were given to you by others, or perhaps they were things you picked up yourself. Maybe they were based in truth, and maybe they weren't. Regardless, I hope you are able to set them down. I hope you are able to leave them behind for good. I hope that you, like Jason, can say, "I used to be that person, but I'm not that person anymore."

those who
aren't helping
me grow

My toxic relationships
that hold back my gained
reputation –

letting go the people
t hurt me the most,
d people that put me
wn when I'm already
wn.

I didn't talk to my
mom and I want to
have a relationship
with her again

I'm tired of feeling so lonely and
out of place at this school. I've moved
from place to place all my life and
I'm jealous of the kids that have
had the same friends for years.
Sometimes I feel really awkward,
especially when I like someone and
I have no idea how to start a
conversation. I just want to feel
included.

I regret being nice to the people that treated me like the worst person in the world.

The people who have left my life a mess, yet I'm still holding onto.

*

my family tends to ~~forget~~ about me & I would drink/smoke to ~~forget~~ about them. I've been hurt by others & would turn to substances & anger to others. I <u>want</u> <u>real</u> friends. I want more confidence. I <u>WANT</u> TO BE ME!

Relationships that hold me back

my friendshi with my ex best friend

Feeling <u>NOT</u> good enough
Past marriage had ~~spouse~~ that was very demeaning + told me that I was ~~crazy~~ + would never be able to manage without him—
After divorce—became nurse manager—married a wonderful person + have 3 beautiful children!
Still occasionally let doubt creep into make me feel <u>NOT</u> good enough—I'm letting that <u>GO</u>!

The Anger towards My Father and Sister

Not telling her to leave him soone

26

IT ONLY TAKES ONE

When I was a kid, my school took a field trip to watch a building implode. From what I remember, it was some sort of grain silo or something, and it was owned by one of my classmate's parents. I can't think of a single valid educational reason to take a bunch of elementary school students to see something like this, so my best guess is that one of the teachers just thought it would be cool to watch something blow up.

We all piled into our chaperones' cars, drove out of town to where the building was, and parked a few hundred yards away. It was wintertime, so we stood outside shivering as we waited for the big moment.

After we'd been there for a bit, word came that there had been some sort of delay. We all climbed back into the cars to warm up, and a few minutes later someone said, "Look! Quick!"

We looked across the field just in time to see several puffs of smoke as the charges detonated around the silo. In no time at all the building collapsed in on itself, the whole thing disappearing in a giant cloud of dust and debris. In unison, everyone in the car went "Whoooooaaaa!" Someone asked,

"Did you *see* that?!" as though we weren't all in the same car watching the same thing. After a few moments, the adults looked at each other as if to say, "Well, what do we do now?" Then we all drove back to school.

I remember being astounded at how fast the whole thing had been. This building, which had presumably taken months or even years to build, was gone in the blink of an eye. Of all the time we spent on the field trip, 99 percent of it was spent driving there and back. The actual implosion took only a moment.

This memory came back to me as I read through the submissions people sent in. In particular, the fourth category of submissions: relationships.

It has always been striking to me how powerful relationships can be, how something as small as one person can make you feel that your life has meaning or that it does not.

I experienced this for the first time when I was very young. Growing up, I went to a school where I did not feel like I fit in. It was a private school, a very buttoned-up "Yes sir" and "No ma'am" sort of place, and I did not do well in that environment. I was constantly bouncing off the walls, distracting the other kids, and causing trouble. In retrospect I think it is likely that I had some sort of undiagnosed attention deficit disorder, but at the time all I knew was that I always seemed to be a problem. I got sent to the principal's office quite a bit, not for fighting or being disrespectful or anything like that, but just for being a giant distraction to everyone around me. I was constantly having teachers tell me, "Kyle, you have so much potential . . ." which even at that age I recognized was a coded way of saying, "You are a giant pain in my ass."

Teachers were always pulling me aside to say, "Kyle, I need you to focus a little more during class time." While they were saying this, I would be nodding emphatically to demonstrate that I was paying attention, but the whole time I would actually be looking out the window behind their head and wondering, *Is that a butterfly or a moth?*

Needless to say, I did not do well with the faculty at the school. But I also did not do particularly well with my fellow students. I was never bullied or anything, because most of the kids were too nice for that. Instead, I was mostly just left on the outside of it all. Kids would include me about as much as they were required to, and usually not much more than that.

At first I thought of this as a numbers problem. There were only twenty other kids in my entire class, so the odds just weren't in my favor. It seemed obvious that if I could just go to a bigger school, I would have a better chance of finding my people.

But then I started to look around at the other twenty kids, and I realized that all of them fit in just fine. Sure, there were more popular kids and less popular kids, but even the less popular kids had one or two "ride or die" friends. Even the weird kids had other weird kids, but I didn't have any of that. I started to think that maybe the problem wasn't the size of the class at all. Maybe the problem was me. I started to think that perhaps there was something fundamentally broken about me, something that had gone terribly wrong when I was in the womb. Maybe I was completely incompatible with other people entirely. Maybe I could go to the biggest school in the world and still not find a single other person who really connected with me.

It was not a big step from that thought to this one: *Maybe the world would be better off if I wasn't around anymore.*

I was in second grade the first time I thought about killing myself. In third grade I wondered, *How would an eight-year-old take his own life? How would I even pull something like that off?*

Then fourth grade came. In fourth grade, a new kid showed up. His name was Zach*.

Zach was like me. Zach was witty, Zach was sarcastic, and Zach did not always have a filter between his brain and his mouth. This meant that Zach and I got to spend a lot of time together in the hallway, where we would talk about the side-by-side houses we were going to build when we grew up, with secret tunnels connecting them underground.

Zach was my first real friend. He was the first person who ever invited me to spend the night at his house. (Prior to this, one of the other kids had told me, "My mom says you can't come over because you're dangerous.") Zach's family became like a second family to me. Zach and I were inseparable for the rest of our time at that school, and we stay in touch to this day.

In a very real way, Zach saved my life.

As soon as he showed up, all of my thoughts about suicide went away. All of my thoughts about "I don't belong here," "I'll never fit in," "The world would be better off without me" just disappeared, collapsing in on themselves like an old grain silo. This constant weight that I had carried for so long, this thing I thought I would never rid myself of, was gone in an instant.

Unfortunately, Zach wasn't the only person who showed me

*Actually, his name is still Zach. He never changed it.

the power that one person can have. I've had plenty of other experiences where the thing that a person brought crumbling down was not my loneliness or despair, but rather my sense of self-worth, my sense of belonging, or my sense of things being right in the world.

It's true that it only takes one person to make you feel like you matter, but it also only takes one person to make you feel like you don't.

That's a sobering thought, because I am one person, and if I am honest, I know that I have done both of those things. In my best moments, I have held people up to the light to show them just how incredible they are. In my worst moments, I have pushed them aside.

As I read through the things people sent in to be burned, I was struck by how many of them had to do with broken relationships. I was struck by how many of the things people wanted to let go of were things that other people had done to them or not done to them, often a very long time ago. But it makes sense that we get hung up on these things, because it is the nature of relationships to change us, and when those relationships end, we are left with those changes—even when we don't want to be.

In high school I once saw a youth pastor use an object lesson to describe the dangers of premarital intimacy. He took two pieces of construction paper and held them next to each other. He showed how they could pull apart easily, neither having lost anything. But then he glued them together. As the glue dried, he explained that sexual intimacy is like glue, that it bonds us to each other in a way that cannot be easily undone. When the

glue was dry, he asked a volunteer to pull the pieces of paper apart. Predictably, it did not go well. Bits of one color stuck to the other and vice versa, and both pieces were ruined.

I find things like this to be really harmful, because they convey the message that a person only has value insofar as they remain pure (whatever that means). To someone who has not met that standard, the message is "You are worthless now, like these ruined bits of paper."

But I also think that the message is misleading because it implies that physical intimacy is the only thing that has this effect on people, and that is not even remotely true.

The truth is that there are many ways in which we make marks on each other every day, ways in which we leave pieces of ourselves with others and take pieces of them with us. I, for one, can remember offhand comments people said to me years ago that still sting to this day. And at the same time, I can remember words of kindness from friends and strangers, words that they probably do not even remember saying to me but that carried me through some very dark times nonetheless.

This is a power that each of us has, and it's an incredible responsibility. Every day we have the opportunity to hand someone something that may weigh them down for the next eighty years of their life, or to give them something that might lift them up for the same. Every day we have the chance to demolish the granaries they've built inside, to implode their sense of self-worth or their sense of self-doubt, to demolish their confidence or their insecurity.

Reading the heartbreaking submissions people sent in made me realize that almost all of the worst things in life are caused

by other people. But my own experience has shown me that almost all of the best things are as well. I don't know what to do with that truth other than to acknowledge it, to accept that it only takes one person to make someone feel that they have a place in this world or they don't. And whether we like it or not, it just so happens that one person is exactly what each of us has to work with.

27

WITH A LITTLE HELP FROM MY FRIENDS

A few years ago I got invited to speak at an event in Idaho. The event was held at a campground in the mountains, a few hours from the nearest major city. My client told me that I shouldn't worry about getting a hotel because they would have a cabin for me to stay in, and also because there were no hotels around anyway.

I flew into Boise, then drove into the mountains, following a winding road beside a rushing river. I'd never been to Idaho before, and I was pleasantly surprised at how much less potatoey it was than I had been led to believe.

When I got to the campground I checked in with my hosts and they gave me a key to my room. I got back into my rental car and drove it up the twisting gravel road, parked in front of the cabin, then headed inside.

As far as campground cabins go, it was about what you would expect: rustic, homey, and unpretentious. It was nice.

There was only one problem: when I walked into my room, I found that the bed was simply a bare mattress. No sheets, no covers, no pillows, nothing. I poked my head into the bathroom and found a similar situation: no soap, no shampoo, no towels.

I figured there must have been a mistake. Perhaps someone who worked at the campground had forgotten to get the room set up that day. I decided I'd walk back down to the check-in station and explain the situation and we'd get it fixed in no time. But as I walked down the hill, I noticed that every person I passed was carrying a sleeping bag and pillow.

Not wanting to look like the one idiot who didn't get the memo, I hopped in my rental car and drove into the tiny little town a few miles away. There were very few stores to speak of in the first place, and since it was a Sunday, nearly all of them were closed. Finally, I pulled up to the combination grocery store/feed lot and walked inside, hoping to God that they carried sleeping bags, pillows, towels, and soap.

To my dismay, they only carried the last two.

In this situation, a reasonable person would have swallowed their pride, driven back to the campground, and admitted that they'd missed the memo about this being a BYOB (Bring Your Own Bedding) event. The staff would have probably chuckled and then gone and retrieved one of the backup sets of bedding that they surely keep for situations like this.

I, however, am not a reasonable person. That night, I slept on a bare mattress underneath a scratchy grocery store bath towel that covered perhaps 40 percent of my body at any one time. I wore every single piece of clothing I'd brought and still spent half the night shivering.

The next morning my client asked how I'd slept, and I said "Great!" I never said a word about the bedding mix-up, and the only way they'll ever find out is if they read this book.

The point of this story is that I have a problem admitting I need help.

I don't know when this started. I don't know where it came from. I don't know if this is something that is particular to me, or to millennials, or to midwestern males between the ages of twenty-eight and forty-two who have blue eyes, or what. What I do know is that I have a very hard time ever admitting that I need help. And even once I've admitted it, I have an even harder time asking for help directly.

I don't think it's a pride thing, either. Some people don't like to ask for help because they see it as a sign of weakness, a piece of incontrovertible evidence that they're not up to the task at hand. For me, though, I just don't want to be a bother. I don't want to waste another person's time on my problems when I know they have problems of their own. This is ironic because I have no issue wasting people's time with a dumb internet video or a rambling story or one of my silly projects. I actually love doing that. But when it comes to "Hey, will you help me do this thing that is really important to me?" I have a very difficult time bringing myself to ask the question.

This is problematic for a lot of reasons. For one thing, it limits me to only doing things that can be done by one person. Or worse, it puts me in danger because I try to do something solo that should only be done with help. I can't tell you the number of times I've started putting together a piece of IKEA furniture where the instructions clearly state that two people are required for the process and thought, *I'll be the judge of*

that. But probably worst of all, my refusal to ask for help keeps me from a lot of really great experiences that happen when you admit that you need another person.

As the Viking ship approached and then passed the two-year mark (on a project that was supposed to take one), the seemingly immovable object of my stubbornness met the unstoppable force of reality, and I was finally forced to admit that I could really use a hand.

I'd finished the triple-layer scales on one side of the dragon's head and neck, and I'd added the special ventral scales and a row of spikes along the dragon's belly. It was all looking great. But it was also taking an incredibly long time, and I was starting to feel the weight of that.

I still had to finish scaling the other side, then add the spikes and other details. Then I had to completely rebuild the rear of the ship, which had collapsed. Then I had to add scales and spikes to that, too.

The road ahead was looking quite long.

Finally, one day I was talking with my friend Jesse, and he mentioned that his wife was looking for some extra work. Jesse's wife is an amazing artist with a great attention to detail, and I've always admired her skill.

"This might be beneath her," I said, "but I need some help cutting out scales for the Viking ship. Would Erin be interested in something like that? It's pretty mindless work for someone with her skill set, but I'd pay her for it and she could do it while watching TV."

Jesse mentioned it to Erin that night, and she said she'd love to. The next day I dropped off a giant stack of cardboard at their house, and a few days later I picked up an enormous

garbage bag full of perfectly cut dragon scales. We repeated this exchange a number of times, and it saved me an enormous amount of work. Before, I had to constantly switch back and forth between cutting a bunch of scales and then gluing them on and then cutting a bunch more. But now I could spend the entire day just putting the scales on the dragon, and the process went so much faster.

With Erin's help I completed all of the scales on the front half of the ship and began cutting out the spikes for the dragon's back. Shortly thereafter, my friend Adam texted me out of the blue: "Hey, man, do you need any help with the ship? I can come do whatever."

For the first time maybe ever I said, "Yeah, man, that would actually be super helpful!"

When my friend Jeremy asked me the same question a few weeks later, I gave the same answer.

Adam and Jeremy each came several times, helping with everything from gluing on details to sweeping up the shop to patching up holes in the ship and everything between. They saved me a ton of time, and they also made the time in the shop a lot more enjoyable. We'd listen to the radio or quote our favorite movies or laugh about who knows what, all while working on this enormous cardboard art piece inside an RV storage unit. It was certainly much more fun than working alone.

The thing I didn't expect when I accepted people's help was that they would enjoy it, that it would be fun for them, that they would get just as much out of the transaction as I did. I'd been doing cardboard art long enough that it had become fairly mundane, but I forgot that most people have never had the chance to work on something like this. I forgot how excited I'd

been the day I got to help Wayne White. I forgot how much joy there can be in helping someone else take on their crazy idea.

Erin and Adam and Jeremy showed me that giving and receiving help does not have to be a zero-sum game, that things getting better for me (i.e., my work getting done faster) doesn't have to mean that things will get worse for you. In fact, it rarely means that at all when both parties are decent people.

The interesting thing about all of this is that it started, in a sense, with someone else asking for help. It started when Jesse told me that Erin was looking for extra work. It was almost as if that one small ask opened the door for me to make an ask of my own, to admit that I, too, needed some help. And in doing so, it turned out that our needs matched. Erin needed work, and I needed a worker. The situation was beneficial for both of us.

The whole thing made me rethink my "I don't like to ask for help" policy. For so long I'd shied away from ever admitting I needed help, all because I didn't want to burden someone else. But I never stopped to realize that in refusing to ask, I may be depriving another person of something they need as well: a person to talk to, an afternoon out of the house, a mindless task to distract them for a moment, a job to make them feel needed.

Whether we like it or not (and often we don't), we are wired for relationships. We are built to go through life together, to carry each other's burdens, to lean on each other and lend a hand. We're not supposed to do this alone.

In Wendell Berry's book *Hannah Coulter*, there's a passage that so beautifully articulates how this is all supposed to work:

> The work was freely given in exchange for work freely given. . . no bookkeeping, no accounting, no settling up. . . Every

account was paid in full by the understanding that when we were needed we would go, and when we had need the others, or enough of them, would come.

It's a beautiful picture of what relationships can be. And yet, for many of us, that's not how relationships have worked in our lives. At some point along the way, someone told us that everything in life is an economic transaction. At that point some of us started keeping ledgers in our heads and our hearts, little handwritten columns of who owes what to whom. Others, such as myself, just stopped asking for help altogether.

The good news is that these wounds can be healed. The bad news is that wounds that are created in relationships often need to be healed in relationships, too. Bad relationships cause us to see the world through a pessimistic lens, and the only cure is to immerse ourselves in good relationships. But that requires vulnerability. It requires openness. It requires asking for help.

28

THE WORST KIND
OF FAT GUY

One of the hardest lessons that I've had to learn in life is this: most of it has nothing to do with you.

When people get upset with us, mistreat us, or fail to show us kindness, our first response is often to take it personally. We automatically assume they did this to us intentionally, maliciously, when in fact the truth is often the opposite. Most of the time we were simply in the wrong place at the wrong time, caught in the crossfire of whatever else was happening in this person's life. The pain they inflicted actually had nothing to do with us at all.

I know this because it happened to me.

When I was in high school, there was a kid we'll call Ross. Ross was popular, had a girlfriend, and was good at sports, which is what I call the High School Triple Crown. But for whatever reason, sitting at the top of the social hierarchy didn't bring him enough satisfaction, so he supplemented it by being

a bully to anyone he viewed as less important than he was. This was a category I was unlucky enough to fall into.

Every time I would see Ross, he would make a point of saying something degrading to me about my looks or my clothes or my socioeconomic status. He'd put me down in front of other people, but then sometimes he'd inexplicably show me kindness, too, which made me let my guard down a little. Then he'd make fun of me again. It was a toxic relationship, but I didn't know enough to identify it as such at the time, and even if I had, I couldn't have done much to get out of it since most of our interactions were forced by class schedules and sports teams.

In one of those terrible coincidences that tend to happen in stories like this, Ross and I would often get paired during football practice to do partner stretches. Ross was the opposite of me in every sense. He was extremely fit, and I was still very much in my pudgy, awkward phase. But we were also opposites in another way: on a scale of musclebound to extremely flexible, Ross was on one end and I was on the other.

During the stretches, we were supposed to hold our arms out to the side, palms down. Our partners would then grab our wrists from behind and pull our arms back as far as they could go. When Ross did this stretch, his arms could barely go backward at all, being constrained as they were by all the aforementioned muscles. But I, lacking such muscles, could almost touch my hands behind my back. Flexibility was the one area where I had something he didn't have, and he couldn't stand it.

A normal person would laugh at this situation, or say

something like, "Oh, wow! The universe is full of such a wide variety of unique individuals! What a privilege to see two such varied specimens in one place!"

But Ross didn't say that. When it was his turn to help me stretch my arms, he would say, "Ugh. You know something, Scheele? You're the worst kind of fat guy: the flexible fat guy."

He said it with such conviction that it sounded like he had consulted a list of all the different types of fat guys sorted from best to worst, and at the very bottom of that list he'd found that of all the fat guys, the absolute worst type of all was the flexible fat guy.

I knew he was just saying it to get under my skin, that he'd just made the whole ridiculous thing up. But even though I knew this, I still couldn't shake the feeling that I *was* the worst type of fat guy.

The funny thing is, I wasn't even a fat guy. I was a little soft around the edges, but my body weight at the time was firmly in the "healthy" BMI range. And yet Ross made me feel like I was the most disgusting person he'd ever seen.

As high school went along, Ross started to leave me alone more. I'd stopped playing football and found my group of friends, and I think Ross found easier targets to pick on. But I could never shake the confusion around my relationship with him. Why had he found it necessary to be so horrible to me when I'd never done anything to him at all?

A decade or so passed, and I found myself talking with someone I'd graduated with. I hadn't been particularly close to this person during high school, but we'd developed a friendship years later. We were talking one day about the people we'd known back then, and I brought up Ross. I mentioned how he'd

always been such a jerk to me and how I didn't understand why he acted that way considering I'd never been anything but kind to him.

"Oh, I know why he's that way," my friend said, like it was the most obvious thing in the world.

"Why's that?" I asked.

"I grew up next to Ross," he said. "I used to go over to his house all the time. In all the years I was over there, I never once saw his mother show him any affection whatsoever. She never hugged him, never told him she loved him, never showed any sign that she cared about him at all. Even as a kid, I remember thinking, *This is the most coldhearted woman I have ever seen.*"

"Oh," I said. "I didn't know that."

"That's not all," he continued. "Ross's dad was a raging alcoholic. For a while he tried to make up for it by buying his kids anything they ever wanted, but eventually he spiraled out of control and lost everything."

"Wow!" I said. "I had no idea."

"Yeah," my friend said. "So that's why he's that way."

Hearing Ross's backstory, I felt sorry for him, and that was a completely novel feeling for me. Before that moment I'd mostly felt anger, resentment, and confusion toward Ross. But now I felt a new emotion: pity.

That pity led me to feel something else that was new: forgiveness. Or perhaps forgiveness is the wrong word, because it almost felt like there was nothing *to* forgive anymore, since I suddenly realized that it had never been about me in the first place. I'd simply been unlucky enough to walk across Ross's path while he was dealing with the kinds of things a teenager should never have to deal with.

Perhaps what I felt wasn't forgiveness but rather understanding. A bit of grace. And that grace allowed me to do something I'd needed to do for a decade: to let go. To let go of any resentment I had, to let go of any negativity, to let go of the need for closure.

It's interesting, because if you had asked me at the time, I don't think I would have felt like I was carrying any of those things. It wasn't as though I sat around every day thinking of all the ways in which Ross had wronged me. Truth be told, I rarely thought about him at all.

And yet, when I heard his story, when I realized the truth of the situation, it was as if a weight had been lifted off me—a weight I hadn't even known I was carrying. And in its place was the freedom to wish Ross the best, to genuinely hope that he finds healing and love.

This was my hope for the people who sent in their relationship regrets to be burned: that they would see what I had seen. That they would realize that their pain, while certainly real, may very well have had nothing to do with them at all. They simply may have been in the wrong place at the wrong time.

This doesn't take away the pain, and it doesn't lessen its gravity. But it does give it context, and often that's what a person needs most to move on. With context, we are able to place our pain where it belongs. We are able to categorize this bad thing that happened to us not as "something I deserved" or "something I must have asked for" but rather as "just one of those unfortunate things that happens in life." And once it's there, we can let it go because it has nothing more to teach us.

Well, perhaps not *nothing*. Perhaps what it has to teach us is this: that when we look at another person, we see only the

smallest fraction of their life. We see only the tiniest bit of what is actually going on. We don't see their home life, their struggles, their insecurities, their fears. We don't see the relationships that they wish would nurture them that don't, the love they so desperately need but don't receive. We see mostly what they want us to see, and very little beyond that.

When you really grasp this truth, it's transformational. It allows you to give others grace, to understand that perhaps the person who hurt you was himself hurt, that the parent who failed you was failed by their parents, too. And when you see this, it gives you the opportunity to break the chain, to say, "This had nothing to do with me, and yet it caused me pain. And in light of that, perhaps the best I can do is to stop the pain here, to keep it from getting passed down the chain to another innocent bystander."

We can't erase our pain or undo the things that people have done to us. But we can redeem the pain. We can learn from it. And we can use what we learn to build a better way forward.

29

KID PRESIDENT

Nobody ever talks about the positive side of peer pressure. We've all heard the stuff about how friends will pressure you to drink or do drugs or jump off a bridge or whatever, but nobody ever talks about how friends will pressure you to join a book club or run a marathon or volunteer at a soup kitchen. I mean sure, my friends were the ones who talked me into wearing a toga and pantyhose to a football game, but they were also the ones who talked me into writing this book and quitting my dead-end job to pursue a speaking career, so it sort of balances out in the end.

"Peer pressure" is really just a scary term for influence, and influence is not inherently a good or a bad thing. It is a powerful thing, though.

In August 2019, I got a call from my friend Brad. Brad is one of the best human beings I know. He's kind and intelligent and caring, and he's also prolifically creative.

Brad has created many things, but the one that is most relevant to this story is this: Brad created *Kid President*.

If you're not familiar, *Kid President* is a video series that Brad

created with his younger brother-in-law Robby Novak. In the early videos, Robby was an eight-year-old kid in a suit who gave viewers a motivational pep talk. The first videos were just a fun side project for Brad and Robby, a way for them to collaborate on making something. Brad never expected the project to go anywhere.

Brad and Robby made eighteen of these videos, and they didn't get very much in the way of views, but the nineteenth one somehow got the attention of the entire internet. That video, which now has more than forty-seven million views, led to more videos, which led to more views, which led to incredible things.

By the time all was said and done, Brad and Robby got to visit the Obamas in the White House, Robby got to meet Beyoncé and Tom Hanks and Nicolas Cage and Steve Carell, they published a book that hit the *New York Times* bestseller list, their videos were shown in classrooms across the country, and Robby became a minor celebrity. In the end, Brad and Robby made more than a hundred videos and racked up more than a billion views.

Then they shut the whole thing down.

There was no big scandal or anything, and there was never an official announcement that *Kid President* was finished. Rather, Brad and his family decided that they'd said what they wanted to say, they'd gotten an amazing story out of it, and now they wanted to let Robby drop the president part of *Kid President* and just be a kid.

Several years went by, and people started to write in and ask, "What ever happened to *Kid President*?" Rumors swirled

around the internet that he'd gotten sick or even died. So finally, in an effort to put the whole thing to rest, Brad and Robby decided to do a send-off series to officially put a bow on the *Kid President* project once and for all.

The idea was that they would do a series of videos updating people on where *Kid President* was now (spoiler alert: he was in high school), and then use the videos to draw attention to other people doing cool work out in the world: they visited a camp for families of cancer patients, a soccer league for refugees, and a community center in Selma, Alabama.

Then Brad called me.

"First of all, you can say no to this and I won't be upset at all. I don't want you to feel like I'm stealing your thunder or anything," he said.

"Slow down, man," I said with a laugh. "I don't even know what I would be saying no to. What are you talking about?"

"Well, I was thinking that since this whole video series is about letting go of the past and putting the *Kid President* thing behind us, the Viking ship would be a great metaphor for that. Maybe Robby and I could travel up to see the ship and do a video about it?"

Before I even heard the entire idea, I said yes. For one thing, I never turn down an opportunity to hang out with Brad. But for another thing, I knew this could be a win for both of us: Brad would get another video for the series, and I would get to introduce the project to a whole bunch of new people.

There was only one problem: the ship was nowhere near ready for prime time. When Brad first called me, the front section of the dragon had scales but no spikes. It had no

wooden planks for the hull of the ship. It had no hardware. Most of those things hadn't even been cut out yet. Oh, and the rear section of the ship was still collapsed in a pile at the back of the warehouse.

Brad said he was fine to record the ship in whatever condition it was in, and he didn't want me to do a bunch of extra work on his account. But I knew that this would probably be the biggest audience the ship would get, and I wanted to wow them.

And so, in the three weeks before the video shoot, I (along with the help of Erin and Adam and Jeremy):

- built and installed the dragon's horns

- built and installed the dragon's main spikes

- cut and glued on hundreds of smaller spikes

- cut and installed all of the "planks" that made up the hull of the ship

- added cardboard bolts and "hardware" to hold the planks together

- rebuilt the entire rear section of the ship

- cleaned up the shop so it didn't look like a cardboard recycling center

I was working around the clock to get things done, but the looming deadline kept me focused. Whenever I would get tired, I would tell myself, *Kyle, you can sleep after the* Kid President *video.*

On August 23, the crew from SoulPancake (the YouTube channel that produces the *Kid President* series) came into town. They checked out the ship, and we talked through all of the different filming needs for the next day. Then the crew went back to their hotel, and I stayed up into the night trying to make everything look perfect.

The day of the filming ended up being a bit of a disaster. We'd rented out a local high school, and we decided to turn the filming into a community event. It had taken us right up to the last minute to nail down the venue, so we'd only sent out an invite two days before. We were hoping that if we were lucky, maybe twenty or thirty people would show up. Instead, more than a hundred people came.

This was a great problem to have, but it was a problem nonetheless. We'd promised free pizza, and of course we ran out almost immediately. We ordered more, but it took a while for it to arrive, and in the meantime more people showed up. By the time we got everyone fed we were more than an hour behind schedule.

As the day went on, things got more off track. We asked everyone to fill out cards with their own submissions for the ship, and then the film crew invited anyone who wanted to share theirs on camera to do so. Since these were fairly personal things, we thought most people would prefer to keep them private, but instead almost every person wanted to share. This was great, but it meant that the whole thing took way longer than we'd anticipated. It also meant that people spent an awful lot of time sitting around: they'd sit around waiting to film their piece, then they'd spend a few brief moments filming it, then they'd sit around waiting for everyone else to film theirs.

Some people had driven hours to be at the shoot, and I felt bad keeping them waiting. The producers kept coming and giving me updates, saying, "I know this is taking forever but we're getting some really good stuff here. We should be wrapping up soon. Then we can go do the big reveal of the ship."

I kept relaying this information to the crowd waiting in the high school cafeteria, hoping they wouldn't revolt. But to my surprise, everyone was exceptionally patient. They all seemed to have the attitude of "This is important stuff. If it takes a while, it takes a while."

Eventually the last person shared their regret on camera, and we loaded everyone up and headed to the warehouse. I'd rigged up a giant curtain to block everyone's view of the ship, and we did a big reveal on camera. People oohed and ahhed, then everyone got a chance to walk up and see the ship up close. We got the final shots we needed, then said thanks to the crowd and sent everyone home. Brad, Robby, and the whole SoulPancake crew took me out for barbecue, and then the day was over. Everyone said their good-byes, and we all headed our separate ways.

A few weeks later, the video came out on YouTube. It was viewed more than 450,000 times, and it led to thousands of new submissions for the ship.

But it did something else, too. For the first time, it made me feel like the finish line was in sight.

Before the video, the entire project had felt like two steps forward, one and three-quarters steps back. But in my sprint to get things done for the shoot, it felt like I'd finally gotten some momentum going. The front section of the ship was basically finished now, and the back section was once again upright. I'd

gotten over my hang-ups about asking for help, so Erin already had most of the scales cut out for the rear of the ship, too. All I had to do now was keep the momentum going.

Brad hadn't pushed me to get to this point (he was emphatic that I didn't need to go to any extra effort on his account), but he did create the right set of circumstances for things to happen. Brad believed that my project was worth sharing with the world, and because he believed that, it motivated me to work hard to make the ship look the best that it could.

It's easy to see the downsides of peer pressure, but Brad is a perfect example of why it can be a good thing, too. It's easy to see all the ways in which people screw other people up (if you have any doubt about that, I've got thousands of submissions I could show you). But we must keep in mind the *good* that other people bring to the table as well, the ways in which they push us to be better than we knew we could be.

I always hesitated when people would say, "I want to stop caring what other people think about me." The truth is, I *want* to care what people like Brad think about me, because he often thinks more highly of me than I think of myself. And because he thinks so highly of me, I want to live up to his expectations.

I want to be the me that Brad thinks I am.

30

THE HARD THING ABOUT RELATIONSHIPS

E ven before the Viking ship project, I collected an awful lot of data about relationships, most of it anecdotal. After I would speak somewhere, people from the audience would come up and say, "I'm going through a rough time right now, and you seem like someone I could talk to."

I would ask what they were struggling with in particular, and in a great number of cases it came down to something relational: a young person dealing with an imperfect parent, a heartbroken individual with a distant spouse, or a person who wasn't sure how to help a friend who was struggling.

These were hard situations to respond to, because the person was looking for a solution to a problem that was not theirs to solve. Over and over again, I found myself saying something to the effect of, "I wish I had a magic piece of advice that would fix all of this, but unfortunately the solution is going to have to start with the other person. There are things you can do to

make that easier for them, to let them know that you're a safe haven, but ultimately the choice is still theirs."

That's the hard thing about relationships: you only have control over one side. No matter how pure your motives, no matter how much more clearly you can see the situation, no matter how much better off the other person might be if they'd just listen to you, ultimately the decision is theirs to make. And in many cases, the other person chooses not to change.

When you're on the other side of a relationship like that, it can be difficult to remember that it's not your fault, that you didn't ask for this, that this is all the fallout from another person's disaster. It can be difficult to remember that this is not how all relationships are, or how they're supposed to be.

In the house I live in, the smoke alarm is extremely sensitive. If I even mention the word "fajitas," an ear-piercing siren fills the air. We've set off the smoke alarm with candles, we've set it off from opening the oven door . . . we've even set it off when the faintest wisp of smoke from a fire pit *outside* drifted in through an open window.

As a result, our kids have developed a split-second reaction to the smoke alarm. Without even thinking about it, they'll jump into action with all the precision of a NASCAR tire change: one will open the back door and begin fanning back and forth to bring in fresh air while another will sprint to the end of the hallway and turn on the attic fan. A third will grab a newspaper and wave it back and forth beneath the shrieking smoke detector. In no time at all, the alarm will subside and my kids will go back to whatever they were doing as if nothing had happened at all.

It's funny to watch, but I also feel like I'm probably giving my kids anxiety issues about the flammability of our house. The problem is, it's not actually our house at all. It's a rental. As such, we can't go moving the smoke alarms or fiddling with their sensitivity. And I certainly don't want to disable them, either; I'll take an overactive smoke alarm over a burned-down house any day.

So many of the cards I received were from people in similar situations, but with people instead of houses. They couldn't control their father's temper or their spouse's disconnection, so they'd just built routines to deal with it. They can't stop the smoke alarm from going off in the first place, so the next best thing is to figure out how to get it to stop shrieking as quickly as possible.

I have a lot of sympathy for these people, especially when they're children who didn't have any choice in the matter. These coping mechanisms are their way of surviving.

But at some point it's good to step back and acknowledge, "This isn't how this should be."

It's also good to keep in mind that while we can't control another person's unhealthy behavior, we can choose not to replicate that same behavior in our own lives.

I was once talking to a fellow speaker about the thank-you gifts that clients give us. We were laughing about the wide range of things that event planners give speakers, swapping notes about the strangest things we'd been given (I once had a client give me the head of a small alligator, which sits on a shelf in my office to this day) and talking about the gifts we secretly can't stand.

I told him about a client I once had who gave me a crystal

statue of an eagle that was so large and heavy that it took up most of my suitcase, causing me to have to empty all of my clothes into my backpack to make the thing fit. When I brought the statue home, my wife took one look at it and said, "That is not staying in our house."

My friend laughed because he'd had similar experiences, but then he told me something I've never forgotten. "You know," he said, leaning in like he was about to tell me a valuable secret, "another speaker once gave me a great piece of advice about unwanted client gifts."

"What's that?" I asked.

"He told me that when a client gives him a gift he doesn't want, he expresses genuine thanks and tells them what a thoughtful gesture it was, and how much he appreciates the gift. Then when he drives back to the airport, he leaves it in the rental car."

"That's . . . that's genius," I stammered.

"That way the client gets the joy of giving him the gift, and he gets the joy of not having to take it home with him. Plus, from an environmental standpoint, if you're going to throw something away it's better to do it at the airport than to burn fuel flying it across the country just to throw it away at home."

I couldn't argue with his logic. As a result, I've started adopting this practice myself.*

It's strange how difficult it can be to throw away the things that other people give us, even when we do not want those things and never asked for them in the first place. And this

*If you're one of my clients, rest assured that I didn't throw away *your* gift. Yours was wonderful, and I treasure it to this day.

applies just as much to the emotional world as it does to the physical. I may struggle to get rid of a crystal eagle statue, while meanwhile you are trying to offload the unnecessary guilt your mother heaped on you for moving away.

In a healthy relationship, these problems are dealt with through open communication: one person tries to give something to the other person, and the other person simply says, "No, thank you!"

But for many of us, the number of our relationships that have that dynamic is in the low single digits. Sometimes that is the fault of the other person, and sometimes it is our own.

The questions then become: Where do we go from here? Can we fix these broken relationships, or are they doomed to be difficult forever?

I think the answer is: it depends.

Some relationships can be salvaged and some cannot. To further complicate things, some of the ones that can be salvaged do not end up being salvaged, and some that are beyond repair seem to hang on with an iron grip. This stuff is never easy.

* * *

A week after shooting the *Kid President* video, I came into the warehouse to find that the middle section of the ship had collapsed. I tried to salvage it, tried repairing the places where the hot glue had weakened after too many cycles of freezing and thawing, but it was no use. The whole section was beyond saving. Without the slightest fanfare, I began cutting it apart and carting the pieces to the trash.

When the tail section had collapsed, it had been heartbreaking. But for some reason, the collapse of the center section felt different. It was almost as if I'd known it was coming. All along I'd been aware that there were problems with the piece: it leaned to the left, the lines weren't straight, and its inner framing was built from glued-together cardboard tubes that were not made for this sort of thing. But I'd sort of pushed all of that to the back of my mind, a problem to be dealt with down the road.

Now that things had deteriorated, it was almost a relief. I no longer had to wonder if the thing would collapse, because it already had. I no longer had to live with the regret of not making the section straight, because now I could rebuild it correctly. This complete structural failure was actually a gift, a chance at a new beginning.

I have had relationships like this, too, where I knew full well that there were underlying issues that would eventually come to the surface. In the past I would try to force the discussion, but I quickly learned that people will only deal with these issues when they feel ready to do so. The best thing I can do is to be there for them when they reach that point.

I've had relationships that have collapsed under their own weight, or under the weight of my expectations (or the other person's). I've had relationships that fell apart because of unresolved arguments, or diverging worldviews, or just the natural drifting apart of people who are on different journeys.

Sometimes these relationships were able to be salvaged later and sometimes they were not. Mostly the difference had to do with whether both of us wanted to make the effort at the same time.

That's the hard thing about relationships: You only have control over one side. You cannot heal for another person. You cannot grow for another person. You cannot learn or regret or reach a realization for another person. You can only do those things for yourself.

I want to stop beliving that popularity is what divides people.

ant to let go
e girl that thinks
earance is
ything.

♡

The voices that tell me everything is worthless and there is no point in existenc

the idea
that
I am
not
enough

That I can't solve a problem because I'm only one person

Thinking that I am un dateable because of my looks compaired to societies expectations and my insceritues that society has pushed on kids

not Believing

Overcoming the idea that I have to be "Perfect"

Blaming Myself for My friend committing suicide

Letting Stereotypes speak for people instead of the people themselves

Im letting go of pas who hurt me and neg beliefs about myself that Im not enough.

I want to let go of the belief that I can save my brother from himself.

Thinking everythi other people say about is true

That I can't change the WORLD

NOT BELIEVING IN ME

31

A STAR NAMED KRISTINA

I once had a friend who paid money to name a star after his girlfriend. We were in high school, so you've got to cut the guy some slack—but not too much, because even at the time I thought it was a stupid idea.

He told me that he and his girlfriend liked to sit outside at night and look at the stars (presumably because the girl's parents preferred to stay *inside*) and that he was thinking about having a star named after her.

"What does that even mean?" I asked, laughing at the absurdity of the idea.

"You don't know about this?" he said, looking surprised. "There's an official International Star Registry, and you can pay to have them name a star after someone."

"When you say 'official,' what exactly do you mean by that?" I pressed. "Is this a recognized governing body? By what authority are they naming these stars? Do the stars know they're being named?"

My friend seemed frustrated by my line of questioning. "It's a real thing, Kyle. They send you a certificate and everything."

I told my friend that I would be happy to take his money and provide him with a certificate, and that I would even let him pick out the star. He could have Polaris, for all I cared.

In the end, he went with the "official" option, and paid something like fifty dollars to have a star named after his girlfriend. They broke up a short time later.

My friend has now been married for more than a decade, and he and his wife have a lovely little girl together. To my knowledge, he has not named a star after either of them.

Sometimes I think about the fact that there is a star named after my friend's high school girlfriend, and then I think about all of the other stars that must have been named after failed relationships, and the whole thing makes me sad. Then it makes me laugh. Then it makes me want to get into the star registry business.

I know you're wondering what this has to do with the Viking funeral, but I promise I'm going somewhere with this.

You may remember that back in chapter 10, when I first laid out the five categories of regrets, I said, ". . . from here on out I'll be telling the story through the lens of the five categories. And for reasons that will become clear later, I'll be starting with the last one and ending with the first."

Well, it's time for that reasoning to become clear.

I wanted to end on the category of beliefs for a simple but important reason: beliefs are the only category you can really do anything about.

What I mean is this: You can change your fears, but only by changing your beliefs about the things you are afraid of. You

can change your identity, but only by changing your beliefs about the person you are, or the person others think you are. You can't change your experiences (because they lie in the immutable past), but you can change your beliefs about those experiences, about how much weight they have and about how much of that weight you must carry with you into the future. And while you can change some of your relationships, there are many that you must live with due to the fact that the people involved are your family members or your coworkers or your next-door neighbors and you can't simply ignore their existence. What you can do, however, is change your beliefs around what those relationships mean to you and about what boundaries you are willing to hold with the people in question.

Beliefs are powerful things, and because of that they must be handled with extreme care. Beliefs have led men to kill other men, nations to slaughter other nations. Beliefs have led to infidelity and insensitivity and injustice, but they have also led to acts of great valor and self-sacrifice. Beliefs are what caused men and women to hold other men and women as slaves, but better, truer beliefs led other men and women to shelter those same slaves and give them aid on their journeys to freedom.

In our own lives, the problem is that we often don't actually know where a great many of our beliefs come from. Some of them we may have been born with, and others we picked up before we were self-aware enough to realize we were doing it. Others still were developed as a response to some awful thing that we experienced or saw in the world. Only a very small handful of our beliefs were actually built through a careful weighing of the facts.

Eventually we end up with a hodgepodge of beliefs, some

of which contradict each other and many of which we cannot fully express or defend in words. These beliefs are constantly bouncing off one another and the world around us, and the resulting collisions can get us into all sorts of trouble. It's only when we stop and take the time to really examine what we believe (and why we believe it) that we're able to bring some order to the chaos. But that can be incredibly difficult.

Faced with this difficulty, we're left with two choices: we can try to sort through the mess, try to untangle the knotted mass of our assumptions and conclusions and convictions; or we can shove it all back down into the box like so many strands of Christmas lights, a problem to be tackled another day. The problem with the latter approach is that beliefs, like Christmas lights, do not maintain their current level of entanglement. Rather, they follow a steady gravitational pull toward chaos. Untangling them is a constant battle; to stand still is to lose ground.

At the same time, there is good news: each belief untangled and separated from the mass makes the rest of the job easier. Each time we are able to pull a supposition out on its own, to hold it to the light and determine its truth or falsehood, we gain a little ground. One by one, we slowly release the knotted cords of our conviction until they are separate, straightened, singular.

This can be a hilariously enlightening experience.

For instance, I was recently watching the movie *Remember the Titans*. The film is based on a true story, and at the end of the movie they give you some updates on what happened to the main characters in the film. Just before the closing credits, simple white text over a black background says:

"Herman Boone coached the Titans' football team for five

more years. He is retired and is living in Alexandria. Bill Yoast assisted Herman Boone for four more years. He retired from coaching in 1990. Herman Boone and Bill Yoast became good friends, and they continue that friendship today."

As the updates continued, I began laughing uncontrollably. My wife looked at me, concerned, and said, "What are you laughing about? That was the saddest movie ending ever!"

"I'm not laughing at the ending," I said. "I'm laughing because I just realized something about myself: Any time there is white text over a black background at the end of a movie, I will automatically believe anything it says. I won't even question it. Like, if right now some text came up that said, 'No one has ever determined exactly how tall giraffes are. We have no way of measuring them,' I would immediately accept that as true."

My wife shook her head. "You are so weird."

She was right. It is weird to believe things simply because a movie presented them to you as truth. But it's just as weird to believe things because an authority figure presented them to you as truth, or because society made you feel as though you would be a fool to question the belief.

It would be foolish to believe that giraffes cannot be measured, but we believe much more foolish things every day. We believe that our worth depends on the opinions of others, that we will only deserve love when we meet some impossible standard, or that the painful things that happened to us must have been things we deserved. Some of us even believe that paying fifty dollars entitles us to name a colossal ball of incandescent gas hundreds of millions of miles away.

But none of these things is true, and when we hold these

beliefs up individually, we can see how flimsy their foundations truly are. And then, one by one, we can begin to dismantle them and replace them with better, truer beliefs, beliefs that actually serve us and empower us to do good in the world.

In the end, though, it's not actually all that important whether a belief is true. What's important is whether it is the sort of belief that enables one to live a life that is true, a life that is virtuous.

In the movie *Secondhand Lions*, Robert Duvall's character gives a speech called "What Every Boy Needs to Know About Becoming a Man." In that speech, Duvall says:

> Just because something isn't true, there's no reason you can't believe in it. . . . Sometimes the things that may or may not be true are the things a man needs to believe in the most.

He gives a few examples, like the idea that people are basically good, or that good always triumphs over evil, or that true love never dies. Duvall's character says that whether those things are true or not, a man should believe in them anyway, because those are the kinds of things worth believing in.

In light of that, perhaps it was not so foolish of my friend to believe that he should name a star after his girlfriend. Whether or not the name had any validity (it didn't), the gesture did, because it came from a genuine place.

That doesn't mean I'm going to stop making fun of him for it, though. After all, who ever heard of a star named Kristina?

32

THESE THINGS HAVE
A WAY OF WORKING
THEMSELVES OUT

Despite the collapse of the ship's middle section, the momentum I'd felt after the *Kid President* shoot carried on. With the head and tail now both upright at the same time, I no longer had to visualize what the ship would look like in my head—I could just look at it.

The front section of the ship was essentially done, so I shifted my focus to the tail. It turned out that the collapse of the middle had been something of a blessing in disguise, because it freed room in the warehouse for me to lay the tail down horizontally as I applied the scales and spikes. This made the detailing much faster, since I could reach everything from the ground instead of crawling up and down ladders and scaffolding.

I was moving quickly now. I began on one side of the tail, applying the first layer of scales, then the second and third before moving to the other side and beginning the detailing

there. Before I knew it, I found myself gluing the last scales onto the dragon's tail. I looked around at the ship and realized that I was in the homestretch now. For two years I had felt like Sisyphus, forever cursed to roll the boulder of progress up a long, steep hill, only to have it go speeding back down to the bottom again. I'd faced setback after setback, from leaky roofs to multiple warehouse evictions to stolen supplies to having two out of the ship's three sections collapse at various points. But against all odds, it finally felt as though I'd crested the hill.

This was a great feeling, but it also meant that I had to start addressing all the things I'd put off for the past two years.

Throughout the project, things had come up that I simply didn't have the time or energy to focus on solving. Sometimes they were things I couldn't solve in the moment, so I put off addressing them until later. Other times they were things I wasn't sure how to even begin solving, so I pushed them down the road for Future Kyle to deal with. Some of these were pretty substantial issues, but I held on to this ridiculous belief that this project was supposed to happen and that eventually these things would work themselves out.

As the project neared completion, though, "eventually" was coming up pretty fast. With that in mind, I dusted off the list of problems I'd procrastinated on and got to work solving them.

The first thing I had to figure out was what to do with the submissions.

When I'd first thought up the idea for the project, I'd envisioned using the submissions themselves as the scales on the dragon. I'd prototyped this and it seemed workable, but over time I'd begun to see several problems with this approach. For one, the dragon's twisting and tapering body meant that the

scales would not all be the same size or shape. This would mean that I'd have to trim each card to fit its particular spot, and to do this without cutting off the text on the cards, I would have to search through the thousands and thousands of cards to find one whose arrangement of text fit the shape I was aiming for. I would then have to repeat this process approximately ten thousand times. By my rough calculation, this would take me until the heat death of the universe.

Another problem was that not all the note cards were the same color. I'd asked everyone to use four-by-six unlined white note cards, since these are cheap and universally available. But as they came in, I found that there is a lot of variation in what note card manufacturers consider "white." Some cards were pure white, some were off-white, some were slightly glossy . . . I realized that if I used the cards to scale the dragon, the many variations in tone would make the dragon appear as though it had some sort of skin condition.

There was also a problem with the symbolism of using the cards as scales. The cards were representing the things people wanted to let go of. In other words, they were the things we were having the Viking funeral *for*. To build the ship out of the cards would be like building a Viking ship out of a dead Viking. As a metaphor, it didn't make any sense.

Last but not least, I simply had too many submissions. Based on my original calculations, I needed somewhere in the neighborhood of ten thousand cards to cover the ship. I had now received more than eighteen thousand submissions.

The decision to switch to cardboard scales had come fairly early in the project, and I'd simply told myself that I would figure out some other meaningful use for the cards later. But as

the finish line neared, I realized I was running out of "later" to work with.

Luckily, the solution to this problem turned out to be the solution to another problem as well.

With the first Viking ship, I'd been having a funeral for my twenties. To illustrate this, I'd simply built some giant letters and numbers that said "my twenties" and placed them in the center of the ship. But with this new ship, it was not so easy. What would go in the center of the ship this time? Just a big pile of note cards?

I'd toyed with the idea of building different pieces of text to sum up the submissions I'd received. I'd thought about building things to represent the five categories, or to represent common submissions, or to represent particularly heartbreaking ones. But each of these solutions felt too clunky, too imprecise and inelegant.

In an effort to try and think of some new idea, I went back and watched the original announcement video I'd made for the project. In that video, I'd said, "If you truly want to become the person you're meant to be, you have to let go of the person you used to be." As soon as I heard that line in the video, I knew exactly what I would put in the middle of the ship.

I reached out to my friend Bob Ewing, who is an amazing lettering artist.

"Bob, I need your help," I said.

"Sure thing, dude. What's up?"

"I need you to design me some text. It needs to all be interconnected, because I'm going to build it ten feet tall, and it needs to be structurally sound," I explained.

"Okay, I'm intrigued. What does it need to say?" Bob asked.

"It needs to say, 'The People We Used to Be.'"

Bob got to work and began sending me sketches of ideas. We went through a few different configurations, but none of them was quite what I was looking for. Then he sent over a new sketch: a beautiful hand-drawn script, with swooping accents that connected the whole thing into one gorgeous block of text.

I took one look and wrote back, "This is perfect."

Once I had Bob's text design, I reached out to Robert McMahon, whose company had helped supply me with massive sheets of cardboard. The last time I'd picked something up from him, I'd noticed a giant plotting machine in the back of his shop. Robert used it to cut precise box prototypes out, but I had another use in mind.

"Robert, I need to call in a favor," I said.

"Sure, man. What do you need?"

"I need you to use your big robot machine to cut out a lettering piece for me," I said.

"Done," he said. "Send over the file."

The text was so big that it took up multiple sheets of cardboard. I knew that if I cut it out by hand, it would take days, and I'd probably still mess it up. Robert's machine had the whole thing done in minutes.

I brought the pieces back to the warehouse and began assembling them. The plan was to build them into a three-dimensional piece of text, then cover it with the submissions people had sent in. From a distance, it would look like a white block of words, but up close you would be able to see the individual handwritten things that people wanted to let go of. The rest of the submissions would spill out around the text, filling the middle of the ship.

One by one, the problems I'd put off were getting solved. But there was one final problem looming, and it was a big one: where to burn this thing.

With the first Viking ship, I'd burned it in a small field on my parents' property, but the second ship was far too big for that. I'd risk burning down the whole forest.

I'd scouted out a few possible locations, but most of them were too far from the warehouse or didn't have enough parking or were inside the city limits, where I was unlikely to get permission to burn something so big. Still, I held on to this unshakable belief that everything would work itself out.

As the ship neared completion, people began asking me, "So where are you going to burn this thing?"

Every time I would say, "I'm not sure yet! I'm still figuring that out."

And every time, a look of pure shock would ripple across their faces. "You . . . you haven't figured out where you're going to burn the ship yet?"

"Nope! But I'm not worried about it. These things have a way of working themselves out."

Now that I'd finished the front and back of the ship and begun building the lettering for the center section, though, my confidence started to waver. What if I couldn't actually find a suitable location? What if I couldn't get a permit? What if I ended up stuck with a completed Viking ship and nowhere to burn it?

I reached out to a church that owned a large, empty field near the warehouse. They shot me down. I talked to a family friend who had property nearby, but she told me they'd just torn up their field to fix some drainage issues and it wasn't ready for

people to park on yet. I called a nearby business that had a large field, but when I explained the idea, they just laughed at me and hung up.

Finally, I decided to post something on social media.

"I'm in the final days of the Viking ship, and now I need to figure out where to burn this thing.

"So I'm putting this out there: Does anyone have a flat, empty field that they wouldn't mind me burning a thirty-foot-long Viking ship in?"

Within fifteen minutes, my friend Kinsey reached out. She said she and her husband, Chris, had a big field behind their house that I was welcome to use. I pulled it up on a map and saw that it was a five-minute-drive from the warehouse. I swung by to take a look and decided it was perfect.

I texted Kinsey and Chris, and we settled on a date with the video crew who would be filming the burn. All of a sudden this nebulous, seemingly never-ending project had an actual deadline. My ridiculous belief that everything would come together had turned out to be true. Now all I had to do was bring this thing in for a landing.

33

I DON'T KNOW
WHAT TO BELIEVE
ANYMORE

My ridiculous belief that things with the ship would work themselves out (and the fact that this turned out to be true) was something of an anomaly for me. I'm not usually one to believe in things without evidence. In fact, the entire concept of belief is something I really struggle with.

If I'm being completely honest, life has often felt to me like a slow, terrifying loss of belief, like carrying a bucket that is losing water and not being able to plug enough of the holes to stop it.

Growing up, you are told that the world works a certain way—that cheaters never prosper, that doing the right thing will always be rewarded, that the people in leadership over you are good and noble and have your best interests at heart.

Then one by one, every one of those things turns out not to

be true, or at least not always true, or even most of the time. Over and over again, the things that were supposed to be immovable show that they are, in fact, quite movable. Some of them are on wheels.

In light of this, you never want to lean on anything too much for fear that it might not be as sturdy as you thought it was, that it might slide out from under you just as you put your full weight on it, just as everyone is looking right at you.

The comedian Marc Maron says, "If you actually made a column of things you're pretty sure you know for sure, and then made another column of how you know those things, most of that column is like, 'Some guy told me.'"

He's right, too. If you think about the number of things you know by direct experience, it's shockingly small. Most of our knowledge comes secondhand, acquired from other people who picked it up from other people before them. That works fine until the point where you realize that some people are liars, and some people are dumb, and some people are both. Or until you play a game of Telephone and learn firsthand just how much a message can change as it's passed from person to person.

Then you have to factor in the people who are manipulative, or the people who have themselves been manipulated without knowing it, and suddenly the circle of people you should listen to has grown rather small, and the number of things you really know for sure may very well be in the single digits.

Here's a silly example: as a child, I was told that oxygenated blood is red but that deoxygenated blood is blue. There were diagrams in my science textbooks showing the circulatory system in a neat red and blue duotone, and my teachers taught

it to me as fact. A few decades later I was told that this isn't true, that *all* blood is red (although oxygenated blood is a brighter red) and that deoxygenated blood simply looks blue in your veins because of the way that light behaves when it travels through your skin. Now whenever someone says that deoxygenated blood is blue, I make sure to tell them, "*Au contraire!* That's actually a common misconception."

But the funny thing is, I don't really know one way or the other. One person told me one thing, then another person told me the first person was full of it. Both times I just accepted the new information without any sort of verification process whatsoever. Deoxygenated blood could be yellow, for all I know. It's not like I have the time to look into it.

This is how most of life is. Someone tells you that Pluto is a planet, and then later someone tells you it isn't anymore, and then someone tells you that it is again. And for some reason, you're expected to have an opinion on the whole thing, to know what category this distant space rock falls into.

It's all pretty ridiculous.

The problem is that the people telling us these conflicting bits of knowledge (most of which have no real bearing on our daily lives) are the same ones telling us how we should navigate school and work and relationships and the deeper things of life. And if they're wrong about Pluto and the color of deoxygenated blood, how can we trust them on the rest of it?

The way I see it, there are two responses to this situation.

The first is to throw your hands up and say, "I don't know *what* to believe anymore." This is appealing because it's safe. If you don't ever go on the record as believing in something, you

don't run the risk of looking like a fool when that thing is later proven untrue.

This is dangerous territory, though, because it's a pretty slippery slope from "I don't know what is true" to "Maybe there's no such thing as truth," and from there it's a short skip to "Nothing means anything," and it's pretty hard to pull yourself out of *that* nihilistic spiral.

The second option is just to choose to believe things based on whether other people believe them. If it's in vogue today to believe that eggs are bad for you, then so be it. If tomorrow we decide that some cholesterol is good and some is bad, then great!

This is appealing because it means you get to be part of a community. Whether we like it or not, communities are generally built around shared beliefs, and when a person decides they no longer share some or all of those beliefs, it is not uncommon for them to be sent packing. Faced with this, many people choose to just toe the party line, deciding that the benefits of keeping their relationships intact outweigh the existential costs of struggling with doubt.

In the end, though, neither of these choices is fully satisfying.

Perhaps there is another option. Perhaps it is best to say, "I know that it is not possible for me to fully know whether all of my beliefs are true. But I also know that I'll never get much done if I don't believe *something*, so I'm going to choose to believe some things not because they are necessarily true, or because other people happen to believe them, but rather because they are the kinds of things I *hope* to be true. So I'm going to believe them, even if I turn out to be wrong."

This is hard, at least for me. Most of the reason why I struggle with this stuff is because I don't want to be wrong. And the reason I don't want to be wrong is that I don't want to look like an idiot in front of other people.

But in the end, I have to accept that I'm *going* to be wrong about some things, and that some people will think I'm an idiot no matter what I believe. In light of that, I have to decide which *way* I want to be wrong. In other words, if I'm going to err, which side should I err on?

Do I want to be wrong because I was too generous or because I was too stingy? Do I want to be wrong because I trusted too much or too little?

It may actually be that looking at the beliefs themselves is the wrong approach. Perhaps instead we should look at the consequences of the beliefs. We should ask ourselves, "If I believe this, THEN what? What will be the natural outcomes of that belief?"

Will this lead me to loving people more?

Will this lead me to loving people better?

Will this lead to the world being a better, more welcoming place?

Perhaps real truth isn't about how well a statement conforms to the facts but rather about how it conforms to our hopes of what the world can be. Perhaps we should be less worried about being objectively right and more worried about the kind of people we are becoming through the process of believing, about the kind of world we are building.

Seen in that light, my belief that the ship's problems would work themselves out was not so silly after all. In the end, it did turn out to be true, but most likely that was because it

was the kind of belief that creates its own truth. It was less an objective statement of fact and more a self-fulfilling prophecy. By believing that things would work out, I was able to avoid despair. By avoiding despair, I kept myself from giving up. And by not giving up, I kept going long enough to create time for the problems to be worked out.

Or at least that's what I'm choosing to believe.

34

I DIDN'T HAVE
THE HEART

Now that we'd set a date for the ship to be burned, I began making a final list of everything that needed to be done. Things such as:

- [] finish detailing back of ship
 - [] add hardware
 - [] bolts
 - [] plates
 - [] fix damaged areas of scales/spikes
- [] repair front of ship
 - [] fix warped plank section
 - [] patch areas with missing scales
 - [] reinforce understructure to fix lean

- ☐ rebuild middle section
 - ☐ frame
 - ☐ skin
 - ☐ detail
 - ☐ planks
- ☐ finish lettering piece
 - ☐ build structural framework
 - ☐ cover inside with cards

I wrote these to-dos on scrap pieces of cardboard, crossing them off as I finished each one. But there was one big task that needed to be done away from the warehouse: cataloging the submissions.

At this point I'd received more than 18,000 submissions from all over the world. The online ones automatically organized themselves into a tidy spreadsheet, but for the handwritten submissions I was scanning in each one as they came in, creating an archive of regrets that I could study later. I'd gotten the scanning process pretty streamlined, but it still took time to feed each card into the scanner, and time was the one thing I was running out of.

I knew I'd have to close the submissions window at some point, so I decided on December 7, exactly one week before the ship burned. I began posting updates on social media, letting people know how many days they had left to submit and how many submissions I'd received so far.

When I first launched the project, I'd been aiming for 10,000 regrets. I'd long since passed that mark, but submissions had slowed recently as I'd spent more time building the ship and less time talking about it. At the pace things were going, it looked like I would probably end up at about 19,000 submissions.

Some people had other ideas, though. One day I shared that the total was up to 18,637 submissions. A past client commented and said, "What do you think . . . 20,000? That's a nice even number."

I laughed and told her that while 20,000 would be amazing, based on the pace we were at, we'd probably land at just over 19,000.

She scoffed and said, "Aw, c'mon . . . go for the big number!"

It was a simple offhand remark, but something about the nonchalance with which she said it made me think, "Yeah, Kyle. Go for the big number!" If she could so easily believe in my ability to get to 20,000, it seemed silly that I couldn't believe it, too.

That comment lit a fire under me, and I redoubled my efforts to gather submissions. Before, I'd been hesitant to publicly say "Let's get to 20,000!" because I knew that if I didn't hit that mark, I'd end the entire project on a disappointing note. But with this one person egging me on, I decided to go all out.

I began posting updated totals every day, asking my followers to help me spread the word. I posted the link to the online submissions portal, posted the mailing address for physical submissions, and posted pictures of particularly meaningful cards that had been sent in. Slowly but surely, the number began ticking upward.

18,637

18,786

19,205

As we got closer (to both the deadline and the goal), more people jumped in. Friends began sharing my posts and encouraging their followers to submit regrets. Teachers began having their classes submit regrets together. Past clients began emailing their entire databases on my behalf. Suddenly this was a group effort.

The numbers continued to climb.

19,455

19,710

19,908

Then we did it. Just before the submissions window closed, the total jumped to 20,107 regrets. Then it jumped again, to 20,452.

Before I shared the total online, I messaged my old client.

"Pssst. I've got a secret," I said. "We got to 20k."

She was thrilled and congratulated me on reaching my goal.

"Thanks for the nudge!" I said. "Couldn't have done it without you."

* * *

It's amazing what a person will believe simply because another person says it's true.

My wife's sister Beth is allergic to mold, and after a series of bad reactions (her lips swelled up like she'd gotten back-alley Botox), her doctor prescribed her an EpiPen.

An EpiPen is a device that uses an autoinjector to deliver synthetic adrenaline into a patient's bloodstream. In the event of a severe allergic reaction, the user slams the EpiPen into the side of their leg. This triggers a spring-loaded hypodermic needle, which fires into the person's thigh and injects the life-saving drug.

EpiPens are tricky, though. Most people who are prescribed them have never used one, and if you've never used something it is difficult for you to become proficient with it. This is a problem when the thing you're using can be the difference between life and death.

Because of this, doctors will often give their patients a practice EpiPen. It looks and feels just like the real thing, but it lacks the needle (and, of course, the drug). Instead, it has a plastic piece that will click when you've hit it against your leg with enough force. If you don't hear a click, you didn't hit it hard enough. The thinking is that it's much easier to learn this lesson when practicing in the safety of your home than, say, when you're being attacked by a swarm of bees and have only moments before your throat swells shut.

One day my wife and I were having lunch with her family, and I found Beth's practice EpiPen. Naturally, I started playing with it. A few minutes later, her younger brother walked by and asked me what I was holding.

"Oh, it's Beth's EpiPen," I said.

"What's an EpiPen?" he asked.

"It's for her mold allergy. If she starts having a reaction, she'll hit this thing against her leg and it will shoot a needle full of synthetic adrenaline into her thigh."

"No way . . ." he said. "That sounds awesome!"

"Yeah, but it's super dangerous, too. If you inject this thing and you don't need it, it could do all sorts of bad stuff to your body. It could even kill you," I said.

"Oh," he said, looking a little concerned.

That gave me an admittedly terrible idea.

"Like *this*," I said. Then I leaned over and slammed the practice EpiPen into my brother-in-law's thigh.

In all my life, I have never seen a person's eyes go as wide as his did that day. He screamed the most genuine, authentic *I am going to die!* scream I've ever heard.

There was a brief moment of sheer panic in his eyes, then I tossed him the device and said, "Luckily that's just the practice one."

I am well aware that I'm a jerk for doing this, but I am of the opinion that when you marry into a person's family, that person's brothers become your brothers, and this is the kind of thing brothers are supposed to do to one another. I fully expect that someday he will return the favor with interest.

Regardless of all that, the point is that for the briefest moment, my brother-in-law genuinely believed that he was going to die. He truly accepted that I had injected him with a deadly drug, despite the fact that no needle had touched him. He believed all of this simply because I told him it was true.

When you think about it, it's almost scary how much power another person's beliefs can have over you, for good or for

evil. If a parent or teacher or coach tells you that something is impossible, or that something is beyond your reach, it can be incredibly difficult to overcome that belief, even decades later. And at the same time, if a friend or partner tells you that they believe in you, that they have no doubt about your ability to accomplish whatever task is in front of you, it can create a feeling of near-invincibility. Whether we like it or not, we place a tremendous amount of importance on the things that other people tell us.

There is a quote attributed to Abraham Lincoln that says, "I'm a success today because I had a friend who believed in me and I didn't have the heart to let him down."

I think that quote applies to all of us, if we're honest. I know it applies to me.

When I was thinking about quitting my job to become a full-time speaker, I was filled with doubt. What if people stop hiring me to speak? What if my calendar dries up? What if I turn out to be a huge failure and have to come crawling on my knees to ask for my job back?

But my wife believed in me, and she told me she had no doubt that I'd make it work. My dad told me, "You've always had a remarkable habit of landing on your feet. Even if everything goes wrong, I have no doubt you'll figure it out." My friends told me they weren't worried about me at all, that they knew I'd do great.

These people I loved believed in me, and it gave me the confidence to move forward. And sure enough, they were right. My career took off, and I've never looked back.

I didn't believe I could be successful until the people I loved believed it.

I didn't believe I was an artist until Andy believed it.

I didn't believe I was a writer until an editor believed it.

And I didn't really believe that I could get to twenty thousand regrets until my client believed it.

And because my friends believed these things, I didn't have the heart to let them down.

35

WHAT DOESN'T
KILL YOU

I have a bad habit of taking things apart and then being unable to put them back together again.

As a kid, I always wanted to know how things worked, so I would borrow my dad's screwdrivers and disassemble anything with screws: toys, electronics, garage sale finds—nothing was safe. I would pull the thing apart not like a surgeon who is trying to fix a diagnosed malady, but like a medical student who is simply trying to get an understanding of how all the pieces fit together and what each one does.

There is a level of disassembly where most things can still be put back together again, but I rarely stopped there. Instead, I would inevitably take things a step farther, detaching some ribbon cable that turned out to be impossible to reattach, or opening some compartment with springs inside and having them bound across the room before disappearing down a vent in the floor. Then whatever I was taking apart would

have to be tossed in the trash, another victim of my insatiable curiosity.

I took apart radios and calculators and remote-control cars. I disassembled books to see how they were bound, examined the inner workings of retractable pens, and unplugged things inside my computer just to see what would happen. In high school I was once taking apart a vintage television set to turn it into an art piece when I recalled that old TVs can hold large amounts of electricity even years after being unplugged. Instead of stopping, I wrote a note telling my parents that I loved them and left it on the kitchen table in case things went sideways.

This habit of tearing things apart is not confined to the world of the mechanical, though. I do the same thing with words and ideas and stories, too.

Picking apart language is a bad habit to have when you are in my line of work. Although I detest the term, I am what most people would describe as a "motivational speaker": I travel around the country giving talks to professionals and students and community groups, with the general hope that the audience will leave inspired in some way.

My desire to dissect and understand language is a major handicap in this industry, because it limits my use of one of the speaking world's most powerful tools: pithy quotes.

I have a love/hate relationship with quotes that goes back many years. On the one hand, I love their compactness. A good quote can store far more inside it than its size would let on. Considering how profoundly meaningless most writing is (think of almost any work email you've ever received), it is

incredible how a good quote can bring a person to tears or inspire them to action, all in the space of a sentence or two.

On the other hand, I find that the vast majority of what passes for motivational quotes are not only vapid, but in fact entirely devoid of actual truth.

Take, for example, the phrase "What doesn't kill you makes you stronger." If you've ever faced any sort of difficulty or setback (which, as a human being, I can only assume you have), you have no doubt had some person, who probably meant well, offer this phrase to you as a supposed panacea.

The problem is, the saying is patently untrue.

If one were to make a graph showing a person's strength plotted over time, the "What doesn't kill you makes you stronger" hypothesis would hold up quite well for the first part of one's life. An infant starts out with almost no strength at all, unable to control even the movement of their own massive head. But as time goes on, they strengthen first their neck, then their core, then before you know it they are rolling over and sitting up and then crawling and walking and running.

As the infant becomes a toddler who becomes a child who becomes an adolescent, the saying still holds true: things continue to not kill them, and they continue to get stronger.

But things begin to get take a turn in one's twenties. Suddenly the speed at which you've been getting stronger grinds to a rather abrupt halt, and you find that you have to work very hard to even maintain the strength you had before. Before you know it you have acquired a lower-back injury, which does not kill you but also most certainly does not make you stronger. Soon a chiropractor prescribes you an entire

fifteen-minute stretching routine that you must do every day for the rest of your natural life, not to help you make any sort of fitness gains but rather to attempt to slow the inevitable consequences that time has on the bag of meat and bones you inhabit.

It only gets worse from there. On the list of things that don't kill you but also do not make you stronger, you discover things such as arthritis, appendicitis, spinal stenosis, kidney stones, and psoriasis, to name a few.

In fact, I hate to be the bearer of bad news, but postpuberty, your life mostly consists of a lot of things that do not kill you but also decidedly do not make you stronger, right up until the point where something finally does kill you—often the thing you least expect.

"What doesn't kill you makes you stronger" is such an obviously false statement (I mean, if it were true, imagine how strong the elderly would be—practically invincible!), and yet it remains in heavy rotation as part of our vernacular.

Similar things are discovered when you dissect "If you can dream it, you can do it!" or "Live every day like it's your last."

Still, I have learned the hard way that if I do not put some boundaries on my habit of picking apart quotes, it will lead me into a place where nothing means anything anymore. The truth is that words are not retractable pens, and stories are not old television sets. There is a certain mechanical quality to language, but there is also a great deal that is unexplainable—magical, even. To borrow E. B. White's famous observation about humor, dissecting language is like dissecting a frog: you can learn a lot, but the thing dies in the process.

I have learned that if I want to preserve the value of an aphorism, I have to limit the level of disassembly I perform on it. If at first glance I can see that it is ridiculous, I am free to rip it to pieces. But if there is something life-giving in it, I must tread lightly for fear of snuffing it out.

Against my natural instincts, there are times when I will choose to ignore something about a quote that I know to be false because I believe that the heart of the thing is somehow still true or because it's something that I want to be true even if it's not.

The Alan Watts quote I used in chapter 7 is like this. When he said "You are under no obligation to be the same person you were five minutes ago," he was obviously not telling the truth, at least not in any literal sense. There are all sorts of ways in which we are, in fact, *quite* obligated to be the same people we used to be.

But the soul of Watts's quote is something I hope with all my heart to be true: that despite all we've done, there is still room for a fresh start; that despite the pain we've caused, the mistakes we've made, the people we've let down, there is still tomorrow, and tomorrow is a new day. And because I so desperately want to believe that, I am willing to overlook the quote's slight disconnect from reality.

These days I am trying to learn to do with myself what I have only just recently learned to do with quotes: to not focus so much on my faults that I lose sight of my strengths; to not forget that something does not have to be perfect to be valuable; to not tear myself down to such a level that I am unable to put myself together again.

Moreover, I am trying to remind myself that I am not a radio or a calculator or a remote-control car, and that a few missing pieces does not mean I am destined for the trash heap. I may not be able to believe in the absurd idea that "what doesn't kill you makes you stronger," but I can and do believe that it is a great and priceless gift to be alive at all, and that perhaps what doesn't kill me can serve as a reminder of that.

I used to hate myself. Nobody was
there for I used to be pessimistic, sad, hateful,
angry, self-conscious, fat, friendless, lonely,
empty. I was genuinely a bad, rude person.
I've put that version of myself to rest, but
I can never forget it, lest I am doomed to
go through it again. Thank you.

SECTION EIGHT

THE PEOPLE WE USED TO BE

want to let go
being the person
ople step on or
ake fun of.

I want to let go
of the girl who wanted
to die and of the
world that
could've existed
without her.

The guy who
lets people get
under his
skin

Letting others
Influence my
outlook on myself...

2017/2018

I WANT TO
LET GO OF.... My Insecurities

How much I DISTRUST people

I WANT TO
LET GO OF
MY FEAR OF
BEING MY
OWN PERSON

How I
treated
myself.

keeping my
Personality
inside

Not leaving things
in the past

Letting go of
my quiet self

Not to be
afraid to show
my true self.
the and show others
real me

I'm Letting go
Of my Old
Self

I used to be a bad person in
my opinion. I used to be a very
boy crazy person, I also used to
be very sad ? full of self-doubt.
I'd like to leave all my insecurities
and bad images of myself in the
past. I want to move on from the
little shy, insecure, self-doubted person
I was. ♡

My
Younger
Self

letting my past
control the person
I am in the
present

36

OUNCES BECOME POUNDS

Cardboard is a fascinating medium. It is strong but lightweight. A single piece can be easily bent by hand, but when you attach several pieces together with the proper technique you can create incredibly rigid structures that support themselves without any other material framework. At the same time, cardboard is very fragile. You can dent it with an absentminded brush of the elbow or by kneeling on it while working, and once it's dented there is no hope of fixing it. The only solution is to replace the damaged section or to cover it up with another layer.

When I'd first built the basic, flat shapes that made up the dragon's internal structure, I could move each one around quite easily. It was nothing for me to lift one of the sixteen-foot sections over my head like a circus strongman.

But as I added layers of structure and support and detail, the thing slowly became heavier, sturdier, more substantial.

Throughout the project, I'd had my fair share of skeptics.

There was the "no regerts" crowd, of course, but there was also another contingent of people who seemed to think the project was just a waste of time. If I had to sum up their objections, it would sound something like this:

"Sure, we all have things we wish we'd done differently. But why go to the trouble of all this? My regrets don't impact my day-to-day life that much. I can handle them just fine."

To be fair, they had a point. What they were saying is true, at least for a time. Most of us have learned to shoulder the weight of our past, learned to distribute the load where it will do the least harm. But that doesn't mean it's a particularly good idea, especially over the long term.

Years ago, I attended a long-distance backpacking seminar at our local conservation center. The workshop was put on by a woman who had hiked thousands of miles in every kind of weather imaginable, carrying everything she needed on her back.

She showed us pictures of her travels, told stories about encounters with rare and dangerous wildlife, and answered common questions about how a person charges their phone in the wild (they use a tiny solar panel) and where they relieve themselves (into a hole in the ground). Then she showed us her gear.

She showed us the shoes she hikes in and talked about the pros and cons of hiking boots versus cross trainers. She walked us through each item of clothing, explaining why she'd chosen it and how it could be used in several different ways depending on the weather.

She then began pulling things out of her backpack, explaining what each one was, what it did, and where she had gotten it. She talked about which things were absolute essentials, which were

nice-to-haves, and which were luxuries. She showed us her tent and her sleeping bag and her camp stove and her first-aid kit and so on. Then, once she had emptied her backpack, she showed us the backpack itself.

It was a state-of-the-art internal-frame hiking pack. It had a dense waistband of structured foam that had been custom formed to take the weight off her shoulders and distribute it over her hips, with an inner mesh lining that dissipated heat and wicked away sweat. The body of the pack was made from space-age ripstop nylon that was lightweight and strong and dyed some obnoxiously bright color that could be seen from outer space.

As she showed us the backpack, she began to explain all of the features the pack *used* to have: pockets she had removed, gear loops she had cut off, straps she had shortened. She held up a tiny pile of nylon scraps and bits of webbing, all former components of her now-mutilated backpack. She went on to explain that this was an ongoing effort, that after each trip she would reevaluate things and remove any bits she wasn't using.

Sitting in the audience, I was appalled. This was a very expensive piece of equipment, and she'd sliced it up like a cheap steak.

When it came time for the woman to take questions from the audience, I raised my hand. I told her how much I'd enjoyed the session and thanked her for putting it on. Then I said, "I've got to ask, though, is it really worth it to chop up your beautiful state-of-the-art backpack to save such a small amount of weight? Is it worth ruining the resale value over a few ounces?"

She considered the question for a moment, then said, "You know, I understand where you're coming from. When I bought

my first hiking pack I couldn't imagine modifying it. I had the same thoughts as you when I watched other hikers cut their straps or rip out their interior pockets. But then I started racking up some serious miles, and my perspective changed.

"See, you won't notice the extra weight for the first few miles. It won't bother you at all. You may make it five or ten miles without it being an issue; you might even hike for a day or two with no problem. But at some point there will come a moment when your lungs are burning and your legs feel like Jell-O, and the question will suddenly occur to you: Is there anything I'm carrying that I don't absolutely *have* to be carrying?"

She paused for a moment, then looked right at me.

"You're right that I'm only saving a few ounces by doing this. But ounces become pounds, and pounds become pain."

I later found out that this is a well-known saying in the distance hiking community, but when she said it, I felt like it was one of the most profound things I had ever heard. Years later, when a small but vocal contingent questioned the necessity of having a Viking funeral to let go of one's past, her response came back to mind.

In the distance hiking community, weight is paramount. Not only will hikers mutilate their backpacks to save a few ounces, they'll also cut the handles off their toothbrushes, pack a single razor blade instead of a pocket knife, and inflate a Ziploc bag in place of a pillow. It's not uncommon for long-distance hikers to burn the pages of their guidebook as they go, keeping only the sections that they haven't hiked yet.

There are lessons to be learned here. In a sense, life is nothing if not a long-distance hike through difficult terrain, and while it's true that most of us have learned to carry the

weight of our past, it is also true that the ounces of regret become pounds, and the pounds become pain. On the trail, this extra weight is felt in your knees and ankles and back, but in life the pain shows up in other ways, in broken relationships and crippling self-doubt.

Hikers learn to ask not "Can I carry this?" but rather "Do I need this? Does this serve me? Has it earned its place on my shoulders?" If an object doesn't answer all of those questions in the affirmative, it is left behind.

Imagine the freedom we'd feel if we applied these principles to the weight we carry every day. Imagine if we stopped saying "I can carry this" and instead asked "Do I need to?" Imagine if we examined each possible new burden with the eyes of a hiker, choosing more often than not to leave things where they are instead of adding them to our packs.

* * *

By the time I finished each section of the dragon ship, the weight had become quite noticeable. The layers of cardboard and hot glue, the scales and spikes and planks and accent pieces had all added up to something rather cumbersome. It became more and more difficult to maneuver the pieces as I worked, and I stopped laying them sideways and instead began using scaffolding to reach the higher sections, worried that if I continued to move the dragon up and down, it might collapse under its own weight.

A friend visited the shop and asked how much cardboard and hot glue I had used, and I said that I wasn't really sure. Later I went back and added it up, and I realized that the ship

had required more than six thousand square feet of cardboard and just over fifty-seven pounds of hot glue. When I stacked all of the mailed submissions, the boxes towered over my six-foot-two frame, and when I printed the ones that had been submitted online, even using small text it came out to hundreds of pages.

What had started as a crazy idea for a silly birthday celebration had, over the course of several years, turned into this: a massive dragon ship that reached to the rafters, filled with tens of thousands of things that people wished to leave behind them, written in multiple languages and sent in from all over the globe.

And in less than a week, the whole thing would burn.

37

MY DANNY DEVITO
BODY PILLOW

At the very beginning of the project, before I'd publicly announced anything about the Viking ship, I had bounced the idea off a few people to get their feedback. A fellow speaker, someone I'd only ever interacted with online, heard about the project and reached out with an offer to help. She had been hired to do a half-day seminar with a group of more than a thousand students, and she asked if it would be helpful to have them fill out cards for the ship.

I was thrilled. I knew from past projects that momentum begets even more momentum, so the thought of announcing the project and then almost immediately being able to say "We're already 10 percent of the way to our goal!" was very exciting.

I thanked her profusely, then gave her the details on how to explain the project, told her what kind of note cards to buy, and gave her my mailing address. A few weeks after the project was announced, she sent me a picture of the stack of note cards

she'd collected, along with pictures of individual submissions that were particularly meaningful or particularly funny. (My favorite was a picture of a card that said, "I want to get rid of my Danny DeVito body pillow.")

I was ecstatic. "Thank you so much!" I said. I began checking the P.O. box daily, excited to update the project website with the new total when the cards came in.

But the cards didn't come in. Days went by, and then weeks. I messaged her and said, "Hey, friend! Have you had a chance to mail those cards yet?"

No response.

Another week went by, and I tried reaching out on another platform in case she checked that inbox more often.

"I hate to be a pest, but have you had a chance to mail those cards?"

Crickets.

Another month went by. Keep in mind, I'd never actually met this person in real life. We were online acquaintances only, and even in that limited capacity we'd only interacted a handful of times. I didn't want to risk annoying her or pushing her away, but at the same time I didn't want to miss out on a thousand submissions that I knew were in existence.

I reached out again.

I told her that I was sorry if I'd done something to upset her or if I had offended her in some way. I told her that if she'd lost the cards or thrown them away that I understood, that I was just hoping to get some idea of where things were at.

She responded quickly this time, apologizing profusely. She explained that she'd just recently found out that she was pregnant, and that she'd been suffering from extreme morning

sickness. I told her I completely understood (my wife has given birth four times, so I am quite familiar with the ins and outs of morning sickness). She said she was going to the post office that weekend, and she'd make sure to drop the cards in the mail then. I thanked her again and told her I couldn't wait to see them.

I checked the mail every day that week, but the cards never came. Another week went by, then another and another. Soon it had been a month, then two months, then three.

I had a speaking event coming up in the area where she lived, so I reached out ahead of time.

"Hey, I'm gonna be in your neck of the woods! Any chance I could swing by and grab those cards?"

But again, there was no response.

I tried to tell myself that I should give up, that the cards were long gone. But no matter how hard I tried, I couldn't let go of the idea that there were a thousand submissions out there somewhere if I could only convince this person to drop them in the mail.

I tried everything. I explained that I was trying to reach five thousand submissions by a certain date. I told her about a grant I'd applied for and explained that a sudden jump in the number of submissions might be enough to help me get funding. I even tried blatant bribery, offering to give her a Starbucks gift card if she would send the cards. No matter what I said, she would never respond to any of my messages.

Sometimes there were glimmers of hope, though. A year after the project launched, when I'd given up all hope of getting the cards from her, she reached out to say that she'd found them in a pile in her office and was finally going to send them. I

was thrilled, but then I didn't hear from her for a month. When I finally made contact, she said she had in fact mailed the cards, but then two weeks later said they'd been returned due to an incomplete address. She told me she'd correct the mistake right away and resend them, but of course the cards never showed up.

As time went on, I would periodically reach out and try again—the allure of a thousand new submissions never fully went away—but eventually I stopped receiving any responses from her. I reached my goal of ten thousand cards, then surpassed it. Finally, in the last weeks of the project, I crossed the twenty thousand submissions mark, but still the promised cards never came.

As I prepared to stop taking submissions, I reached out one last time:

"Last ditch effort, because I have to try . . . the ship burns in ten days. Is there any hope at all of seeing those cards?"

As expected, she didn't respond.

But someone else did.

In my effort to get to twenty thousand submissions, I'd asked friends to help me spread the word on social media. One of those friends, an artist named Danielle, had posted a link to the project on her Instagram profile. That link had gotten the attention of one of her friends, a filmmaker named Sam Tilson. Sam was working on a documentary miniseries about artists and their work, and he thought the Viking ship would be great subject matter.

Sam sent me a message asking me for some details about the project, and before I knew it he'd bought a plane ticket, flown halfway across the country, borrowed a car, and driven down to the warehouse.

When Sam arrived, there were just four days left until the ship burned. I still hadn't finished the main text piece, hadn't figured out how I was going to get the ship to the burn site, and hadn't even *started* rebuilding the middle section of the ship. With less than a hundred hours left, the ship consisted of a dragon head, a dragon tail, and a half-built piece of text.

In retrospect, it is insane that I thought I could get all of this done on my own in such a short time. Even working around the clock, I think it would've been nearly impossible to do alone.

Luckily, I wasn't alone. I had Sam.

I am only half joking when I say that Sam Tilson may be a literal angel. Not only did he manage to capture some incredible photos and video of the final days of the project, but he also jumped in to help whenever I needed him. If I needed someone to press against the outside of the ship while I glued something from the inside, Sam would put down his camera without complaint. If I needed something held in place so I could step back and view it from a distance, Sam was happy to oblige. As an artist himself, Sam understood the project in an intuitive way and offered some very insightful suggestions that made the project better.

Every day I would pick up Sam at his hotel early in the morning and drive him to the warehouse, and we could work until well after dark.

With Sam's help, I built the framework for the middle of the ship. I installed the exterior planks, added the cardboard bolts and hardware, and added a floor for the text piece to sit on. I built the structural framework for the text piece and finished gluing cards inside. Sam alternated among the roles of photographer, videographer, art assistant, and comic relief. The

clock was counting down, but it actually looked like the ship was going to get done.

Then, in the midst of all of it, a message popped up in my inbox.

"I know this is a million years overdue, and I'm so incredibly sorry that I've been M.I.A. When the cards came back because of the address mix-up, I was completely overwhelmed with other things and I shoved them in a closet. I've been in a season where I felt like I was drowning and I couldn't possibly handle another thing. But none of that is important now. I've just shipped the cards Priority Express, and they'll be there in time for the burning on Saturday."

Below the message was a picture of a shipping label. I checked the tracking number online and saw that the cards were en route, scheduled to arrive the day before the burn.

I couldn't believe it. It had been more than two years since she'd first said she was shipping the cards. I'd sent more than a dozen messages that had gone unanswered in that time. I'd so desperately wanted the cards to get to 10,000 submissions, and then I'd wanted them to get to 20,000. And now that I'd passed both of those milestones on my own, now that I didn't really *need* the cards anymore, they arrived out of the clear blue sky. It was rather poetic.

When the package finally showed up, it did not contain 1,000 cards. It contained 628 cards. The card about the Danny DeVito body pillow was inexplicably missing, as were a few others she'd sent me pictures of. It was an incomplete package, a fraction of what I'd expected. But it was, in some strange way, exactly what I needed. It was closure.

Sam and I grabbed the cards from the post office and

quickly scanned them in. Then we added them to the pile in the warehouse waiting to be burned the next day. The grand total: 21,080 submissions. Twenty-one thousand and eighty regrets, heartaches, mistakes. Twenty-one thousand and eighty burdens. Twenty-one thousand and eighty reasons to leave the past behind.

38

"WE DIDN'T START THE FIRE"

E arlier in this book, I mentioned a song by Billy Joel called "We Didn't Start the Fire." If you've forgotten that already, it's okay—I only mentioned it briefly, more than thirty chapters ago. In fact, if you have forgotten it, that only helps reinforce the point I'm about to make.

"We Didn't Start the Fire" is a song about the first forty years of Billy Joel's life (1949–1989). Each verse covers a specific period of time, and contains an assortment of things from the era that are considered to be historically significant.

The song is fascinating both for what it includes and for what it leaves out. It talks about five US presidents but leaves out three others who served during the same period. The first three verses cover four years apiece, the fourth verse covers just three years, and then in verse five Billy Joel seems to realize how long the song is going be if he keeps going at the same rate, so he dumps *twenty-five years* into a single verse.

Four different professional boxers are mentioned, and there are five references to baseball, but all other sports are left out entirely. *Wheel of Fortune* gets a mention, but not *Jeopardy!*; *The Catcher in the Rye*, but not *To Kill a Mockingbird*. You begin to suspect that some things were chosen not because they have particular historical significance, but rather for the fact that they happen to rhyme with something that does.

The interesting thing about "We Didn't Start the Fire" is that it's really only meaningful to two groups of people: historians, and people who happened to live through the period it covers (or three groups of people, if you count children who misunderstand the lyrics and love the Ninja Turtles).

But the person it's *most* meaningful to is Billy Joel. The more time you spend examining the song, the more you realize that this is not the kind of history you find in a textbook but rather the kind of history that represents the lived experience of a particular person existing in a particular place at a particular moment in time.* For example, the song makes note of the fact that two different baseball teams moved from New York to California in 1958, a fact that is not particularly significant for the vast majority of people but is still a sore subject for people who grew up in New York in the 1950s—people like, say . . . Billy Joel.

For the rest of us, half of the things mentioned in the song have no significance to us whatsoever, and the other half are mostly just things we're vaguely familiar with from history class. If I were to sit you down with a copy of the song's lyrics

*Although some would argue this is true of all histories.

and ask you to highlight all the things you could confidently explain the significance of, my guess is that you'd end up mostly highlighting all the names of famous people and almost none of the foreign leaders or discontinued automobiles.

This isn't a knock on the song, though, or on Billy Joel as an artist, because the same thing is true for every one of the 21,080 things that people sent in to be burned. In fact, it's true for most of the big events of our lives. Things that feel immense to us are completely insignificant to other people. Things that feel unbearable or unjust are not even blips on the radar of the person living a few doors from you.

As depressing as that sounds, it is actually a great gift because it means that we can let go of a lot of the guilt we carry around. We can stop mentally replaying that embarrassing situation from twenty years ago because we realize that the other people involved probably don't even remember that it happened. They're all too busy thinking about their own embarrassments, none of which are significant to you at all.

In my own life, I can think of a particular instance where I apologized profusely to someone for a thing that had happened years before, a thing I'd felt a lot of guilt about for a long time. When I did, the person I apologized to not only didn't remember what I was talking about, but she even corrected my version of events by reminding me of another detail I'd entirely forgotten, something that actually made me seem like a decent human being, or at least not like the monster I remembered myself as.

Another time, a video of one of my speeches started getting shared on social media, and I noticed that one of the people who'd shared it was a girl I went to middle school with. When

I saw her name, I felt a twinge of regret, because I remembered a few times when I had been unkind to her, and the video she'd shared was one where I talked about the importance of kindness. And yet, when I clicked on her post, she didn't mention any of that. Instead, she talked about a time I'd stood up for her in art class, and another time when I'd been the only person not to call her a mean nickname. But truth be told, I don't remember either of those things. Memory is funny that way.

* * *

In preparing to write this book, I went back through my phone and looked at every single picture and video I'd taken during the two and a half years of the project. I wanted to put together an accurate timeline of the whole thing, to remember what happened when and in what order.

The thing that I found surprising was just *how much* I'd forgotten. Not just minor details about the project itself but also major events in my normal life.

For instance, I found a video on my phone showing my wife's old van being loaded onto a tow truck, the victim of a faulty transmission. I looked at the date on the video and saw that this had taken place in the heat of the summer, when my wife was thirty-nine weeks pregnant with our youngest daughter. When I think about all of the factors involved in that situation, I can only assume that it was incredibly stressful for us. But aside from the video on my phone, I have absolutely no memory of it happening at all.

This same thing happens to me every December when I

do my year-end review. I'll go back through my calendar, through my emails and social media posts and photographs, trying to remember all of the things that happened that year. Inevitably, I find myself looking at some picture or email and saying, "Oh, wow, I'd completely forgotten about that." It's amazing how easy it is for an entire year to disappear in one's memory if one isn't diligent about grabbing the valuable things before they swirl down the drain. If you'd asked me how many times my wife and I got to take an overnight trip together without the kids in 2019, I would've said one or two. But it was four.

The other thing you'll find when you do this sort of review is that a great many of the things that bring you joy as you look back are not the sorts of things you would have expected at all. You expect to remember the birthdays and anniversaries and the trips to exotic places, but you don't expect that a simple picture of you and your friends playing sand volleyball will bring you the same amount of joy, or perhaps even more.

When we look back on our lives, there is far too much information for our brains to make sense of at once. So we pick and choose what to remember, or our brains pick and choose for us. The problem is that sometimes they choose poorly. Sometimes they ignore all the sand volleyball and the overnight trips and instead focus only on the times when our van broke down. Sometimes they ignore all the times we showed someone kindness and instead remember only the times we did not. In doing so, they create a historical record that does not serve us, a summary of events that is not true. In such a situation, it is in our best interest to perform a rewrite—not to erase our mistakes or whitewash the painful parts of our history, but

to balance them out a bit by shifting some of the focus off the clouds and onto the sunshine.

<p style="text-align:center">* * *</p>

Over the years, a lot of recording artists have done their own interpretations of "We Didn't Start the Fire." Some of them have written new versions to cover later periods of time, or to cover very specific subcultures, or both. I've often wondered if Billy Joel has any regrets about the song, if there are any things he wishes he'd included or things he wishes he'd left out. I wonder how different the lyrics would be if he were to rewrite the song from scratch today. I wonder if, as a man in his seventies, he still sees the world the same way he did at forty.

It is helpful for me to remind myself from time to time that my own memory is like "We Didn't Start the Fire"—it focuses on some things over others without good reason, leaves out some important events entirely, and probably includes more *Wheel of Fortune* than necessary.

But it is also helpful for me to remind myself that I have an advantage over Billy Joel in that my memory has not been recorded and played over the radio or pressed onto vinyl and preserved for future generations. My memory can still be changed, revised, refocused.

My hope for those who sent in their regrets is this: that in letting go of this thing that has held them back for so long, this belief or relationship or identity or experience or fear, they have made room in the lyrics of their song to focus on something better, something truer, something more reflective of the person they wish to be.

But enough about Billy Joel. Let's get to the part we've all been waiting for: the moment when, after two and a half of years of struggles and setbacks and slowdowns, after delay and difficulty and near defeat, the ship was finally complete. The moment when we, all 21,080 of us strong, did in fact start the fire.

39

THE SHIP BURNS

The morning of the burn I woke up early, made myself some coffee, and headed out the door to pick up Sam. We grabbed a quick breakfast at his hotel, then headed to meet my brother at an equipment rental outfit where we picked up a twenty-foot flatbed trailer.

I'd built the ship in sections to make moving it easier, but that was about as far as my transportation planning had gone. A few days before the burn, I'd called a couple of friends and asked them if they could help me get everything moved to the site. They showed up at the warehouse that morning with a hodgepodge of tow straps, rope, and bungee cords.

We decided to transport the text piece first, because it was the smallest and lightest bit. We loaded it onto the trailer, strapped it down, and began the drive over to Chris and Kinsey's field. This was our first time navigating the route with the trailer attached, but we managed to get there without any issues. We got to the site, unloaded the piece, and headed back to the warehouse.

Next up was the dragon's head. This was the oldest bit of the

ship, the only section that had not collapsed and been rebuilt. It was the most heavily detailed section as well, featuring a smiling dragon's head atop a curving serpentine body, with spikes and fringes and layers of various types of scales all the way down. It was also the section I was most worried about.

As I mentioned a few chapters back, the ounces of cardboard and hot glue had accumulated into pounds, and those pounds had started to take their toll on the internal support structure at the base of the dragon's neck. Every time I would lay the piece down or stand it upright to work on different areas, the bottom corners would get crushed a little more in the transition. Eventually I decided to stop moving it altogether for fear that I might reach a point of no return.

Unfortunately, I had no choice but to lay it down now. Carefully, I positioned my volunteer crew around the dragon's head and we slowly lowered it to the ground. As we did, I watched in horror as the corner collapsed more and more. Spencer happened to be holding that section, and he gave me a concerned look. I shrugged my shoulders as if to say, "I know, man. It is what it is." But inside I worried that we would not be able to get the piece standing again once we got it on site.

We carried the piece onto the trailer, where we secured it with straps and rope. It was not a long drive from the warehouse to the burn site, but I didn't want to risk any of the intricate details blowing off along the way, so we wrapped the head in canvas tarps to protect the cardboard.

As we pulled onto the highway, I experienced a wave of anxiety like I had not felt in many years. Looking back at the ship, I saw planks on the bow begin vibrating in the wind, and I was overcome with fear.

What if the planks blow off onto the highway?

What if we take a sudden turn and the whole thing falls off the trailer?

What if we get it on site only to find that it won't stand upright again because we've damaged the internal supports in the move?

A million questions ran through my head, and I didn't have good answers for any of them. The event was scheduled to start in a matter of hours, and people were already on their way to the burn location from all over the state. There was no margin for error today, no time to make repairs. Everything had to be perfect, and I knew from past experience that my odds for perfection were not great.

As we pulled off the highway and onto the winding back roads, I realized that I had never done the simple and obvious task of measuring how wide a lane of traffic is. Bits of the ship were hanging off both sides of the trailer, and as I looked in the rearview mirror I could see that they were extending ever so slightly into the lane of oncoming traffic. Every time we passed another vehicle going in the opposite direction, my heart would jump into my throat as I anticipated a collision.

I spent the entire drive imagining every possible thing that could go wrong and how each of those things would ultimately reveal to the world that I was a complete and total fraud, that I had no business trying to pull off anything like this, that this whole thing had been a mistake. I berated myself for not having spent more time planning the move and felt convinced that something was going to go terribly wrong.

But then before I knew it, we had pulled into the field and unloaded the dragon's head without a single issue. We made another trip back to the warehouse to load the center section

of the ship, then one more to grab the dragon's tail. And in the end, everything was fine. None of the things I'd worried about had come to pass.

As Spencer and I closed the garage door on the empty warehouse, I marveled at how vast the space felt without the ship inside. "This place feels huge," I commented to no one in particular. Spencer laughed. "You realize the ship touched the rafters, right?"

We assembled the pieces in the field, staking lengths of paracord into the ground as guylines to keep the ship protected from gusts of wind. Despite all my concerns about the dragon's head, we were able to stand it upright on our first try. It was as if after all the struggle of the past two and a half years, the universe said, "Today's your day, man. Enjoy it."

As I stepped back to look at the ship, I suddenly realized that I had never seen it all together like this before. The entire time the ship had been in the warehouse, I'd only ever been able to see it from one angle due to the narrow dimensions of the space. But now I could view the thing from all sides, and it looked better than I had ever imagined. I am a person who rarely feels a real sense of pride in anything I've done, instead focusing on a laundry list of defects that only I can see, but as I stood back looking at this massive creation, I allowed myself, for the briefest moment, to be proud.

A video crew was on site to document the entire day, and the local newspaper had sent a reporter as well. As friends and family began to arrive for the event, the videographers moved silently around the field, capturing footage of the ship from all sides, watching as my kids and their friends played tag in the open field.

Most of the people there had never seen the ship in person before, having only seen the pictures I'd posted online. As they stood craning their necks to look up at the dragon, everyone commented on how much bigger the thing was in person.

My friend Olivia stopped me and said, "Kyle, this is really incredible." I said thanks and tried to change the subject, having never really learned how to be comfortable accepting a compliment. But Olivia stopped me. "Kyle, I'm serious. You did something really great here. You should be proud of that." I stopped, smiled, and said, "Thanks, Olivia. That means a lot to me."

I grabbed the boxes of submissions and began placing them beneath the lettering piece. I'd done a practice run earlier that week with some blank note cards, and I'd learned that it would be necessary to crumple the cards to help them burn completely. I grabbed some volunteers from the crowd and we began the process of crumpling up thousands and thousands of pieces of paper together. As we did, we talked and laughed and read aloud certain cards that were particularly meaningful, particularly heartfelt, or particularly funny. Once the cards were all in place, I doused the center of the ship with diesel and kerosene, soaking the submissions in accelerant.

I'd called the Fire Department ahead of time to let them know about the event, and they'd agreed to send a truck over as a precautionary measure. But as the crowd began to huddle together against the cold December wind, the firefighters were nowhere to be seen. Finally, just as I was starting to think they'd forgotten about us, a big red truck pulled into the drive.

Everything was in place now.

Using a bullhorn I'd borrowed, I thanked the crowd for

coming. I explained a bit about the history of the project, about how it had started and the difficulties I'd run into along the way. I talked about regret, about the need to let go of the past to move toward a better future. I shared what the project had meant to me, how it had changed me and stretched the bounds of my comfort zone. I talked about my gratitude for those who had sent their regrets, and my hope that the project had helped them in some way.

As I spoke, I had to keep stopping every few seconds because I was getting choked up, but the crowd was patient with me and let me say what was in my heart.

Eventually I finished, and I asked everyone to take several large steps backward. The crowd moved back to a safe distance as the video crew got into place. I looked at my wife, who smiled and nodded as if to say, "It's time." Two and a half years of struggle had come down to this. There was only one thing left to do now.

I lit two flares, then walked slowly toward the ship and threw them inside.

The fire started slowly at first, catching a few of the note cards and then spreading up the center text. Before long the entire middle of the ship was engulfed in the blaze, and the flames began creeping up the dragon's neck and tail.

As 21,080 regrets burned away to ash, I began to cry. A single tear ran down my face, and I didn't wipe it away. Another followed, and before I knew it, I was sobbing uncontrollably as two and a half years of emotion came bubbling to the surface all at once. There was joy and sadness, love and loss, relief, gratitude, and peace. But most of all, there was an overwhelming sense of fulfillment, a sense of an ending, a sense that I had completed a

long and difficult journey and now I was cresting the final hill toward the lights of home.

As I stood there weeping, my friend Ryan walked over and gave me a giant hug. As he wrapped his arms around me, he whispered into my ear, "You did it, man. I'm so freaking proud of you." After Ryan came Spencer, and then Adam, and then my dad, one of the few people in the world who can still make me feel small when he hugs me. Finally, Lindsay came and tucked herself under my arm, leaning her head against my shoulder as we watched the flaming ship begin to collapse in on itself.

The dragon's head curled backward, twisted around, and crashed into the flames, and the crowd erupted in a triumphant cheer. The tail followed soon after, and before I knew it the whole thing was a pile of smoldering ankle-high ash and coals.

My beautiful cardboard dragon, which was by far the largest and most difficult thing I had ever built, which had taken years of physical work and emotional struggle, burned away to nothing in just over six minutes' time.

40

GREENER PASTURES

Perhaps Shakespeare was on to something when he wrote, "Parting is such sweet sorrow." There is something about an ending that is bittersweet, the sadness of one thing coming to a close mixed with the joy of a fresh start. It is a complex feeling, and like all such things it defies being put into words.

In the days after the ship burned, I felt the echoes of all the emotions I'd experienced in the field that day. There were moments of sadness at the thought that the whole thing was over, moments of gratitude for having gone on the journey, moments of joy as I read the messages of congratulations from friends and followers, and even a few brief moments of pride as I realized, *Kyle, you crazy sonofabitch, you actually pulled it off.*

I'd livestreamed the burning for those who couldn't be there in person, and a few days later I sat down to watch the recording. As the video began to play, I was blown away to see that thousands of people had tuned in from all over the world to watch the ship go up in flames. In the comments, people began sharing where they were from and how they'd heard about the project. Someone would say they'd seen me speak

at a particular event, and there would be a sudden burst of comments as others chimed in, "No way! I was there, too!"

When the ship started to burn, one person said they'd been waiting for this day for months, and another said they'd been waiting for years. The flames spread quickly through the mass of fuel-soaked papers, and one viewer confessed that she was tearing up as she thought of the regret she'd sent in. Others admitted that they were crying, too.

Finally, as the video showed the ship collapsing in on itself and the crowd cheering, one of the commenters wrote, "To moving on!"

"To moving on!" someone else echoed, and the comments exploded in a chorus of the same.

"To moving on!"

"To moving on!"

"To moving on!"

* * *

A local news station did a story about the ship, and a grumpy old man commented on one of their social media posts, saying he thought the project was a waste of time. Someone asked if he'd even read the article, and he said, "As a matter of fact I *did* read the article, and I also watched the story on the news four times today."

When I saw his comment, I burst into laughter. This man watched a news story, thought it was dumb, and then proceeded to watch it again *three more times*. Then just to be sure, he read an article about it online.

I couldn't think of a more apt metaphor for what the project

was about. Here was a man who knew for a fact that he didn't like what was on the TV, who could have changed the channel at any point, who could've turned off the TV and done something else entirely. But instead, he chose to complain about what was on, even as he continued to watch it over and over again.

Lindsay asked if I was bothered by the comment, and I said, "Nah. When a person watches a show they hate four times in the same day, I do not look to that person for advice about what is or is not a waste of time."

She laughed. "Good point."

Aside from the old man, the vast majority of the responses to the project were positive. When the story aired, I was inundated with texts from friends: "Just saw you on the news! So cool!"

A week later, out of the blue, I got another wave of texts.

"Congrats, man!"

"Saw the news! That's awesome!"

"You're famous! Ha-ha!"

I figured the news station must have re-aired the story or something, but then I saw that one of the texts had a picture attached. It was a shot of my friend's front porch with the day's newspaper lying on the ground. On the front page was a picture of the ship, along with the most straight-to-the-point headline of all time:

"ARTIST MAKES CARDBOARD VIKING SHIP AND BURNS IT"

I showed the picture to Lindsay. "They called you an artist!" she said.

I laughed. "I guess it's official now."

*　*　*

My inbox was an interesting place for a few weeks after the ship burned.

I received notes of congratulations from friends across the country who'd been following my journey from the beginning.

I received notes of gratitude from people who'd sent in submissions, telling me how much it had meant to watch them burn.

I received notes from people who'd been at the burning in person, saying how moved they'd been at seeing me get so emotional that day.

More than anything, though, I got a lot of messages asking some variant of, "So . . . what's next?"

When I responded, I said that, to be honest, I had no idea. I said that I had some sleep to catch up on and that I'd be fine if I didn't look at another piece of cardboard for some time. Most of all, though, I said that I wanted to spend some time nurturing the non–oddball-artist side of my life. I wanted to take walks with my wife and wrestle with my kids and not worry about any big, audacious projects for a while.

So that's what I did.

My older brother and his family had flown into town the day before the ship burned, and we spent the next few weeks hanging out with them, celebrating the holidays with the family and eating slightly more food than was strictly necessary.

The days got shorter, then changed their mind and began stretching out again. Christmas came, and then New Year's. One year rolled into the next, and a few months later winter took her final bow and let spring take the stage. Everywhere I looked there was another reminder that the end of one thing is always the beginning of something else, something new.

As the land began waking from its season of rest—trees sending out buds, flowers bursting into bloom—I ran into Chris one day. We commented on the nice weather like two old men, and I asked him how his pasture was recovering after I'd burned a giant hole in one end of it.

"Actually, it's interesting that you say that," he said, "because the spot where you burned the ship has grown back greener than anything else around it."

I raised my eyebrows.

"I'm sure there's a perfectly scientific explanation for why that is—" he said, but I cut him off.

"Yeah, but why ruin the magic?"

"Exactly," Chris said. "Why ruin the magic?"

A NOTE ON NEW BEGINNINGS

Perhaps the most common question I got about the ship, especially as it got closer to the finish line, was, "Aren't you going to be sad to burn this thing after all that work?"

And every time, I said no.

For one thing, what else was I gonna do with it? It was a sixteen-foot-tall, thirty-foot-long cardboard dragon ship. It's not like I could keep it in my living room.

For another thing, it was always meant to be burned. From the beginning, I knew that the finish line was a pile of ashes. So if I got attached to the ship and decided not to burn it, all I was really doing was deciding not to finish—not to do the thing I said I was going to do, not to let go of the regrets of 21,080 people who had trusted me.

But more than any of that, the reason I wasn't sad to burn it was this: burning the ship allowed me to move on to new things.

As much as I loved this project, it was hard. It took longer and cost more than I ever anticipated. It took up so much room

in my life (both literally and figuratively) that I didn't have space for other things.

But once it was gone, all of that changed.

A week or so after the ship burned, I cleaned the last of my stuff out of the big, empty storage unit. I swept out the last of the cardboard scraps, cleaned up the final bits of paper and hot glue, and prepared to close the big garage doors one last time.

Before I did, I stood there looking around at the vastness of the space. As the ship had neared completion in the final days, it had gotten pretty crowded inside the shop. Getting from one side of the ship to the other became a matter of navigating a winding maze of ship pieces, scaffolding, and supplies.

But all that was gone now. And without the ship in there, there was a lot of room for someone else to do something new.

And there's room now in my life (and my budget) to start a new adventure of my own.

My hope for you, dear reader, is that whatever you wrote on your card or thought of as you read this book, whatever went up in flames in the ship or simply in your imagination, has made room in your heart and in your life for a new beginning.

I hope today is a blank slate for you, an empty warehouse full of nothing but possibility.

What will you fill it with?

ACKNOWLEDGMENTS

I used to get annoyed at the fact that every book's acknowledgments section starts with the same sentiment, something about "A project like this could never have been pulled off without the love and support of blah blah blah."

But now I get it.

Now that I'm the one writing the acknowledgments, I don't particularly care if the average reader finds this part a little cheesy or annoying, because the truth is *this part isn't for you.*

Here's who it's for:

First and foremost, Lindsay. You're my rock, and none of this would've happened without your support and encouragement. You're the best, and I love you.

Donald Hancock, who TWICE found a space for me to build the ship in, and who believed in it during a time when I was on the precipice of giving up.

Mom and Dad, who raised me to be a weirdo and let me burn the first ship on their land.

Chris and Kinsey Olson, who allowed me to burn a giant hole in their pasture.

Sam Tilson, who is a literal angel.

Spencer Brown, who has now helped me move two separate cardboard Viking ships.

Matt and Travis Scheele and Dad, who helped me move the second ship.

Erin Tyler, who cut hundreds and hundreds of dragon scales and triangles by hand on short notice.

Adam Jahnke, who was always down to jump in and help with whatever was needed, from gluing on dragon spikes to tidying up for the shoot.

Jeremy Alvarez, who came and cleaned up scraps off the floor for hours so the shop would look nice for the SoulPancake shoot, and who came back to help touch up the letters so they'd look perfect.

Nick Mehn, who is a good friend and a talented photographer.

Brad Montague, who introduced my project to a bigger audience than I ever could've dreamed of, and who always shows up with the right words of encouragement at the exact moment I need them most.

Andy Miller, who believed I was an artist long before I did, and whose friendship I cherish deeply.

Branden Harvey, who is a constant source of insight and encouragement.

Dave Durham, whose generosity knows no bounds.

My Kickstarter backers, who gave the project an infusion of cash when I needed it most.

The SoulPancake crew, for putting together an incredible video and sharing it with the world.

Springfield Paper Company, who sold me the first batch of cardboard for cheap and even delivered it.

Robert McMahon and Southern Missouri Containers, who hooked me up with SO MUCH CARDBOARD and who used their giant robot machine to cut the lettering piece to perfection.

Bob Ewing, who designed the lettering in the center of the ship and NAILED it.

Locke and Stache, whose video about the first Viking ship set this whole thing in motion and who have always been so supportive of my ideas.

Every one of my friends who shared the post on social media and drove people to submit their regrets.

Reuben Uhlmann, who helped me with the framing stuff, lent me scaffolding, and introduced me to the best box knife on the market.

The Cook brothers, who lent me scaffolding and always make me laugh.

Each of the 21,080 people who sent me something they wanted to let go of. I know this was an act of trust and surrender, and those are rarely easy.

Natalie Newville, who encouraged me that I could get to 20,000 regrets, so I did.

Wayne White, who introduced me to cardboard art, taught me the craft, and continues to inspire me with his life and work.

Adriana Stimola and Erica Rand Silverman, who believed in this book when it was just a few chapters in a Word document.

Mickey Maudlin, Chantal Tom, and the team at HarperOne, who helped turn that Word document into a real book.

A whole bunch of people who are slipping my mind at the moment and whose contributions I will suddenly remember, horrified, the moment this book goes to print.

And the financial support of viewers like you.

APPENDIX:
SELECTED ONLINE
SUBMISSIONS

- My shyness and failure to stand up to others.

- Feeling like I always have to please everyone and meet everyone's expectations .

- How badly I treated people for my entertainment.

- The fear of what people think of me.

- Fear of being rejected. Needing to be liked by others.

- Playing small.

- I want to get rid of the past me that thought I wasn't good enough.

- The hurt and anger I feel towards my father. Letting go of my resentment and realizing that I'm not the reason he left.

- Letting my anxiety keep me from truly living.

- How badly I've treated others, how badly I've treated myself.

- That I wasn't a good enough mom.

- Comparing myself to other girls and putting myself down for not looking like them.

- Being afraid of being alone.

- My inability to see my own self-worth and letting others influence my perspective of myself.

- Doing something I hate because other people want me to do it.

- Letting my depression call the shots.

- Overthinking things that I can't change .

- Wasting precious time from hating myself for so many years.

- My dependence on him and my inability to speak up and reach out.

- I struggled with seeing myself as a good person for a long time. I fell apart and didn't take care of myself. I got into an emotionally abusive relationship and let him define me. I lost friends and I wasn't happy with that me. That has all been over a year ago. I am healing still, but I am stronger. I am no longer afraid to be myself. My biggest regret was allowing someone to try and push me away from the me I was meant to be.

- My sexual assault.

- The constant fear that everyone hates me.

- Hateful things I have said to people that I didn't mean.

- Waiting too long to tell someone how i felt and then seeing them become "the one that got away."

- Blaming myself for things i cant [sic] control.

- I wish I had been nicer to my mom.

- Being a sexual abuse victim.

- Never making it to Eagle Scout.

- The hurt from having a narcissistic parent.

- Thinking that people liking me is the equivalent of my happiness.

- Guilt for not spending more Christmases with my dad after my parents divorced. He died 5 years ago and now that I'm older and have kids I see how important it was to him and how much it would've meant. I just hope he knows how much I love him .

- Being afraid of who I am.

- Letting someone use me for over 7 months. The willingness I had to be treated poorly, and like an object, as long as I was near that person.

- My hatred for my biological parents and for the man who decided it was okay to sexually abuse the little girl I used to be.

- Beating myself up for my mistakes instead of learning from them.

- Feeling like my abuse was my fault.

- My need to live up to unrealistic expectations of myself from other people.

- My parents' divorce.

- The fear of the unknown.

- My crippling anxiety.

- The bratty, selfish, ungrateful person I once was to everyone I crossed paths with.

- Feeling like I am not enough.

- My Comfort Zone.

- The pain of seeing my mom fight cancer.

- I don't want to be someone people use so much for their own benefit anymore.

- Feeling like I'll never be completely loved.

- Jealousy.

- Feeling guilty for caring for myself.

- Being an asshole.

- Laziness and doubt.

- Wanting to be like everyone else.

- I want to let go of everything that has happened between me and my dad, despite him not being in my life, I want to grow from this. I cannot change him, but I can change myself.

- I want to let go of all the anger inside of me.

- Judging myself.

- Not being good enough.

- I've been told over and over I will never make anything of myself, and I'd like to not let these hateful words get to me anymore.

- The feeling that I'm never going to be good enough.

- Suicidal Ideation.

- I want to let go of wanting to have my father in my life again. He left when I was a young child and 14 years later, he has not tried to grow as a person and come back.

- My mother putting me down.

- Telling myself I'm not good enough for my dad to be proud of me.

- My past life.

- Being pushed out of a group.

- Being so upset about someone who couldn't care less about me.

- I want to stop tearing people down that tear me down.

- Dating Hitler himself.

- Fear of abandonment.

- The mentality that I'm better and know more.

- The crippling fear that my past mistakes have created me into a person who is what I never wished to be.

- Being so critical of myself and letting people walk all over me.

- The girl I used to be, the one that depended on someone 24/7 for happiness, the one that wasn't confident in the way I looked, and the one that was hurt by every hurtful thing someone said about me.

- I want to stop convincing myself that I am undeserving of happiness.

- The Divorce from Hell.

- My Grandma passed away and I blamed it on her. I blamed her having a stroke on the fact that she didn't take care of herself. She didn't eat right. She didn't exercise. I refused to go see her in the hospital because I blamed her for being there. When she passed away, I felt so much guilt and regret. My stubbornness got the best of me, and I didn't get to say goodbye to the person who had the biggest impact on my life.

- Falling in love with a 33 year old man when I was 16.

- The voices in my head telling me I can't or I won't ever be good enough.

- The fact that I have never had a chance to meet my father.

- Holding on to heartache.

- My father wishes I was the son that died.

- I've tried my whole life trying to please everyone around me, I've never thought about how I should do what makes me happy.

- The lies and the hurt and the pain.

- The guilt of not taking care of my mom better and having her overdose.

- My eating disorder.

- Being too self absorbed.

- Being scared to be my true self in front of others.

- My childhood. I want to let go of it so I can give my kids a better one.

- Second guessing myself.

- The fear of being different from everyone else.

- Always being afraid I'd die alone.

- Not loving myself for who I am.

- My biological dad leaving me when I was born. He got remarried and his wife got pregnant, and he was praying for a girl. I couldn't see why he wanted a girl when he already had one.

- This idea that it's my fault if something is going wrong in someone else's life.

- Loving someone who doesn't love me back.

- Being afraid to be alone and not realizing how harmful a relationship can be.

- My perfectionism.

- Thinking I was unloved and uncared for.

CREDITS AND PERMISSIONS